D1480243

THE STORY OF FOOD IN PHOTOGRAPHY

THE STORY OF FOOD IN PHOTOGRAPHY
SUSAN BRIGHT

THE STORY OF FOOD IN PHOTOGRAPHY
SUSAN BRIGHT

FEAST

FOR

THE

EYES

aperture

Wolfgang Tillmans, *Last still-life, NY*, 1995

EYE CANDY

SUSAN BRIGHT

We are what we eat. Food both fuels and shapes our physical bodies from the inside, as well as being an outward expression of our pleasures and our principles. It crosses and transgresses boundaries in every sense. Eating is one of the most base, visceral, and profane of acts, yet it is also caught up in our rituals, religions, and celebrations—it is the most human of needs, both physically and culturally. Food can signify a lifestyle or a nation, hope or despair, hunger or excess. It is the site of protest and control. It can reinforce stereotypes or undermine them. It is given to riot and spoof—as in the ridiculous food fight—but also symbolizes the most refined aspects of a culture. It carries our desires and fantasies; it can stand in for sex, be a signal of status, or engage in our politics, betraying our attitudes about immigration, domestic issues, the environment, animal rights, and travel. Ultimately, food is not only about literal taste, but also Taste with a capital T—both the lifestyles we aspire to and the building blocks of culture itself.

And so, similarly, photographs of food are rarely just about food. They hold our lives and time up to the light. As a subject that is commonly at hand, food has been and continues to be widely depicted. Many of the photographers in this book demonstrate that the most obvious of subjects is often the most demanding, and photographs of food—much like food itself—can invoke deep-seated questions and anxieties about issues such as consumption, aspiration, tradition, gender, race, desire, wealth, poverty, pleasure, revulsion, and domesticity. It can be a carrier for all kinds of fantasies and realities, and photographs of food can be complicated and deceptive, touching on many aspects of our lives, both public and private. In addition, these pictures can be found in all sorts of places—not only in cookbooks, but also in art, fashion and advertising, or as vernacular, industrial, and editorial photography. But despite the ubiquity of photographs of food—or perhaps because of it—these images are rarely written about in their entirety.

SETTING THE TABLE

Early photographs of food feature in two parallel histories: that of art and that of cookbooks. But both environments show that photography is the magpie medium, borrowing, copying, and appropriating from other practices with bravura to create something unique. Early nineteenth-century art photographers faithfully followed

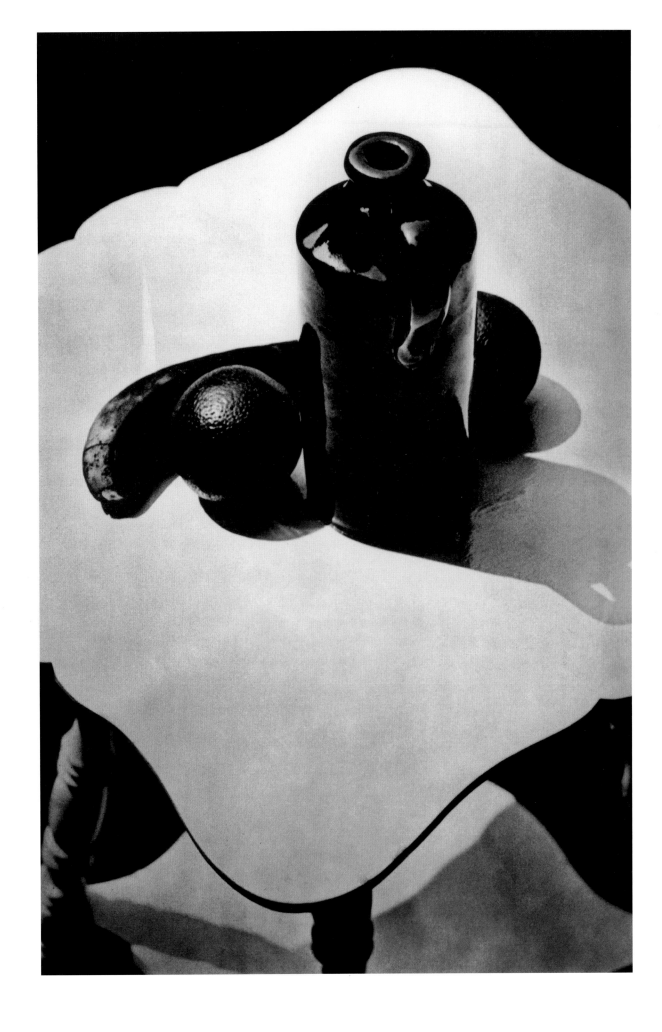

Paul Strand, *Jug and Fruit*, 1915

the traditions of painting, reproducing established genres and calling upon the same strategies and symbolism. Early photographic still lifes, in emulation of paintings, gestured allegorically toward the different states of human existence by depicting certain foods: peaches for fertility, apples as the forbidden fruit, or grapes to reference the Greek god Dionysus, insinuating excess and good living. Early photographers concentrated on the richness of objects, the things that make up our world—turning what was visible into artifacts, and transforming them to resonate beyond mere subject matter.

But alongside allegorical meanings and similarities to painting, the photographing of food has also showed photography's great differences to painting and the insecurities about its own status that have plagued its history. This can be seen in the richly toned black-and-white still lifes by Roger Fenton (pp. 30–33): the food he photographed may resonate with the history of painting that went before it, but it also works to show the abilities of photography to the fullest. Filling his scenes with rich textures and shapes to heighten the senses and show off his skill, he showed great dexterity in illustrating depth on a flat surface—something which painting could do more easily, using color and the three-dimensional texture of paint. Without an established history within art, photography had yet to prove itself—so the frames of Fenton's photographs were trimmed to a curve at the top, as if to signal his work as art, rather than mere document. This device of trimming prints to this shape was common among other early photographers such as Julia Margaret Cameron in order to mimic the actual shape of the paintings they were directly referencing. As such, the picture isn't about what is visible, and what is seen in the world, but more about what is photographed, and what is art.

Like art, cookbooks also tell us about the values of their time, and are no less rich in symbolism and connotation. In addition, they have often traded in stereotypes and assumptions; they, too, are carriers for all kinds of fantasies. Early examples

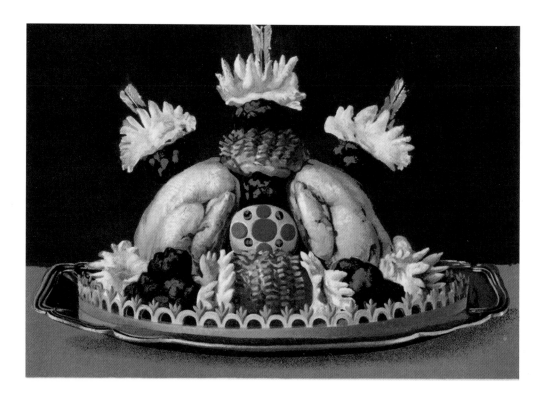

Photographer unknown, *Poularde à la Godard*,
chromolithographic print from *Le Livre de Cuisine*, 1869

8

were no different: when photography was first used to illustrate recipes, it did not represent food eaten in the home or recipes passed down through families, but instead food for chefs, representing gastronomy and indulgence. This incredible image of *Poularde à la Godard* is a chromolithographic print—a technique that was among the first steps to color photography in the nineteenth century—found in the hugely influential *Le Livre de Cuisine* (1869) by chef and pâtissier Jules Gouffé. This book, and his *Le Livre de Pâtisserie* (1873), had a lasting impact on the evolution of French gastronomy. They are culturally important not only for the food they describe, but also for their many illustrations, woodcuts, and extraordinary reproductions, which showed the potential and power that color photographs could have within the pages of a cookbook. The lavish meal constructions speak to sophistication, extravagance, and French perfection, but to contemporary eyes, the elaborate concoctions make a turducken look humble.

However, going into the twentieth century, home-cooking manuals increased in popularity, stemming from a tradition most commonly associated with *Mrs. Beeton's Book of Household Management* (1861). Early examples in the United States, such as *Good Housekeeping Everyday Cook Book* (1903), *Mrs. Rorer's New Cook Book* (1902), and *Mrs. Allen's Cook Book* (1917), all included small black-and-white photographs. The photographs are carefully arranged and tastefully constructed to show tidy homes and tidy lives, but their cultural significance is huge—they paved the way for both the tone and usability of later cookbooks. These books come from the varied standpoints of domestic science, magazine writing, and, in the case of *Mrs. Allen's Cook Book*, the making of "modern" food, using products such as Coca-Cola and Pillsbury flour. The author of that book was not afraid to advocate

Photographers unknown,
pages from *Mrs. Allen's Cook Book*, 1917

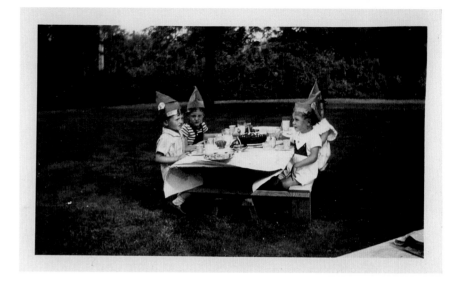

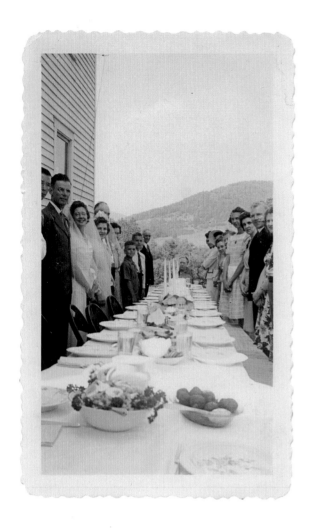

for making women's lives easier by using boxed and canned products; in this respect, she was an important predecessor of the brand-sponsored "cookbooklet" (pp. 86–91) and the cultural icon Betty Crocker (pp. 118–23).

But it is perhaps meals as they appear in vernacular photography that tell us the most about our relationship to food. Snapshots of food have increased and asserted themselves over the history of the medium, to the point where they are now part of the contemporary eating experience, captured with smartphones and distributed through image-sharing apps. But holidays and celebrations were being photographed almost as soon as cameras became readily available. Due to the expense of very early photography, it was mostly the pursuit of the wealthy. Food did appear in nineteenth-century family photographs, but it was more into the twentieth century, as the camera became more accessible, that food often took center stage. Since then, snapshots have been taken when extended families gather together around the table. Birthdays, parties, and weddings are often photographed around the cake, and summer vacation pictures would seem lacking without the requisite ice cream cone or picnic shot.

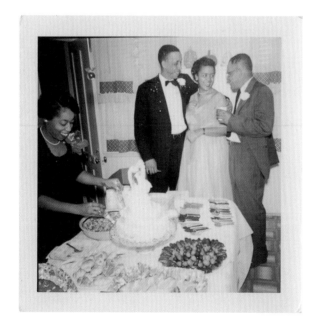

Photographers unknown, found wedding and birthday photographs

But the photographs that we now associate with the commercial practice of "food photography" (as opposed to food in still life, art, or vernacular images) undoubtedly have their roots in the rise of magazines and packaged foods. The interwar period saw an explosion of inventive printing and publishing techniques in photography. No one mastered these methods more than Nickolas Muray (pp. 100–105), who, while working in Germany, had perfected experimental color processes while studying photoengraving and working for a publishing company. On moving to America, he transformed that skill into a commercial practice, creating vibrant tableaux for magazines in both advertising and editorial. His photographs of food and homemaking are among his best, bringing a new and daring aesthetic to magazines like *McCall's*. These heavily styled scenes of food offered a fantastical escape and a vision of America far removed from the food shortages and anxieties of the war. Due in part to the success of Muray's photographs, the almost Technicolor results of the three-color carbro process became a staple of American lifestyle and fashion magazines from the late 1940s into the 1950s—despite the fact that the process itself was fiddly and time-consuming.

In addition to magazine editorials and advertising for brands such as Lucky Strike and Coca-Cola, Muray also worked for an ever-expanding range of processed-food companies, as new products needed new photographs. Muray was adept at altering his more active aesthetic to sparser scenarios such as frozen-food packaging, which needed to be more obvious and leave space for text and logos. These products represented something quick and modern in postwar America, available

Anton Bruehl, cover of *Vanity Fair*, March 1933

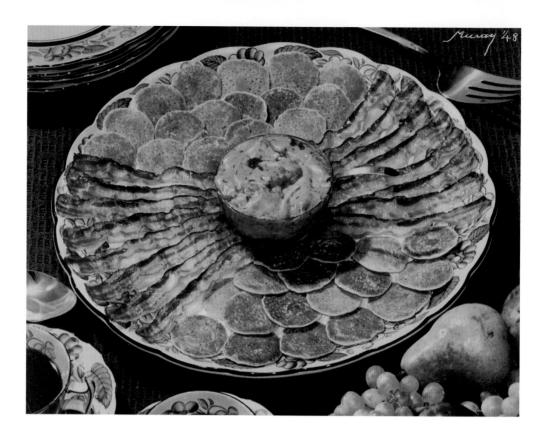

in the new shopping malls that were beginning to appear around the country. Commercial photographers such as Anton Bruehl and Victor Keppler (pp. 96-99) also brought their own modern aesthetic to the homes and lives of Americans through their images of food in their bright, upbeat colorful pictures, all of which suggested an America moving forward, rather than looking back nostalgically to the past.

As advances in color printing made magazines and cookbooks more affordable, photography became more of a feature. Popular product lines and time-saving gadgets such as pressure cookers, crockpots, and stand mixers produced their own books and cookbooklets; the latter were designed primarily to advertise the brand and incorporated plentiful, vibrant photographs, as can be seen in the examples made for Aunt Jemima, Crisco, and Knox Gelatine (pp. 86-91). The impact of these photographic and advertising techniques coincided with the fantasy of nationhood and the increased availability of food after the Second World War, especially in the United States. These books had a lasting influence on commercial food imaging, and indeed on the way that a nation ate. Foods such as tuna fish, avocados, and orange juice made their way into kitchens and became family staples due to the success and ubiquity of the promotional cookbooklet.

Betty Crocker is also worth mentioning here. The first of its kind, *Betty Crocker's Picture Cookbook*—or "Big Red," as it came to be known—was a guide to home cooking published in 1950 by General Mills. Its famous file system—with heading tabs like "Quick Breads" and "Frostings Confections" sticking out from its pages— and decadent color photos, bursting with American bounty, are a joyful gateway into the nation's food industry and changing tastes of the time. The pictures, like those in the cookbooklets, are more exuberant than they are appetizing, speaking more to tastefulness than to taste itself. They also present a postwar nation of plenty and leisure, which was seen as being in direct contrast to communism.

Nickolas Muray, *Homemaking Cover, McCall's* magazine, ca. 1940

Such books and the magazines of the time also gave rise to the art and business of food styling. Often shot under hot lights in the studio, food had to be meticulously arranged to last while the photographer worked. Heavily propped and fastidiously set up, food photography from this period relied on techniques that have become somewhat mythic and, of course, made the food completely inedible—such as spraying it with hair spray so it would appear shiny and fresh. Ice cream might be made from powdered sugar, ice cubes from plastic, foam from soapsuds, and condensation with glycerin. But it is not just the food that made a food photograph important; the tableware, tablecloths, garnishing, and props showed mastery in making a scene complete, and were illustrative of the collaborative teamwork needed in commercial photography.

FOOD FOR THOUGHT

The 1960s and 1970s saw the increased publication of cookbooks and a shift from postwar ideas about national identity to a desire for armchair travel, a precursor to the multiculturalism of the 1980s. Popular cookbooks with skillful photographs illustrated the advances in color printing and food styling in North America, Europe, and beyond, reflecting changes and attitudes particular to each nation. In Australia,

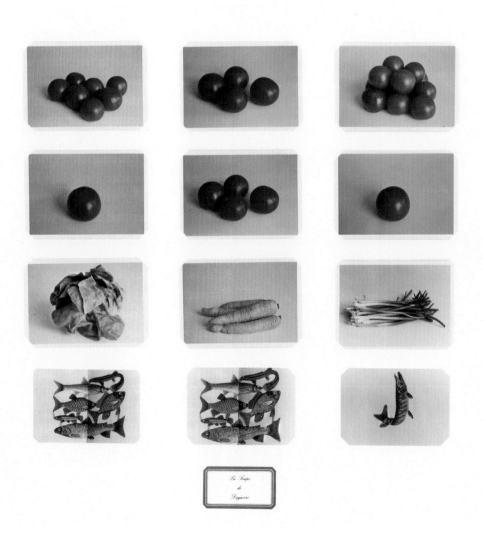

Marcel Broodthaers, *La Soupe de Daguerre*, 1975

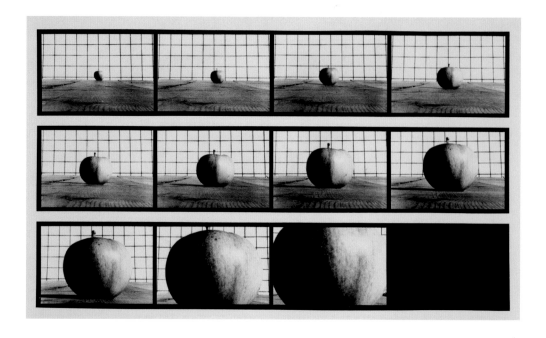

The Margaret Fulton Cookbook, first published in 1968 and going on to become a staple for generations, illustrated the impact of European immigration at the time, with the inclusion of Italian and Greek recipes. In the UK, *Good Housekeeping Colour Cookery* (1968) was as aspirational and unrealistic as many of its American counterparts, but differs in its more international feel. This was represented by lavish pictures of Scandinavian salads as well as a dramatic tableau of "Ceylon Prawn Curry," which reflected the wave of immigrants coming to Britain from Southeast Asia. There was also an increase in books featuring foods from a single country, as recipes and accompanying photographs from Mexico, Morocco, India, and Thailand became popular. This was the golden age of jet travel, and Western television began to feature more "ethnic" chefs. This fascination with the exotic also inspired the American Time-Life Foods of the World series (1968–78).

Coinciding with this explosion of cookbooks, the 1960s and 1970s also saw the rise of Conceptual art and, with it, artists who used banal subject matter, mixed high and low culture, and favored repetition and seriality, both in topographical and typological explorations. They used food for comic effect, as can be seen in John Baldessari's *Choosing Green Beans* (1972), Fischli and Weiss's Wurst Series (Sausage Series, 1979, pp. 182–85), and Marion Faller and Hollis Frampton's series Sixteen Studies from Vegetable Locomotion (1975, pp. 158–59). Marcel Broodthaers's *La Soupe de Daguerre* (1975, p. 13) is more mysterious, however: are these ingredients for soup? Unlikely, as this combination of "real" fish and tissue cutouts could hardly be cooked. At the bottom is a label that suggests museums and classification. Here, Broodthaers presents food as a puzzle—very much at odds with the bombastic messaging of Pop art, in which food also often featured, and the advertising and lifestyle aims of cookbooks. Perhaps he is parodying oversimplified representations of food and the polarized positions across hierarchies and genres in the artificial divisions between high and low culture.

While much art of this time favored systems, artists also turned to performance and visual playfulness. *Semiotics of the Kitchen* by Martha Rosler (1975) does not use food, only the kitchen equipment. In this performance/video piece,

Marion Faller and Hollis Frampton,
782. Apple Advancing, 1975

Rosler works through the kitchen in alphabetical order—apron, bowl, chopper, dish, egg-beater, and so on—demonstrating each appliance with increasing aggression, in a parody of the growing popularity of cooking shows on TV and the idea that a woman's place is in the kitchen. Rosler has said of her work, "I was concerned with something like the notion of 'language speaking the subject,' and with the transformation of the woman herself into a sign in a system of signs that represent a system of food production, a system of harnessed subjectivity."

The theoretical language of semiotics gave artists much-needed linguistic and visual tools to reclaim their work from critics and their value judgments, often to comic effect. Roland Barthes famously illustrated how the tools of semiotics could be applied to the messages and meanings of images in his 1964 essay "Rhetoric of the Image," using an ad for the pasta brand Panzani. By deconstructing the scene, he showed (among other things) how "Italianicity" could be read in it. These systems for the construction of meaning are key to how food is photographed in cookbooks and popular culture, both of which rely on easy readings across a wide audience. Clichés and stereotypes suggest authenticity—especially when illustrating food from

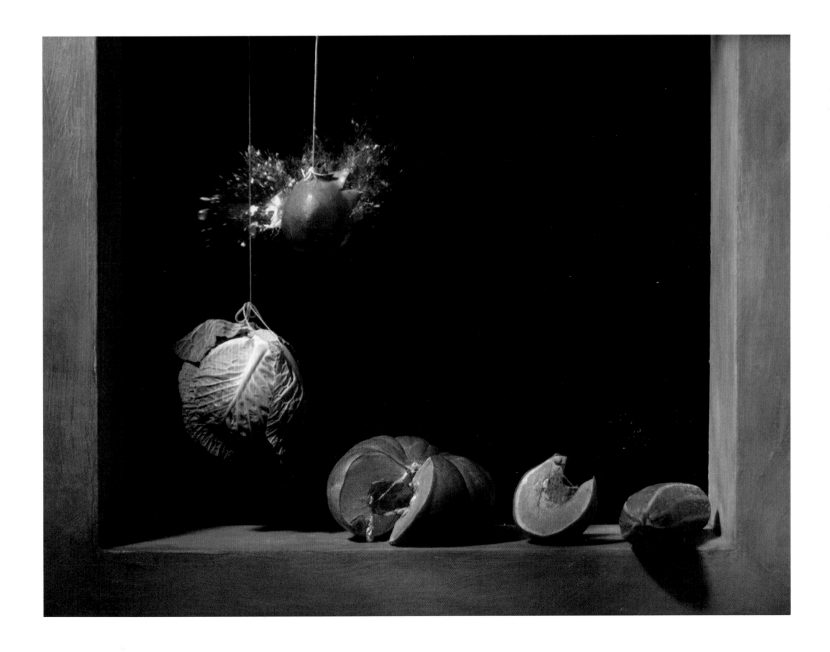

Ori Gersht, *Pomegranate—Off Balance*, 2006

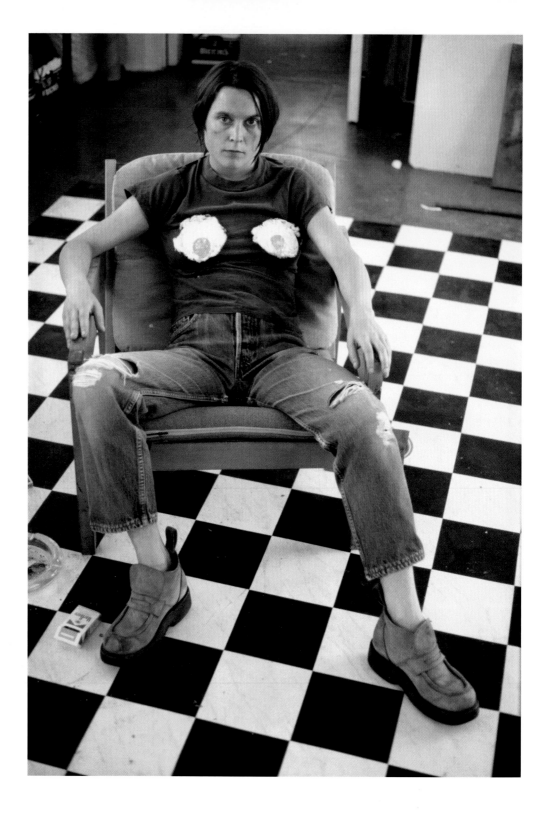

other cultures. This device would later be used by artists such as Martin Parr
and William Yang (pp. 238–45 and 248–49), who play on such clichés for instant
recognition and a visual shortcut to understanding.

Another artist who has used food to illustrate its cultural and semiotic connota-
tions is British artist Sarah Lucas. Food can be loaded with a relationship to politics and
gender, especially the female body. Three decades after Carolee Schneemann's perfor-
mance piece *Meat Joy NYC* (1964, p. 133), Lucas made some of the defining work of the
1990s. In response to the "lad culture" that had appeared at this time—also apparent in

Sarah Lucas, *Self Portrait
with Fried Eggs*, 1996

food, with the rise of celebrity chefs such as Marco Pierre White and Gordon Ramsay—Lucas employed food such as bananas, fish, and chicken in both her photographs and her sculpture, to both call out the base language used to refer to women's bodies and reclaim it. Food still titillates, but with a very different stance; she refuses to take a submissive position when the joke is about male aggression. Lucas's art takes the eroticism of food and turns it into sexual politics instead.

In *Pomegranate—Off Balance* (2006, p. 15), Ori Gersht deals with politics and national identity. "All my work has a direct connection with my upbringing in Israel, and this idea within the Jewish diaspora of a utopian place we can never quite obtain—the return to a place that doesn't really have any material presence in the world, and that can never be realized," Gersht has said. Here, food is used as a carrier for autobiographical ruminations on place and violence, calling upon traditions of Western art and the history of photography. It is painting that the photograph most obviously references—the still life by Juan Sánchez Cotán titled *Quince, Cabbage, Melon, and Cucumber* (1602) in particular. The quince in the painting has been replaced by a pomegranate, not only for its ability to dramatically explode—immediately bringing to mind the experiments of Harold "Doc" Edgerton (pp. 108–111)—but also for its symbolic place in Jewish culture, as a sign for fertility and righteousness eaten during Rosh Hashanah. The lighting is dramatic, heightened by the black background, making a stage in which Gersht builds the sculptural scene.

The use of food to create a sculpture is something we see repeatedly in this book—not just in art, but also in commercial photography, most famously demonstrated by Irving Penn (pp. 172–75). In Gersht's photograph, the sculpture is a stand-in for calm, balance, and harmony, while the exploding pomegranate illustrates the rarity of this state.

WHAT'S COOKING?

During the 1990s and into the 2000s, the rise of the celebrity chef, foodie culture, and eating out contributed to a rise in the popularity of cookbooks once again. The Western world shifted away from the idea that French cuisine was best, and embraced food from a wide range of countries, fusing flavors with the very best of local ingredients. Once again, a more international approach was accelerated by the availability of cheap flights to countries such as Thailand and Sri Lanka, and South Asian food grew popular in the West. Restaurants were increasingly producing their own cookbooks (such as the famous River Café series), and books by television personalities—such as Nigella Lawson and Jamie Oliver in the UK, and Mario Batali and Ina Garten in the United States—became more prevalent. Rachael Ray, Jane Grigson, Gordon Ramsay, Martha Stewart, Wolfgang Puck, Bobby Flay, and Anthony Bourdain followed and became household names, many with their own line of cookbooks and wares.

Photography became increasingly dominant in these books, and a much more relaxed style prevailed. The pictures featured food that you wanted to eat—food as it was cooked, rather than overly styled and presented on the table. The styling was made to look somewhat nonexistent, and, most important, photographers were more likely to be credited. Taking photographs for cookbooks became a more credible, legitimate space in which artists could work. Well-known photographers have shot for cookbooks—including Joel Meyerowitz, Adam Bartos, Richard Learoyd, Ron Haviv, and Jason Fulford, to name a few—illustrating the fact that photographs have become more important than the recipes in many instances.

This represents an important shift in how food is photographed for these books. With the rise of the Internet, most people turn to the web for cooking inspiration rather than books. But conversely, the production and sale of cookbooks and food magazines has never been stronger. A cookbook is no longer necessarily something you buy for the recipes; instead it has become more of a coffee-table book. Cookbooks are more collectible, as fetishized objects.

Perhaps this trend started out of necessity: with the rise of digital platforms, printed books needed to rethink their shelf appeal in order to reach consumers, and publishers have reached into the bag of tricks from art and design books. This has elevated cookbooks to become like photobooks; their pictures have become more aligned with still life and art practices. Though the pictures, in some cases, could operate in a proper artbook, in a cookbook they remain connected to lifestyle and taste, continuing to provide an aspirational experience that situates the reader in a very particular time and sensibility. They are for show, for seductive visual pleasure and for longing—all very far away from the labors of shopping, cooking, and washing up, but not so far away from the very first cookbooks, such as *Le Livre de Cuisine*.

The distinctions between art and commerce that previously defined photographs of food are becoming much finer with the increasing cultural acceptance of commercial food and product photography, as well as a renewed interest in its history and pioneers such as Nickolas Muray. At the same time, fine-art photography has returned to the still life genre with new vigor. No longer at polar ends of acceptability, a crop of up-and-coming commercial photographers—such as Keirnan Monaghan

William Yang, *Cream Cake, Germany*, 2002

Keirnan Monaghan and Theo Vamvounakis, *Potato and "Butter-milk" Soup*, 2016; for *Gather Journal*, food styling by Maggie Ruggiero

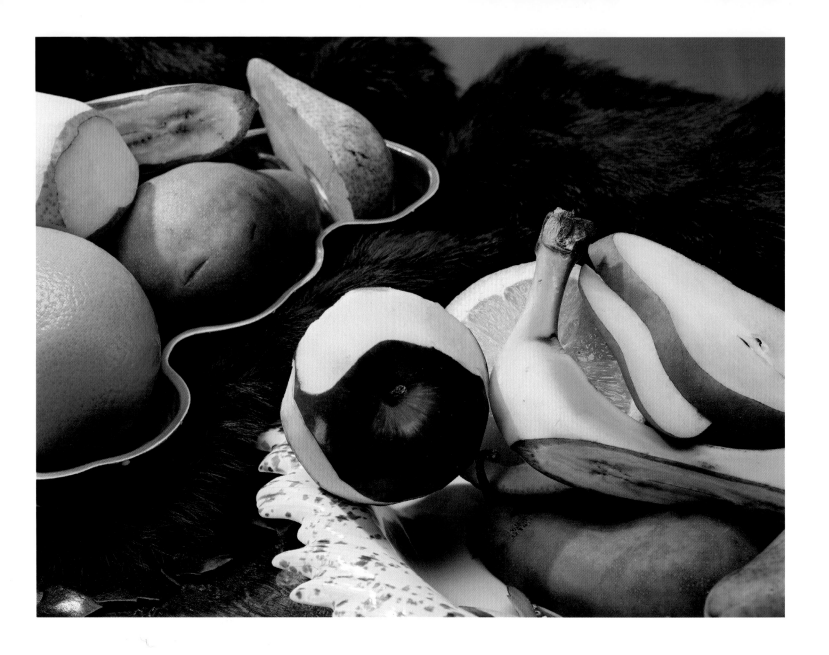

and Theo Vamvounakis, Grant Cornett, William Mebane, Trey Wright, Lauren Hillebrandt, Paloma Rincón, and Stephanie Godot—produce exciting work that is often indistinguishable from art and its recent fascination with still life. Artists such as Maurizio Cattelan and Roe Ethridge also reference the commercial food photography of the 1950s through the 1970s, while Daniel Gordon and Laura Letinsky incorporate lifestyle pictures found in magazines and online into their collaged still lifes.

In short, many artists are turning to deconstruction, collage, montage, and appropriation to comment on the ubiquity of certain subjects on the Internet—food being one of them. Right now, commercial food photography is incorporating the tropes of fine art, while fine art simultaneously comments on commercial and digital practices. This creates a seesaw of taste-making, and the connotations of aspiration, class, and style are up for examination. All the while, irony, deadpan humor, retro styling, and bold statements dominate. Much of it may seem superficial—but at a time of renewed nationalism around the globe, when we are once again grappling with the intricacies of nationhood in the culture at large, photography is an important marker of how food can define who we are.

Roe Ethridge, *Fruit*, 2011

Michael Zee (@symmetrybreakfast),
Monday: Cantaloupe, kiwi, pomegranate seeds, Argan oil, beetroot yoghurt, and French pine honey, 2016;
Friday: Ahi tuna and salmon poké, tamanishiki rice, raw fish marinaded in soy and tensho yuzu ponzu vinegar, fresh vegetables, yellow miso, and black Mourichi Koucha tea, 2016

And yet, despite how food has been photographed in art and commerce, it is how it has been photographed in vernacular imaging that has perhaps had the biggest impact on food as subject matter—and how those photographs are consumed. Photo-sharing on social-media platforms such as Instagram, Snapchat, Facebook, and Twitter have made photography part of the dining experience itself. So many people are taking pictures of their meals that restaurants expect each party to take more time at their table. And for those restaurants, as well as for specialty stores and brands, this sharing, tagging, and geo-tagging of food photos has become a kind of grassroots advertising scheme, in which both the authenticity of the author (and their established connection to the viewer) and FOMO (fear of missing out) might drive others to want the same experience—and it's all delivered directly into the hands, homes, and pockets of an attentive audience. Photographing your food has never been more popular or encouraged. This may explain why traditional commercial photography has simultaneously become more like fine art—as well as more diaristic, mimicking the "realness" of social media.

The rise of photographing food has also changed, or at least heavily influenced, the way we eat in the home. The Western breakfast, for example—a historically routine affair of cereal or toast—is now (if we are to believe Instagram) a feast of avocado toast, muesli with a host of berries and toasted nuts, and chia-seed smoothie bowls. Food has become even more of a social currency, and social media provides a space in which to share, find like-minded people, and form communities. It has spawned a host of hashtags to accompany photographs—hashtags that instantly position and self-identify the photographer with a certain group or shared aspiration. These can include the more jovial #nomnomnom, to the more pointed #whatveganseat or #eatclean. On a more serious level, these communities also connect those who struggle with food issues, such as eating disorders, and who have traditionally been outside of the mainstream.

Blogs and social media have also spawned a trend in books that promote healthy eating, the shunning of certain nefarious foods, and wellness, often written by young women who have little or no nutritional training. These sites have garnered huge followings and their authors include, most famously, Gwyneth Paltrow and Kris Carr in the US and Ella Mills in the UK, to name a few. The message is simple: eat like me, look like me. Highly constructed photographs of kale salad and quinoa abound.

But platforms such as Instagram can be outlets for more than just aspirational food porn, a term coined to poke fun at the glamorization and proliferation of photographs of food on social media. Like the book *The Country Diary of an Edwardian Lady*—in which Edith Blackwell Holden provides personal observations from her daily life in 1906 and intricate details of the woodland creatures near her home, along with exquisite paintings—Instagram can also act like a diary or journal, and of course food plays a part in this. Photographs of food in this context can be touching, a way of communicating with families and friends. There are mothers documenting care packages made for children who are away at university, families eating at holidays, and lovely tables, set for celebrations. Food is photographed as it brings people together, as ritual and tradition.

Whereas letters, drawings, small gifts, and especially recipes were exchanged between friends and family in earlier times to sustain relationships and show support, photographs have become part of our larger cultural gift economy—one in which our private experiences are made more public, and a wider circle of friends and followers reciprocate their support through likes and re-sharing. Food photographs have often crossed the boundaries between private and public, and are a natural fit for today's social media. They invite people into our lives on a much larger scale, in an act more akin to publishing than letter-writing.

Many of the pictures in this book delight in the most ordinary and simple of subjects. The smell and taste of certain foods have an evocative power; for some, nothing says home like their mother's cooking, while for others the opposite is true. For Marcel Proust, as he wrote in his book *À la recherche du temps perdu* (*Remembrance of Things Past*), memories were triggered most famously by sweet madeleines dipped in tea. Food can arouse repeated and constant links between perception and memory, and when photographed, it is likewise transformed into a network of comparable connections and associated symbolic orders. Much like literature, photography is a medium closely woven with desire and longing—a vehicle for memory and a generator of metaphor and symbol. It also describes in the minutest of detail.

The photographs here will hand the viewer a key for coding and decoding society, if one is prepared to take the time to really look. They can celebrate, pervert, inform, and inspire. From the banality of the diner breakfast special captured by Stephen Shore to the allegorically dense still lifes of Laura Letinsky, from Roger Fenton's elaborate nineteenth-century setups to the cookbooks of the 1960s, food—and how it's photographed—defines how we live and how we value ourselves, and, at its very best, connects us to our dreams and desires.

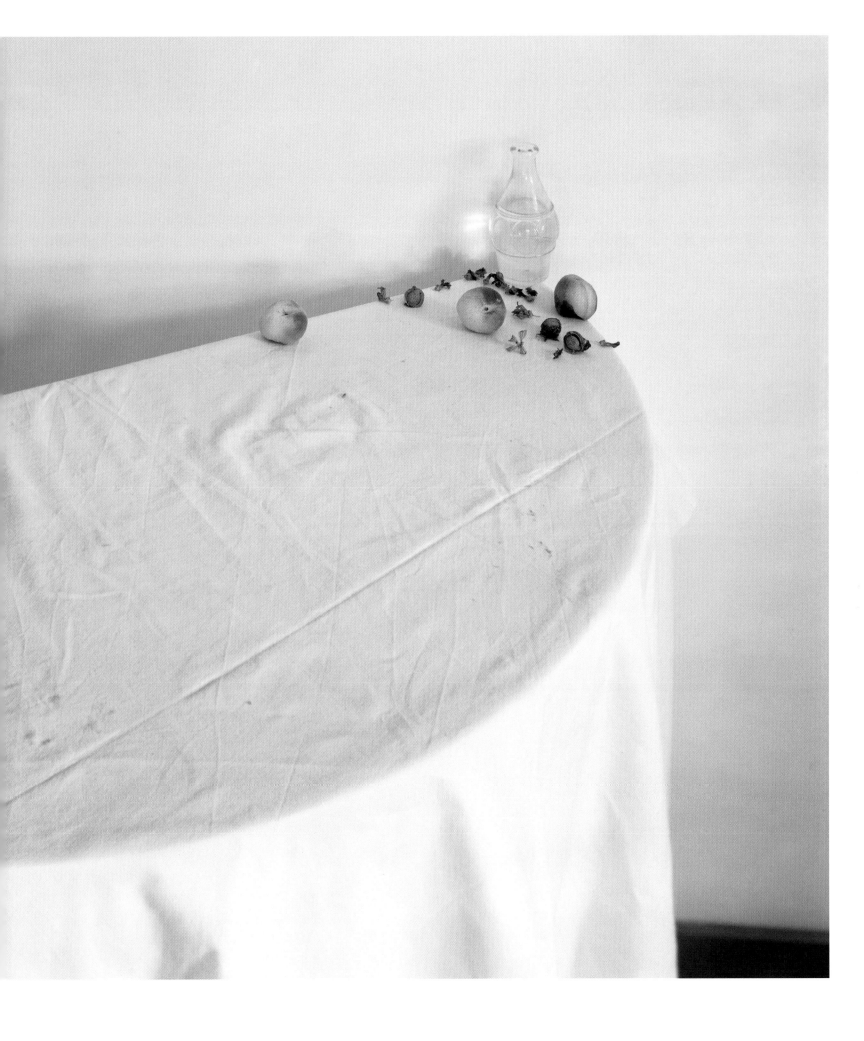

Laura Letinsky, *Untitled #43*, 2002; from the series Hardly More Than Ever

WILLIAM HENRY FOX TALBOT

A Fruit Piece (1845) by William Henry Fox Talbot was one of the first photographs to take food as its main subject matter, rather than depicting a wider table scene or picnic. Talbot published this photograph in the final section of *The Pencil of Nature*, which was the first photographically illustrated book to be sold commercially. Sold in installments, it aimed to show various approaches to the new art of photography. This photograph represents the established genre of still life within that context. Here, Talbot takes his cues from painting; the arrangement of fruit as subject matter has a long history and series of associations—something Talbot was well aware of and used to his advantage. Peaches have long symbolized fecundity, apples are rich with religious connotations of the forbidden fruit, and pineapples are a sign of hospitality (and exoticism) in European iconography. Their inherent cheerfulness can be seen in both fine art and architecture.

However, with the switch of medium to photography, something very different is at the heart of the food here. The symbolism becomes secondary; instead, the photograph was very carefully constructed, using devices that highlight Talbot's photographic skill. The tartan cloth on which the fruit sits succinctly shows that the composition was photographed at a slight angle, bringing depth and volume to an image that could otherwise seem less dynamic. The food was carefully chosen to have apposing textures and scales, in order to contrast and highlight Talbot's skill at capturing surface. As such, the food was photographed in a tightly orchestrated setup that emphasizes both the medium and the photographer's ability. Talbot used the hierarchical qualities so associated with food in still life to signal that his photograph was art and should be considered as such. In this very early photograph, what was made evident was that food—and photographs of it—could be carriers of meanings and associations, way beyond their simple function of showing us something to eat.

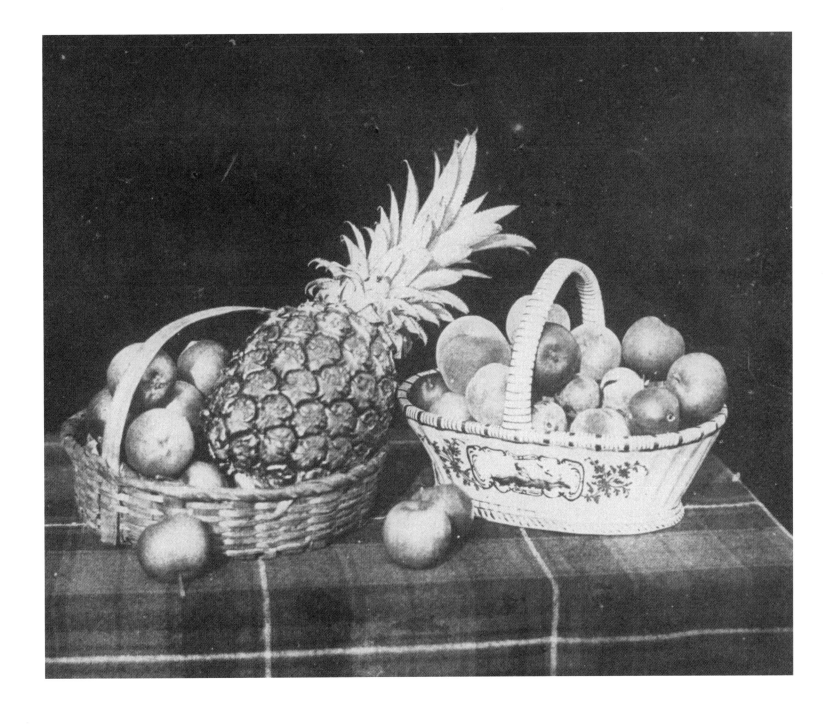

25 William Henry Fox Talbot, *A Fruit Piece*, 1845

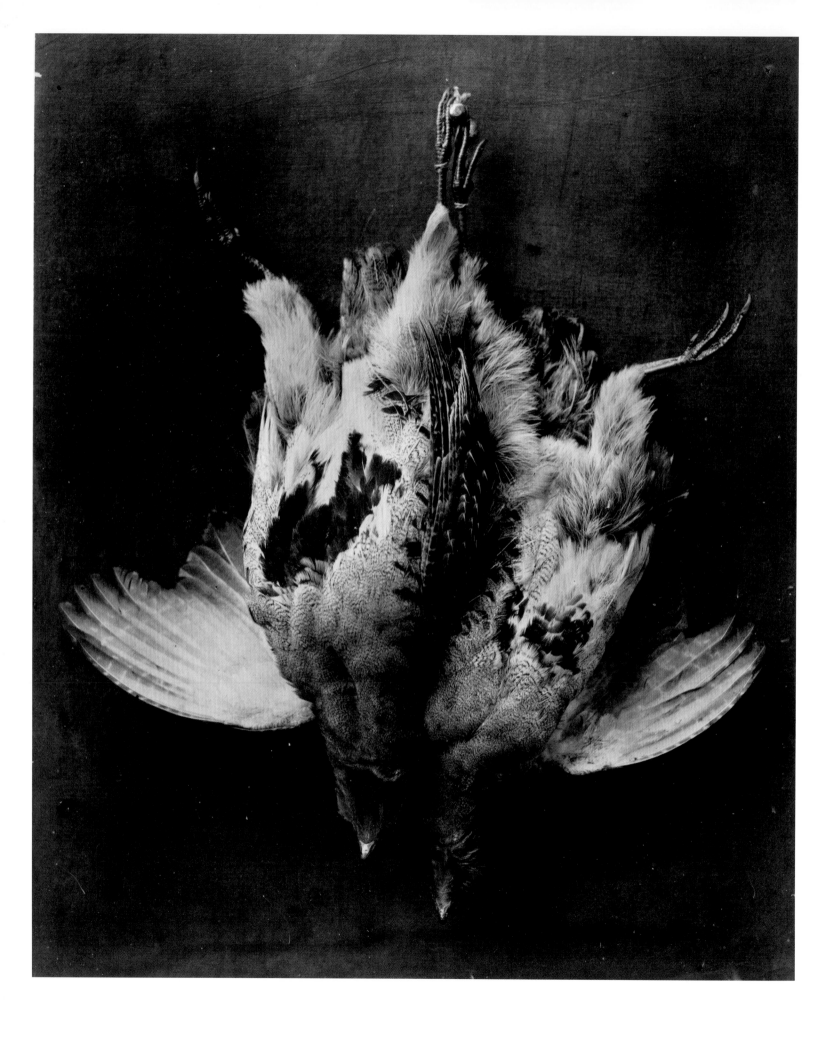

William Lake Price, *The First of September, England*, 1855

FUR AND FEATHERS

Similar to Talbot's still life, food was photographed here not as one would eat it, but before it has been prepared into food. The wild animals seem more grotesque than raw fruit and vegetables as we have become more removed from the hunting process. There is a focus on the richness of objects—the things that make up our world— albeit with some artful arrangement, skillful printing, and photographic trickery. The photographs of dead animals serve two purposes: that of art and that of document. First, the print of game birds, *The First of September, England* (1855) by William Lake Price, is carefully gold-toned, in order to replicate the autumnal colors of the early grouse-hunting season. It documents the spoils of the shoot, but the toning shifts it from being a straight document to an object with artistic intent. The subject matter also references painting, especially Dutch and Flemish still lifes of the seventeenth and early eighteenth centuries, which showed somewhat gratuitously piled and hung animals, arranged in lush and sumptuous compositions.

Charles Philippe Auguste Carey's *Still Life with Waterfowl* (ca. 1873, p. 29) was more intentionally made to be art. The hanging birds have obviously been meticulously arranged, and the scene constructed for the photograph. With the shift of the still life genre from painting to photography, the props became less symbolic; here, a saucepan suggests that the birds will become food, but gone are the more magnificent and lavish piles of animals which both represented status and served as vanitas. Perhaps Carey was purposely trying to forge a different identity for the art of photography—moving away from the symbolism of food in painting, while simultaneously pulling on its legacy. This is a particularly elegant example of using food in its raw form as still life; other examples from this period often lacked the grace of the paintings they were emulating, and could seem cluttered and grotesque, with their stronger links to the real.

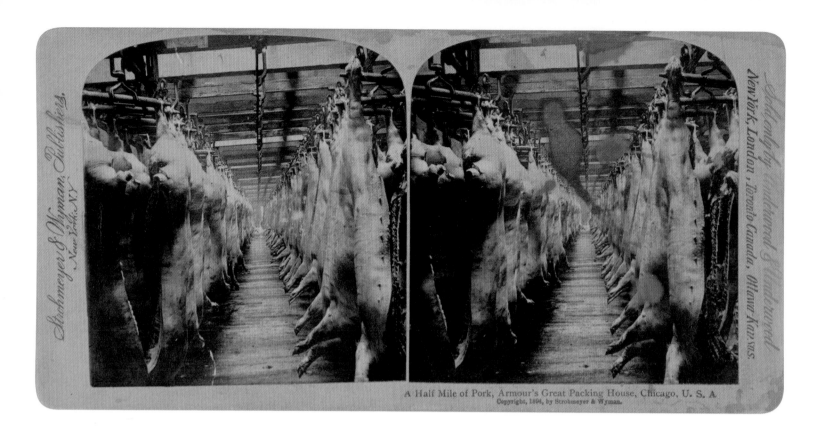

The roots of the slaughterhouse photograph by B. L. Singley, distributed by the stereographic publishing company Strohmeyer & Wyman, lie more in documentary. It does not refer to painting or hunting scenes; however, the lines between art and documentary are blurred. The care taken to tone the image and the fact that it is stereographic, rendering the scene 3-D, suggest that it was not made to illustrate the conditions or the mechanics of the slaughterhouse, but rather to be viewed and enjoyed as entertainment. The dynamic scene, titled *A Half-mile of Pork—Armour's Great Packing-House, Chicago, Illinois* (ca. 1894), shares stylistic similarities with many other cards distributed by the publishing house—of pineapple plantations in Hawaii, or views of parks and bridges. Viewing the image in 3-D would have exaggerated the vanishing centerline in the middle of the image. While it looks like the dynamic view is championing a more modernist aesthetic, this was a device on which commissioned photographers regularly used to emphasize depth.

↑ B. L. Singley, *A Half-mile of Pork—Armour's Great Packing-House, Chicago, Illinois*, ca. 1894

↗ Charles Philippe Auguste Carey, *Still Life with Waterfowl*, ca. 1873

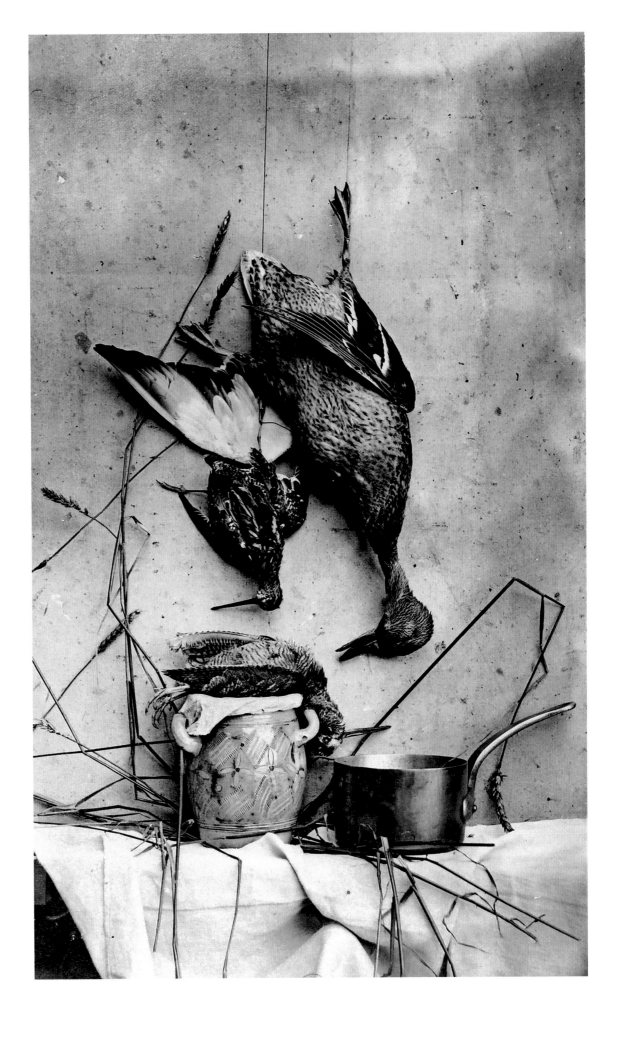

ROGER FENTON

Roger Fenton's still lifes are unequalled in their exuberance and complex compositions. As a photographer working in this genre, he excelled at capturing light, texture, and the richness of the fruit and flower combinations he constructed. Fenton worked as a photographer for only eight years (from 1854 to 1862), and despite royal and museum commissions and his travels abroad—most notably to photograph the Crimean War—it is his still lifes that stand out. He made around forty still-life photographs in total. What is characteristic of his work is the mixing of food and flowers, as well as the use of tankards, statuettes, rich fabrics, and marble. At the time, they were compared to the still-life painting of George Lance, and to a contemporary eye, they certainly share a certain gaudiness. They fill the frame with an abundance of food in its ripest state: the grapes glisten, the peaches are plump. The use of fruit and flowers in Fenton's photographs—which could not be in season at the same time—suggests the use of a hothouse, while the pineapple may be a gift from abroad.

Like Talbot, Fenton's tartan cloth is used to striking effect: to create a grid and suggest depth in the picture. But unlike in Talbot, the table is piled high, with a cornucopia of clashing textures, shapes, and colors that is expertly captured in black and white, running from the dark blacks of the grapes to lush creams. The range of velvety hues in Fenton's photographs is due to the fact that he worked with several different cameras and used many different techniques to create specific types of prints, from chocolaty brown to purple. Again, the types of food were selected for their textures, to make the most of the camera's ability to capture stunning detail, rather than for their symbolism. They were carefully considered in their juxtapositions, and it is important to note that many of the prints were larger than real life. This reflects the vogue for displaying large fine-art prints at the time—just before the commercialization of photography, and the advent of mass-produced tourist prints and cartes de visite.

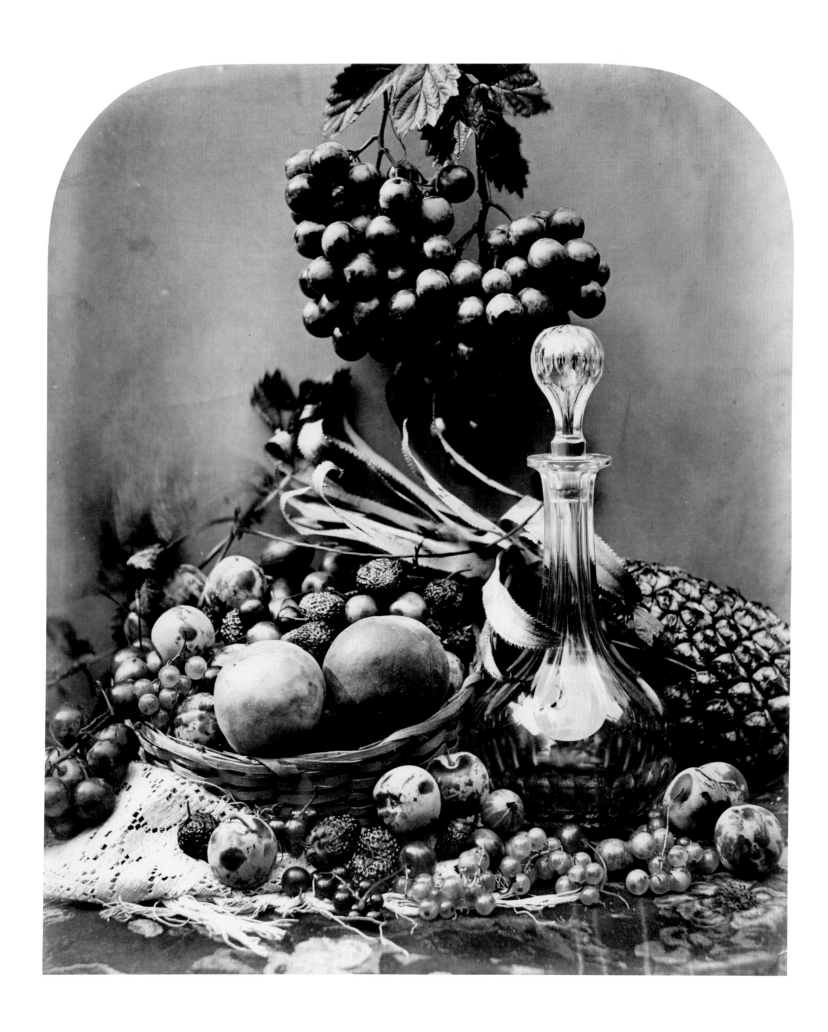

31 Roger Fenton, *Decanter and Fruit*, 1860

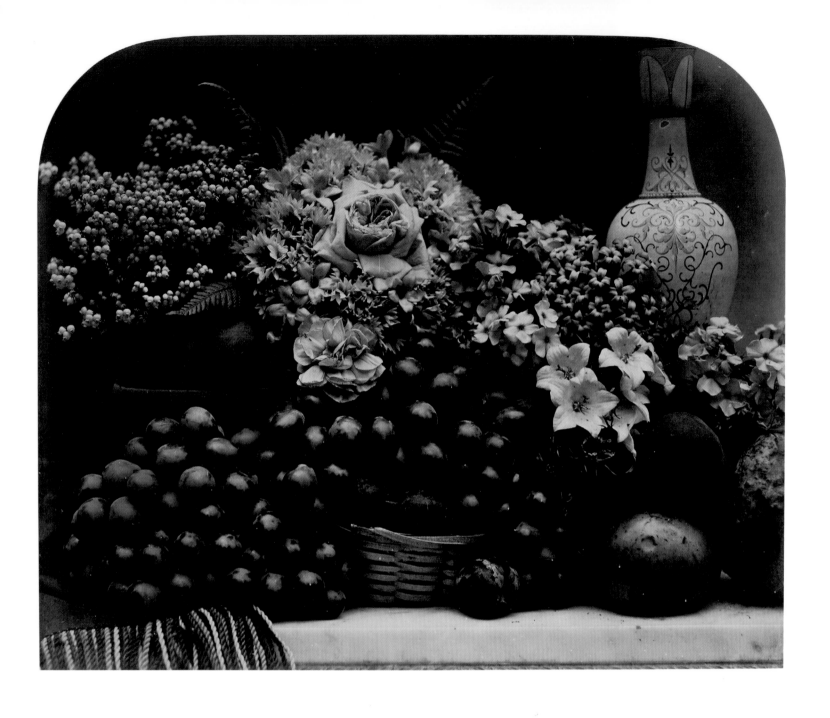

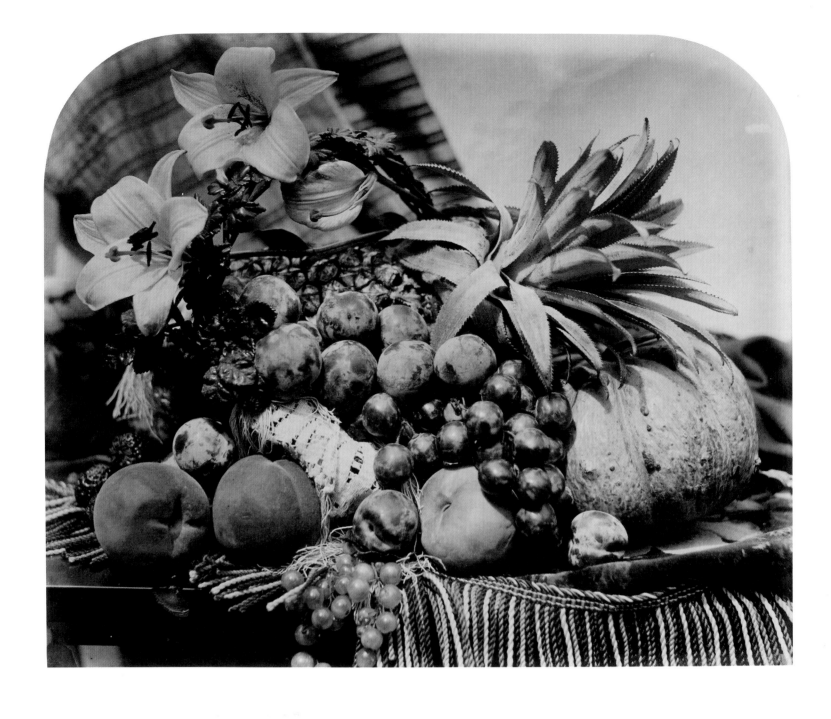

↖ Roger Fenton, *Still Life with Fruit and Flowers*, ca. 1860

↑ Roger Fenton, *Still Life with Fruit and Flowers*, ca. 1860

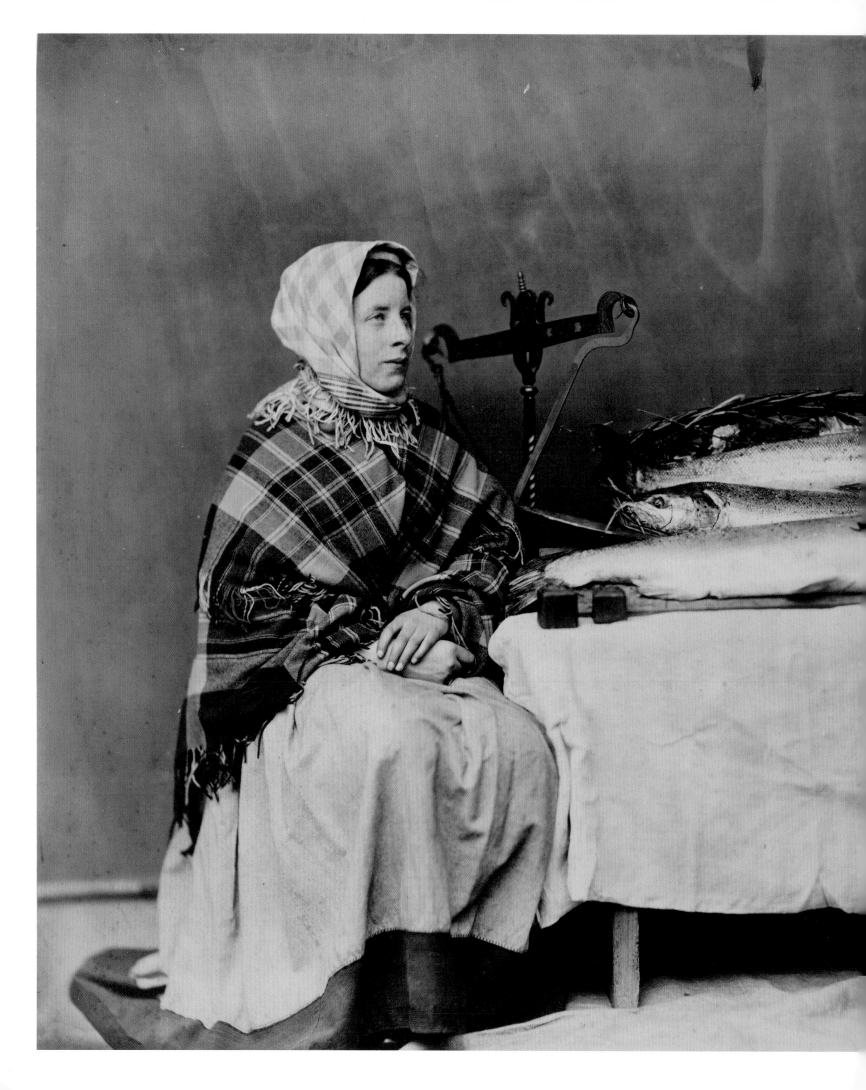

ROBERT CRAWSHAY

Known as the "Iron King," the Welsh industrialist Robert Crawshay was also an enthusiastic early-adopter of the camera, dedicating himself to the new art of photography. His photographs are very carefully constructed and beautifully printed, combining many of the common genres and tropes of photography of this time. The picture *A Slow Market, Merthyr Tydfil, Wales* (1868) shows Crawshay to be a consummate stage director. First, the fisher-maid is his own daughter, showing the Victorian penchant for dressing up and a photographic preoccupation with the working class by those wealthy enough to take up photography as a hobby. Crawshay's daughter wrote in her diary in 1868, "Papa came in with the ugliest, dirtiest, nastiest old straw bonnet that ever existed and a cap (thank goodness that was clean) for me to be photographed in as a fish woman, which lasted till lunch time."

The studio setting was carefully reconstructed to look like a market stall, but with a plain background, so the artifice is obvious. There is an artful cut in the cloth covering the table that mimics the open mouth of the fish. It's a fine example of studio portraiture and of still-life composition.

Robert Crawshay, *A Slow Market, Merthyr Tydfil, Wales*, 1868

SKEEN AND COMPANY

Founded in 1860 in Colombo, Sri Lanka, this family company came to be one of the most successful in Sri Lanka. It concentrated its business on photographs of the local markets, agriculture, ethnic groups, and the growing infrastructure of trains and roads built under the British Empire. Extravagant still-life photographs of food were also sold to naval, military, bureaucratic, and merchant visitors as souvenirs. This example was elaborately embellished by its owner, and, as such, has become an object in two halves: that of the image itself, and that of the border. The photograph differs from the other still lifes seen up to now because it does not reference the conventions of European painting, either in form or in the attendant symbolism of the fruit. Here, it's arranged in a flamboyant cornucopia, showing off both the inside and outside of the fruit for an audience who may have never experienced a coconut or a jackfruit before. The fact that the owner of the image also wrote the names of the fruit on the border clarifies that fascination with the unknown.

This idea of exoticism is carried through to the props that frame the picture: the large palm fronds were also used in studio portraits of locals in the Pacific made by Western photographers of the period, and the lizard adds a touch of supposed realism. What the food does here is offer an exciting glimpse into another world, far from damp Victorian England, and become a marker of otherness, exoticism, and escapism.

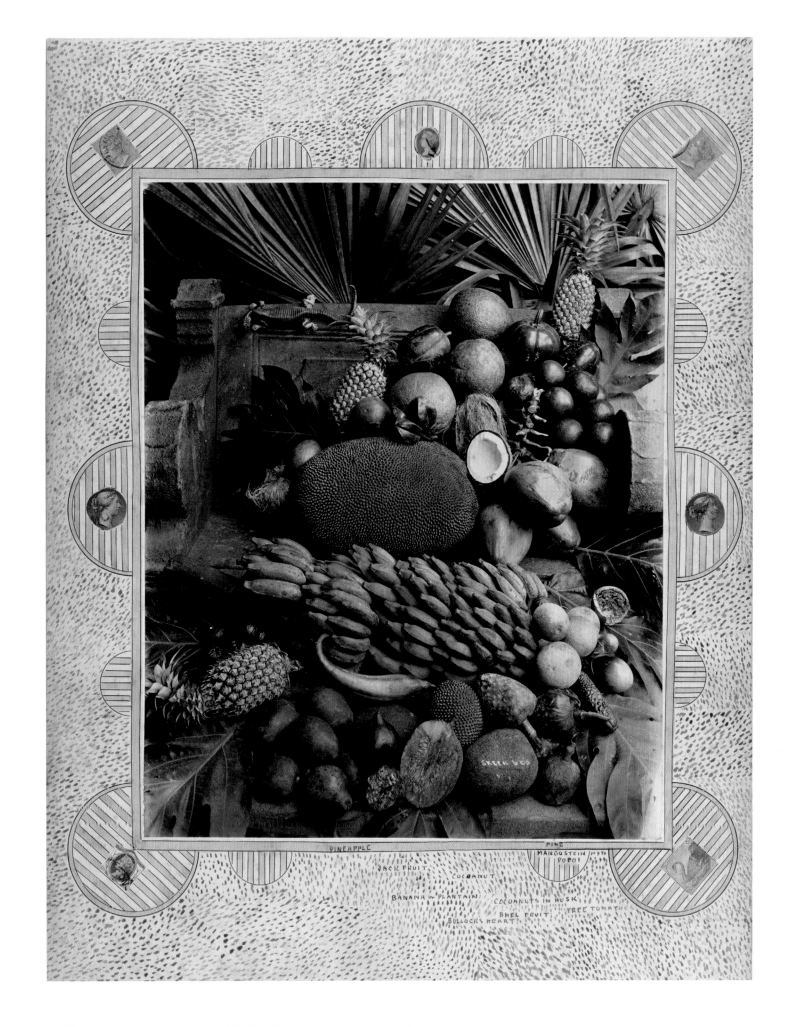

William Louis Henry Skeen, *Still Life of Exotic Fruits and Lizard from Ceylon, Colombo, Sri Lanka*, ca. 1880

THE BOOK OF BREAD and THE BOOK OF CAKES

The Book of Bread by Owen Simmons (1903) and *The Book of Cakes* by T. Percy Lewis and A. G. Bromley (1903) are companion books published by the journal *The British Baker*. (Sadly, the photographers were not credited.) Both the images in *The Book of Cakes* and the twelve gloriously colored plates in *The Book of Bread* were produced using a chromolithographic technique, the same as was used in very early cookbooks, such as *Le Livre de Cuisine* by Jules Gouffé (1869). The process was one of the first steps to commercial color photography in the late nineteenth century.

Both *The Book of Bread* and *The Book of Cakes* are technical books aimed at trade sales and were not intended for large-scale commercial consumption, so the photographs were done to best show the texture of baked dough or decoration on cakes. There was no aspiration to make the pictures art; both books are early examples of illustrating cooked food, rather than raw material with references to nature. *The Book of Bread* has a section dedicated to the illustrations in which the author proudly states, "However critical readers may be, they will be forced to admit that never before have they seen such a complete collection of prize loaves illustrated in such an excellent manner"—a sentiment that probably still rings true today. They continue, "The loaves are now produced photographically correct, of exactly full size, and the colors are as nearly perfect as is possible for them to be by any process at present known."

The pride with which the publishers explain the photographs shows they were an important marker in the quality of their publications. Now, with recent renewed interest in baking in Britain—due to phenomenally successful TV shows such as *The Great British Bake Off*—we can see how the act of making a cake or baking bread is more closely tied to British identity than one may think.

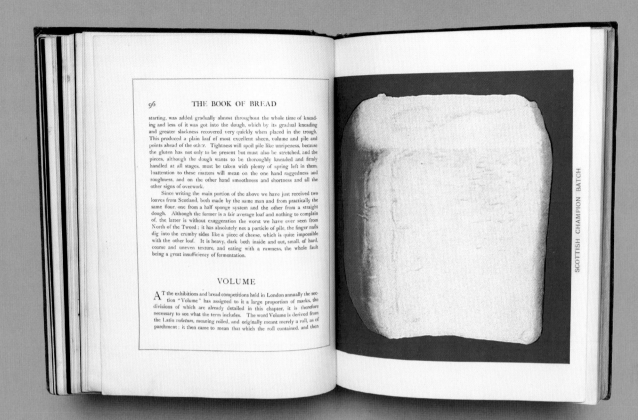

starting, was added gradually almost throughout the whole time of kneading and less of it was got into the dough, which by its gradual kneading and greater slackness recovered very quickly when placed in the trough. This produced a plain loaf of most excellent sheen, volume and pile and points ahead of the other. Tightness will spoil pile like unripeness, because the gluten has not only to be present but must also be stretched, and the pieces, although the dough wants to be thoroughly kneaded and firmly handled at all stages, must be taken with plenty of spring left in them. Inattention to these matters will mean on the one hand raggedness and roughness, and on the other hand smoothness and shortness and all the other signs of overwork.

Since writing the main portion of the above we have just received two loaves from Scotland, both made by the same man and from practically the same flour, one from a half sponge system and the other from a straight dough. Although the former is a fair average loaf and nothing to complain of, the latter is without exaggeration the worst we have ever seen from North of the Tweed; it has absolutely not a particle of pile, the finger nails dig into the crumby sides like a piece of cheese, which is quite impossible with the other loaf. It is heavy, dark both inside and out, small, of hard, coarse and uneven texture, and eating with a rawness, the whole fault being a great insufficiency of fermentation.

VOLUME

AT the exhibitions and bread competitions held in London annually the section "Volume" has assigned to it a large proportion of marks, the divisions of which are already detailed in this chapter, it is therefore necessary to see what the term includes. The word Volume is derived from the Latin *volutum*, meaning rolled, and originally meant merely a roll, as of parchment; it then came to mean that which the roll contained, and then

SCOTTISH CHAMPION BATCH

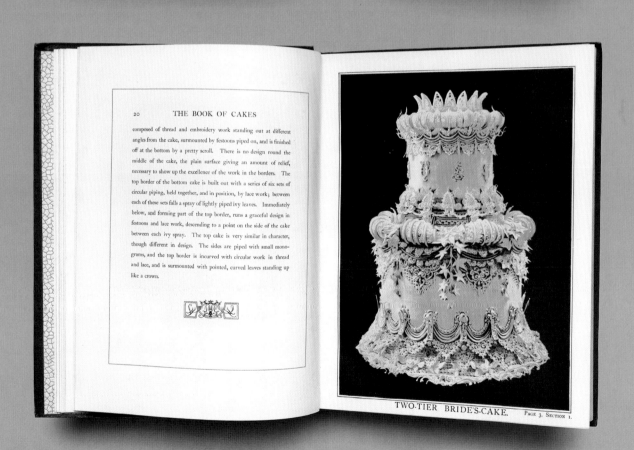

composed of thread and embroidery work standing out at different angles from the cake, surmounted by festoons piped on, and is finished off at the bottom by a pretty scroll. There is no design round the middle of the cake, the plain surface giving an amount of relief, necessary to show up the excellence of the work in the borders. The top border of the bottom cake is built out with a series of six sets of circular piping, held together, and in position, by lace work; between each of these sets falls a spray of lightly piped ivy leaves. Immediately below, and forming part of the top border, runs a graceful design in festoons and lace work, descending to a point on the side of the cake between each ivy spray. The top cake is very similar in character, though different in design. The sides are piped with small monograms, and the top border is incurred with circular work in thread and lace, and is surmounted with pointed, curved leaves standing up like a crown.

TWO-TIER BRIDE'S-CAKE. Page 3, Section 1.

Photographers unknown, pages from *The Book of Bread*,
1903, and *The Book of Cakes*, 1903

few tons of flour, all milled together, and all railed in the same truck, some of the consignment was considered unusable by one customer out of several who had flour out of the same consignment, whereas no one else noticed anything unusual. This had been caused by the flour being covered by a newly dressed tarpaulin, and the few bags on the top that the sheet touched absorbed the smell. We know of cases of paraffin contamination through flour being put in a truck that some time before carried the oil. It was not the contact of the oil, but merely the smell arising from the dry floor of the truck and permeating the sack. New sacks will often convey a smell, and are, therefore, often filled with wheat offals before being filled with flour. But the curious thing is, perhaps, that such contamination, like a plague of red ants in bakeries, disappears almost as rapidly as it comes. Where it is only a dry contamination, such as from the mere effluvia of the dressed sheet or the dry floor, there is no need to worry or to destroy the goods, and they are worth keeping at a small discount. The smell soon disappears, and, in proof of this, we have known many cases of such rejected flour being used by another man without the package being changed, or anything whatsoever done to the consignment, and without the slightest indication that anything had even been wrong, even in cases where the new recipient had been told that the flour had been found tainted and rejected by others.

Flour that, in underground places, has come in contact with the worst of water has been all right inside, if shot from the sack before becoming musty. We know of shipwrecked cargoes of Vienna and other flour that have returned handsome profits to the buyers because others were afraid of the supposed excessive damage. For the first week or two that sacks of flour stand in water it seems that the soakage into the sacks is to the extent of about one inch per week. If the wheat has got thoroughly wet, causing the interior to become unsound, the damage is, of course, permanent, but not so if merely the outside, or the bran, has become wet. In modern mills wheat is frequently passed through water or "washed" for purposes of cleaning, and also occasionally damped for purposes of easier milling. If the sacks of flour have been packed in a truck on wet straw, or the latter

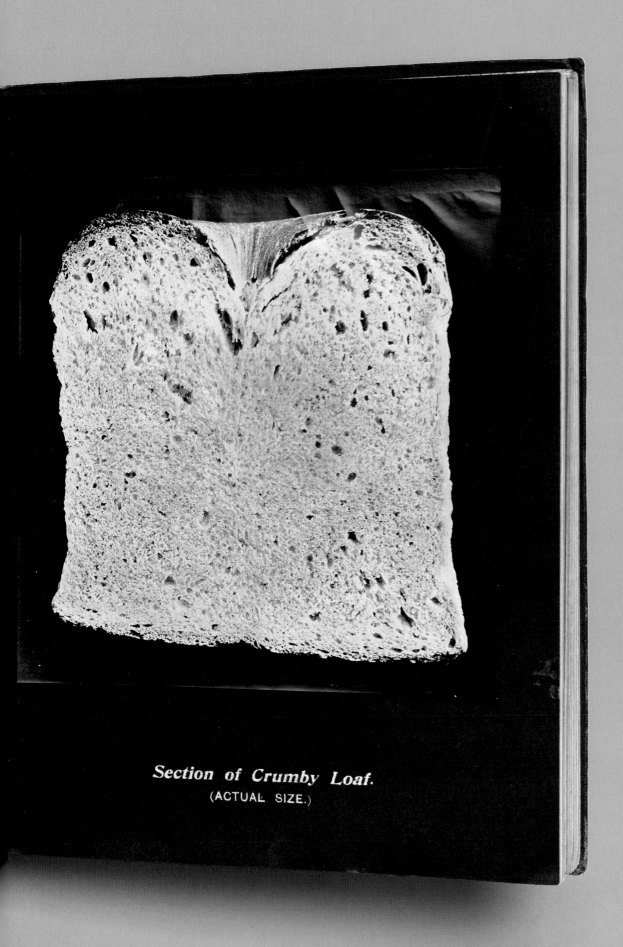

Section of Crumby Loaf.
(ACTUAL SIZE.)

Photographer unknown, pages from *The Book of Bread*, 1903

Rub the butter into the flour. Make a bay, and put into it the sugar, eggs, and essence. Thoroughly work up and make smooth under hand. The paste may be shaped either by blocking in a spindle-shaped wooden block, or by being rolled out thin on a slab, and then cut out with a spindle-shaped cutter and pinched. The latter is probably the quicker, but the former more reliable as to regularity, as in this case the mixture may be weighed off, 7 ozs. being divided into four. Place on baking-sheets, put a small bit of citron in the middle of each, and bake.

In some districts these goods are known as Waterloos, but why shortbreads should be called so it is not easy to guess.

TWO PLAIN SAVOY MOULDS.

Photographer unknown, pages from *The Book of Cakes*, 1903

CHARLES JONES

The photographs of Charles Jones have a startling clarity and modernity, belying their early date and humble subject matter. Rather than looking backward at art history, they seem to look forward to photographers such as Edward Weston (pp. 70–73), who would go on to photograph vegetables such as cabbages and peppers in a similarly modern style over thirty years later. The strength of Jones's work lies in the simplicity of isolating the vegetables on a plain background and capturing natural light to highlight the roundness of form. This marks a significant difference from how food had been photographed in the previous century. The references to painting are divested. The careful juxtapositions, symbolism of fruit and vegetables, and links to nature that were so evident in the work of British pioneers such as Roger Fenton and William Henry Fox Talbot are altogether absent. Although the style could be described as documentary, the photographs are no less artistic in intent.

The act of photographing food served little purpose commercially, but was done to show the virtuoso skill of the photographer, both as creator and printer. However, Jones's photographs also echo the style of close-ups used in *The Book of Cakes* and its companion *The Book of Bread* (pp. 38–43), a style that was to become essential to photography in all cookbooks. By going close, Jones elevates the vegetables not only in size, but in status; they take on a seductive elegance and grandeur. The detail in the photographs demonstrates Jones's intimate knowledge of the vegetables (and flowers) that he photographed and represents the pride he took in his gardening—Jones worked as a gardener for a number of private estates, achieving public recognition for his horticultural skill.

In the late 1980s, the collector Sean Sexton encountered five hundred of Jones's gold-toned gelatin-silver prints at Bermondsey Market in London. The prints were made sometime between 1900 and 1910, while Jones was head gardener at Ote Hall, in Sussex, England. No negatives remain; they were used as makeshift cloches to protect more tender vegetables and seedlings from winter frost. After retirement, Jones advertised his services as a photographer in the magazine *Popular Gardening*, although there is no evidence of him receiving a commission.

Charles Jones, *Peas*, ca. 1900

↖ Charles Jones, *Onion Rousham Park Hero*, ca. 1900
↑ Charles Jones, *Cabbage Colewort Rosette*, ca. 1900

WILLIAM H. MARTIN

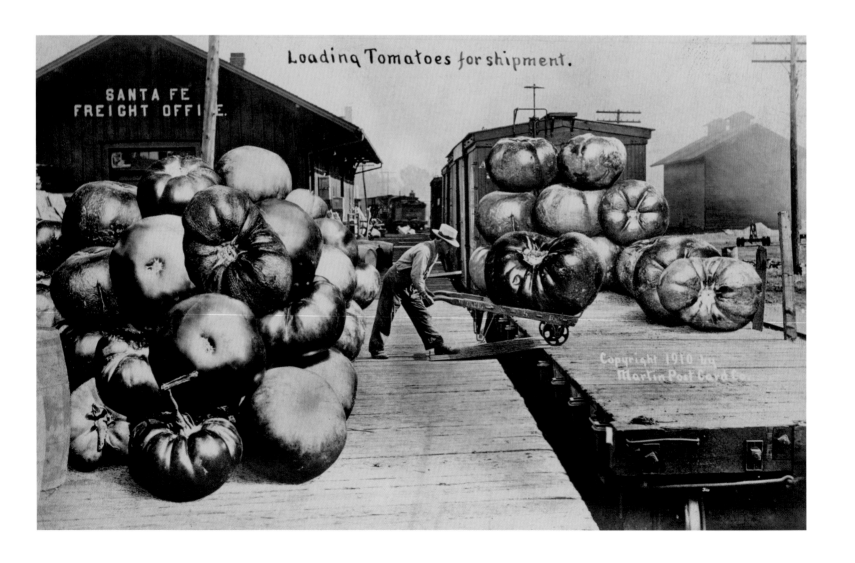

These ebullient postcards by William H. Martin appeared at the height of postcard popularity in the United States. Between 1907 and 1908, the United States post office reported that 667 million were sent. These photographic exaggerations were made using photomontage, perfectly encapsulating the joyful and surreal possibilities of commercial photography in the early years of the twentieth century. Boasting about the size of a fish you caught, the frame of a cow, or a bumper crop is the stuff of rural living, and Martin both mocks and celebrates this in his pictures.

But these bountiful crops are not just lighthearted jokes; they also go right to the heart of a mythic American preoccupation with agricultural abundance. This has come in various guises, from magazine editorials such as those in *McCall's* (pp. 100–105) to oblique references in Cindy Sherman's Disasters series (pp. 206–7). Depictions of American abundance—and thus prosperity—are used to political or cultural ends, and often have little to do with reality. Food is the perfect way to suggest wealth and plenty, and cards such as these did their part to promote the myth of a rural American utopia. Postcards of this nature, known as "tall-tale" cards, also helped to forge the identities of rural communities and encourage settlement in a country still trying to establish its own identity. They differed by state, and the food used—be it peaches, corn, or potatoes—was that which was common to that region.

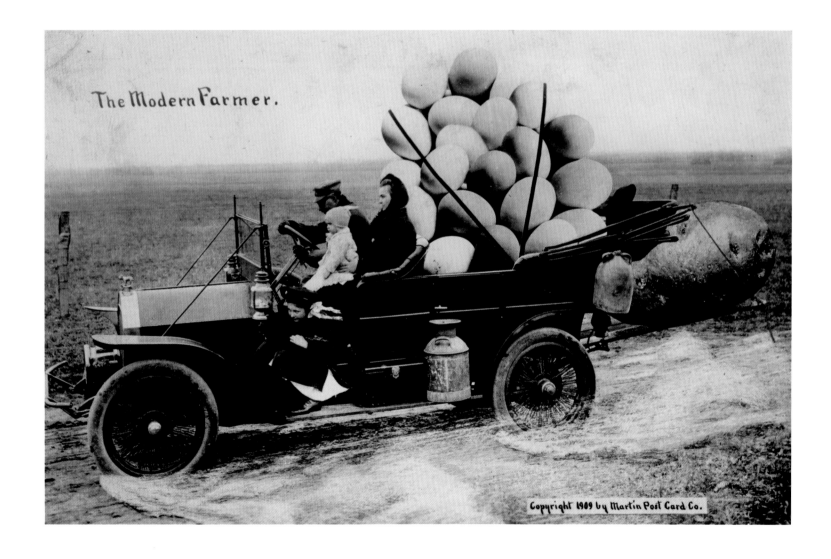

↖ William H. Martin, *Loading Tomatoes for Shipment*, 1910
↑ William H. Martin, *The Modern Farmer*, 1909

EARLY COLOR PHOTOGRAPHY

These examples of early color photography are all pioneering in their own gentle ways and point to the road forward for artists and photographers moving into the early decades of the twentieth century, as photography rapidly changed and developed. They all showcase softer hues, from a time before color became a staple of commercial photography, before the more brash, dynamic use of color with the Vivex and three-color carbro processes became synonymous with early photo advertising.

1910s

↖ Wladimir Schohin, *Stilleben*, 1910

↑ Dr. Arthur Traube, *Leibnizkekse*, ca. 1931

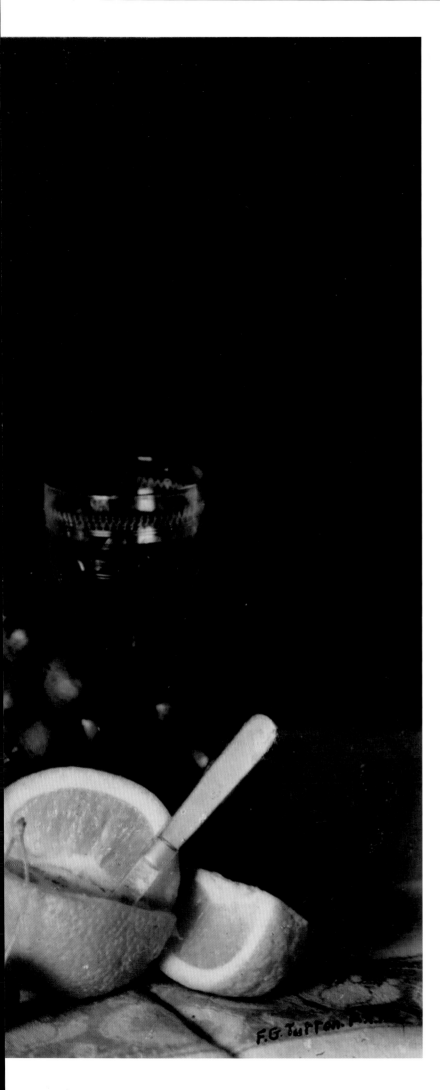

The autochrome of an egg by Wladimir Schohin (1910, p. 50) is startling in its modern simplicity; it captures the yellowish-orange of the yolk, which was notoriously difficult to recreate with this process. Autochromes were costly, difficult to reproduce, and fragile and as the century progressed, autochrome developments lagged behind those in monochrome cameras and printing. Autochromes remain a delicate moment of nostalgic luminosity.

The three-color separation print made by Frederick G. Tutton thirteen years later uses similar hues. Whereas food, especially fruit, was used in earlier black-and-white still lifes to showcase texture, it is color that is forefronted here. The wine is a dark claret, while the red of the cherries, strawberries, and apple were carefully arranged next to the softer pastels of the peach and orange so they would pop. The knife sticking jauntily out of the orange seems startlingly modern in comparison with the constructions by those such as Fenton, who kept more closely to painting's template when constructing similar scenes.

Finally, the photograph of cookies by Dr. Arthur Traube (ca. 1931, p. 51) was made using Traube's own invention: a process called the Uvachrome, which was later improved upon and became what we now know as the dye-transfer process. What is more striking here than the use of color is the humble status of the cookies which he uses to highlight his technique, as well as the practice of looking down onto food from above. The strategy of looking down onto a tabletop is now so common—especially using a smart-phone camera—that it hardly seems unusual, but it was utterly modern and different for this time.

Frederick G. Tutton, *Dessert*, ca. 1923

PAUL STRAND

Here, Paul Strand entirely disposes of all symbolic and allegorical underpinnings of the way food had been photographed in reference to art history. Instead, what is at stake in his still lifes is another rendering of photographic skill and an attempt to show that photography is a legitimate art form, with its own identity and set of aesthetic vocabulary. In this respect, his intention was not that different from that of photographers of the nineteenth century, such as Fenton and Talbot—but it is not the food's lushness and connections to nature that are important here, but their simple shape and abstraction.

Strand was also influenced by painting, in this case by Cubism and artists such as Matisse, Picasso, Brancusi, Cézanne, Picabia, and Braque, whose work he would have seen at Alfred Stieglitz's 291 gallery in New York. *Still Life, Pear and Bowls, Twin Lakes, Connecticut* (1916) was one of Strand's first attempts at recreating a completely abstract aesthetic, something which could be seen to graphic effect in his later documentary work. It uses a reduced form that highlights photography's unique descriptive properties. This later became known as "straight photography," a term that is now associated with Strand and his pioneering early pictures. The role and potential of photography with a modernist aesthetic—and, thus, the potential of photography itself—would eventually drive Strand to more political subjects and away from the mentorship and friendship of Stieglitz, who had encouraged him early in his career.

Paul Strand, *Still Life, Pear and Bowls, Twin Lakes, Connecticut*, 1916

EDWARD STEICHEN

Edward Steichen's sugar cubes take the marked modernism of Strand's still lifes and push that abstraction even further. Man-made sugar cubes represent ease, progress, and machine efficiency, while their uniform shape is an early example of the industrialization of food. Although originally from Europe, the sugar cube is a perfect food-object to easily and quickly satiate the quintessential American sweet tooth. Thoroughly modern and modernist in Steichen's treatment, the cubes would ultimately be printed onto silk crepe de chine scarves, to dramatic effect. Skillfully lit, the sugar cubes were thrown into sharp relief so their elongated shadows tilt graphically to the left, contrasting with the light. The effect is a dynamic patterning of light and shade. They are hardly recognizable as food at all.

Steichen, among other prominent artists of the day, had been commissioned by the Stehli Silk Corporation to create the patterns for scarves in their Americana series, and they marked a shift away from floral patterns to something far more dramatic, modern, and, crucially, American. His photographed designs distort the function of everyday objects and highlight his innovation and skill with modernist abstraction—as can also be seen with other materials he chose to photograph, such as thumbtacks and string. It is telling that Steichen chose sugar cubes as the sole foodstuff for this commission, breaking from the roundness and connection with nature that had previously been associated with photographs of food.

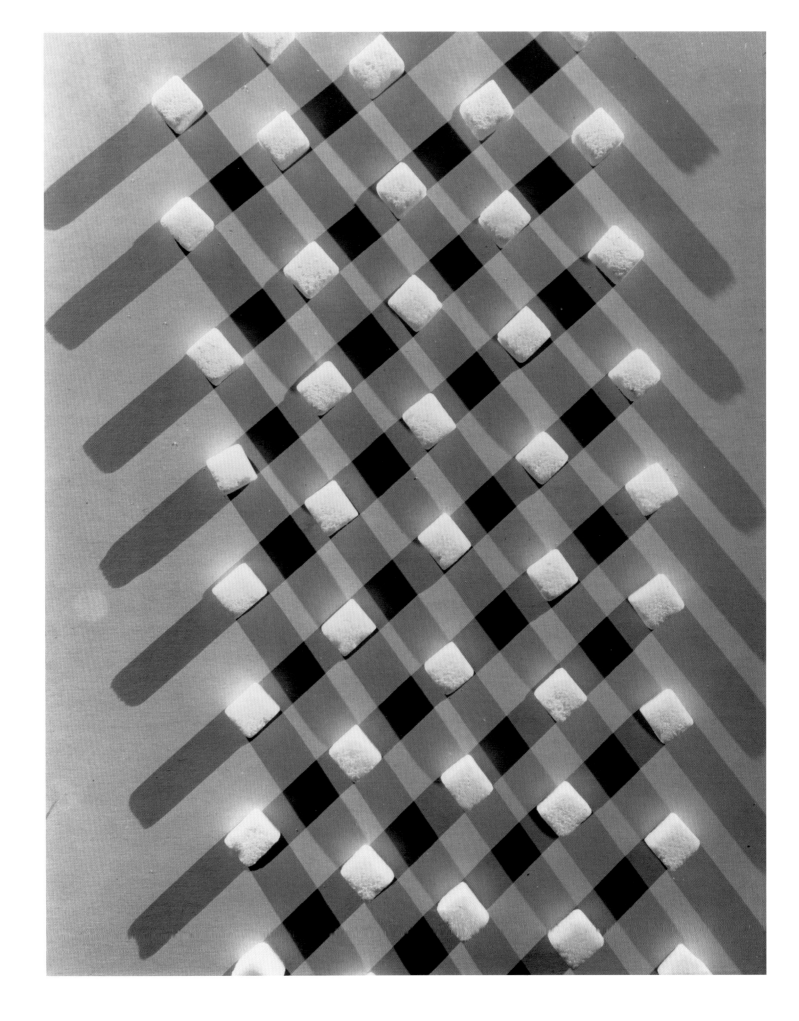

Edward Steichen, *Sugar Cubes: Design for Stehli Silk Corporation*, ca. 1920s

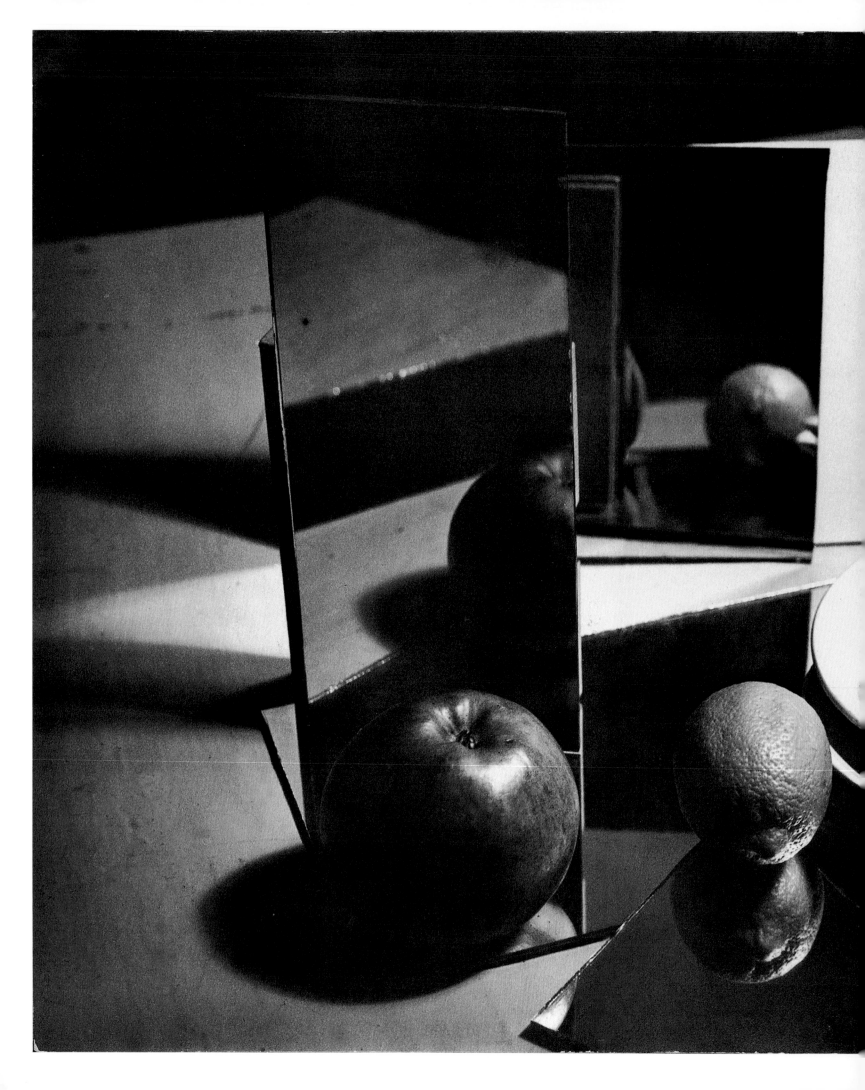

FLORENCE HENRI

Florence Henri visited the Bauhaus school in 1927 and became a key figure in the European avant-garde between the world wars. It was while she was at the Bauhaus that she realized photography had great potential as a tool for addressing formal problems. In her photographs, she attended to space, volume, and balance with skillful use of mirrors and food. This allowed multiple viewpoints and represented an important break from central perspective—both of which were key to Cubism and Purism, by which Henri was greatly influenced. As luminescent as moonlight, her still lifes traverse the specificity of fact and the tension of abstract perfection—a territory seen later in the work of Elad Lassry (pp. 290–93), who similarly uses food and mirrors in his compositions. Henri also used collage to create her still lifes, then rephotographed them—as can be seen here with the apple and oranges. Her interest in these fruits is purely in their form, as the sphere is a recurring shape in her work.

Florence Henri, *Composition Abstraite*, 1929

PAUL OUTERBRIDGE

Paul Outerbridge's *Avocado Pears* (1936, pp. 62–63) is not a commercial image—it was not commissioned, nor does it attempt to sell anything—but it does invite the viewer into the picture rather seductively. The addition of the lemon as a prop and the angle of the wood nod to food styling, so crucial to the composition of commercial food photographs. The bruising on the avocado, of course, is at odds with what would appear in an ad, since food advertising of any period only offers the very best and most delicious examples. The brown, damaged flesh makes the picture odd. This strangeness, and the slightly off-kilter approach, are similar to Outerbridge's famous nudes, many of which are a little unsettling, featuring bodies that are less than perfect.

As a pioneer of developing color photography, Outerbridge has become known as one of the masters of the three-color carbro process—which demanded not only photographic, but technical and craft skills as well. Like many American artists, he traveled in Europe in the 1920s, mixing with avant-garde artistic circles. Drawing on those influences when he got back to New York, Outerbridge used a modernist, closely cropped aesthetic in his earlier still lifes of food, if not one as bold as in Paul Strand's earlier work. In *Avocado Pears*, the cutting board and knife are placed at significant diagonal positions, adding dynamism to the photograph.

Outerbridge is best-known for both his nudes and his considerable commercial work of the 1930s and 1940s. His still lifes, like *Avocado Pears*, are radically different from the advertising images he created for the now-defunct supermarket chain A&P. Yet they show Outerbridge's ability to switch seamlessly between his art and commercial jobs without affecting his astute understanding of color. These domestic scenes (left) were created for the supermarket's own brand of coffee and, like a lot of advertising, rely on a mixture of cliché, myth, and humor for their success. The messaging is clear: this coffee is so good, it even gets men into the kitchen.

↖ Paul Outerbridge, *Prowlers Welcome (Father and Son in Kitchen)*, 1941
← Paul Outerbridge, *Coffee Drinkers*, 1940

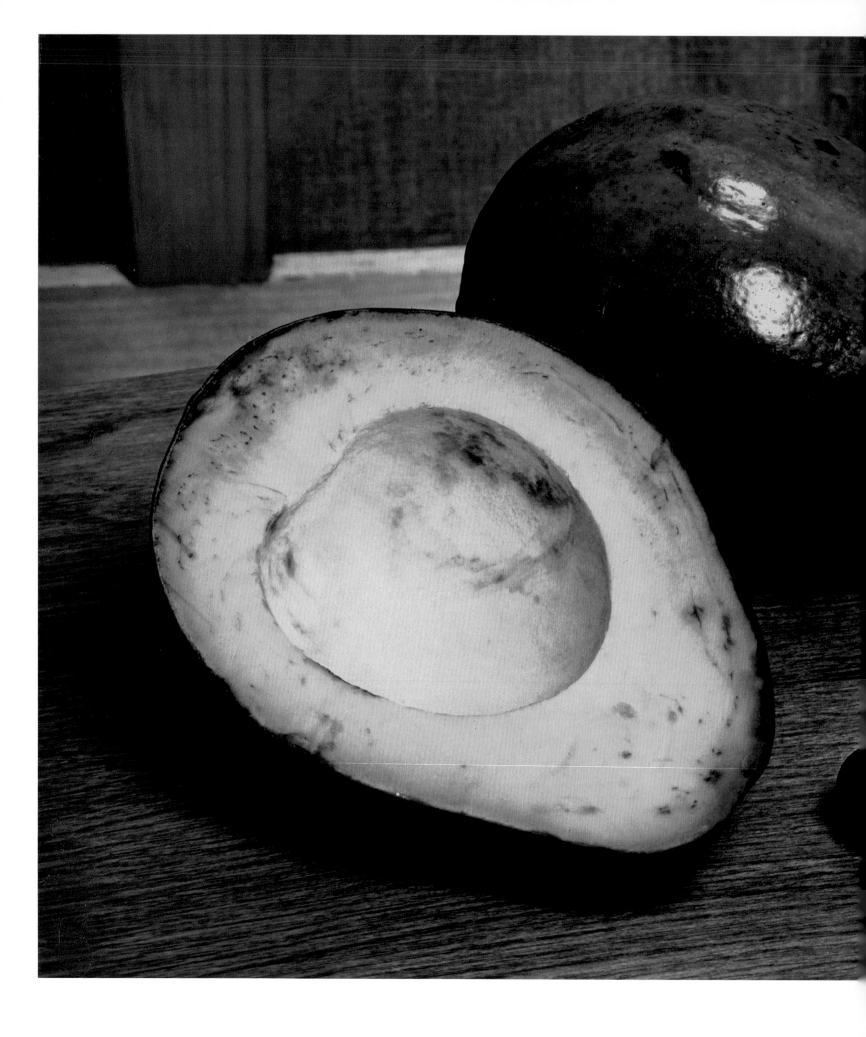

Paul Outerbridge, *Avocado Pears*, 1936

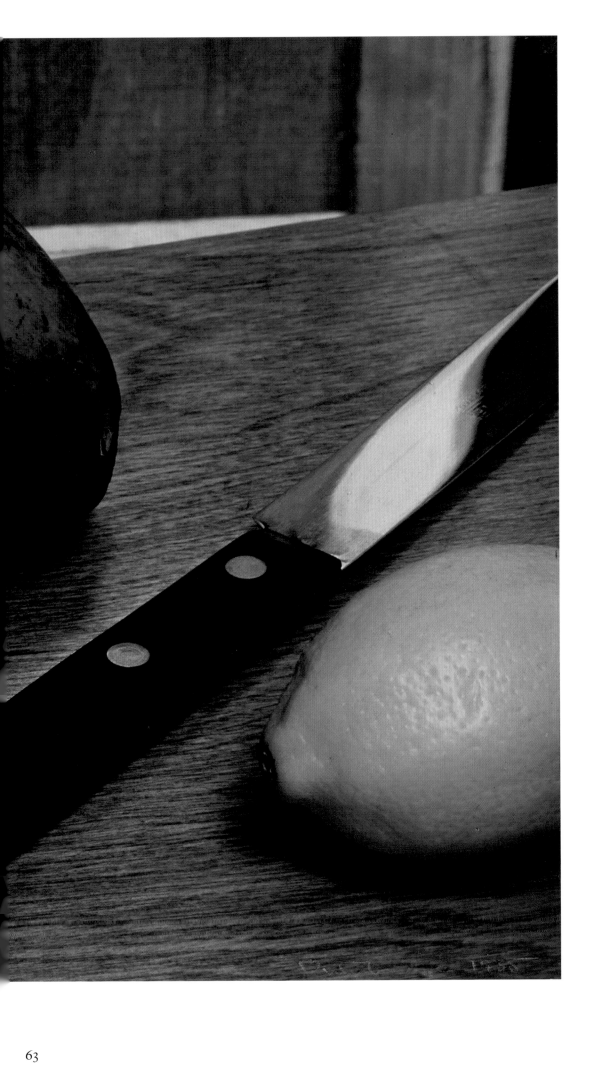

MAN RAY

In the early 1930s, when the artist Man Ray was at the height of his fame—both as a member of the Surrealist avant-garde and as a commercial photographer—he was commissioned by the French electric company Compagnie parisienne de distribution de l'électricité (CPDE) to produce a portfolio of ten photographs. They were reproduced as photogravures, printed in an edition of five hundred, and distributed to the company's special customers and clients.

The 1931 portfolio, titled *Électricité*, was mainly concentrated on domestic subjects and used a technique called the rayograph, a photogram process that does not involve a camera. Ray had perfected the technique in the 1920s, and this portfolio includes some of his best examples. By laying different objects on top of one another, Ray was able to create vibrant, vigorous visions of a modern and mysterious world, aided by the invisible forces of electricity. Modern domestic equipment such as electric irons and toasters were featured to promote electricity as a way to be forward-thinking and improve the domestic lives of working-class Parisians, who still mostly relied on coal, wood, or natural gas for power. The roasted duck featured here is especially dynamic—with its zingy helix, suggestive of the space age or psychedelic graphics that would come into prominence later in the century. The inclusion of rice rather than potatoes in the dish also suggests modernity rather than tradition.

Man Ray, *Electricity Cuisine*, 1931

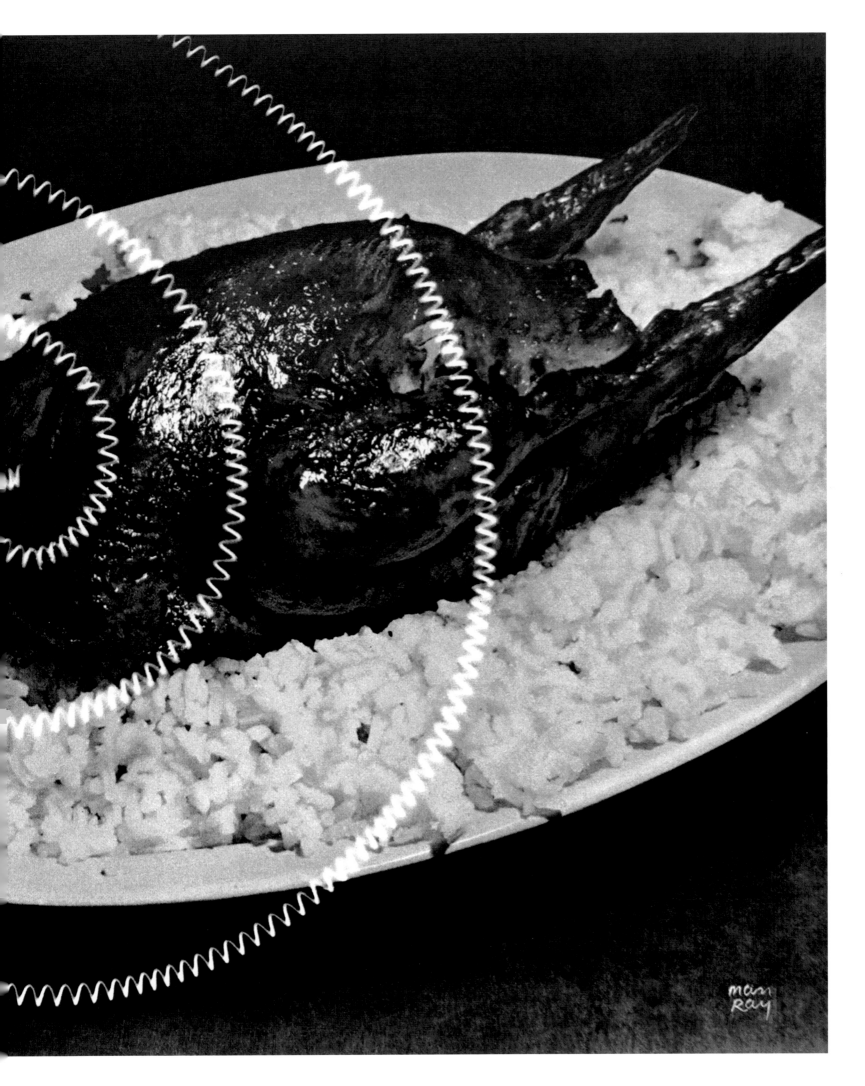

PISHCHYEVAYA INDUSTRIYA (FOOD INDUSTRY)

Pishchyevaya Industriya (Food Industry), made up of two publications commissioned by the Soviet Union's State Publishing House for the Arts, is credited to the artist and designer El Lissitzky. However, Lissitzky fell ill, and the construction and design of the books were left to his wife, Sophie Lissitzky-Küppers. She regularly visited editors involved in the project and claimed that they "vied with each other in their inspiration and in the production of the new photographic material." Lissitzky also regularly corresponded with Lissitzky-Küppers from his sanatorium in Georgia, giving instructions and making clear the rigid codes and rules for Soviet political significance. In addition to this, final photographs in the books are credited to other photographers.

The result of this collaborative approach is that the books are an unusual mix of photographic imagery that includes montage, lithographs, and photographs. The visual language tries to show the unique character of the Soviet Union and its apparently successful steps into more industrial food production. The final publications consist of one book and one set of photogravure plates presented in a portfolio, the latter of which is featured here. The focus of the photographs is on high levels of food production, as was typical of Soviet propaganda of the time. These highly stylized pictures offered a behind-the-scenes illustration of a productive country with new and innovative ways to feed its population, seemingly comparable to advancements in the West. Being German, Lissitzky-Küppers brought a European modernist aesthetic to the design, making this rare book a curious hybrid and unusual object that was mostly distributed to libraries rather than among the masses.

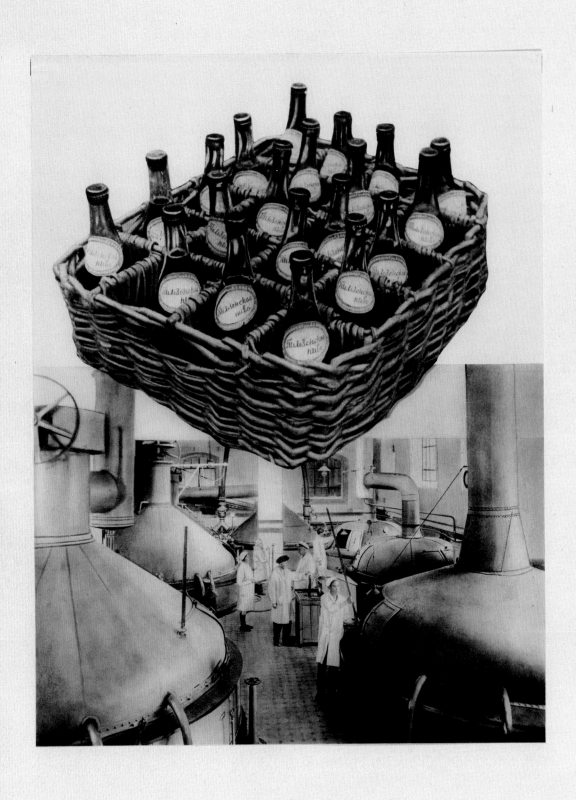

На Жигулевском пивоваренном заводе Варочное отделение

Photographer unknown, photogravure plate from
Pishchyevaya Industriya (*Food Industry*), 1936

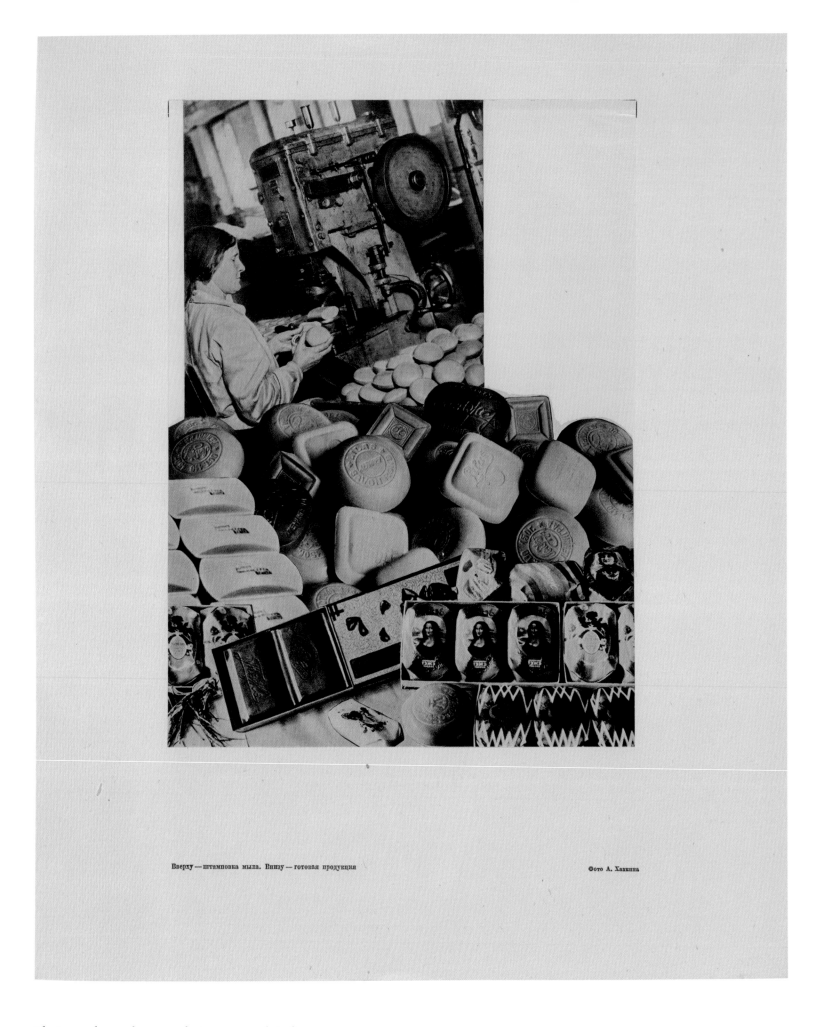

Вверху — штамповка мыла. Внизу — готовая продукция

Фото А. Ханина

Photographer unknown, photogravure plate from
Pishchyevaya Industriya (Food Industry), 1936

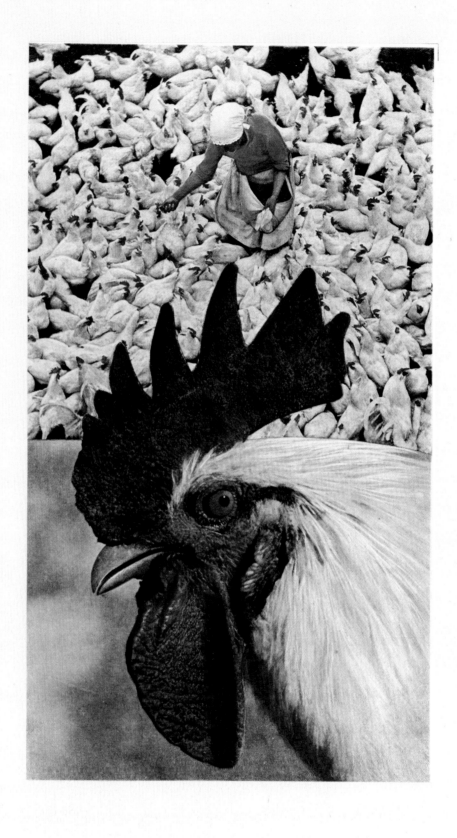

На птицекомбинате Фото А. Скурихина и Б. Грюнталя

Photographer unknown, photogravure plate from
Pishchyevaya Industriya (*Food Industry*), 1936

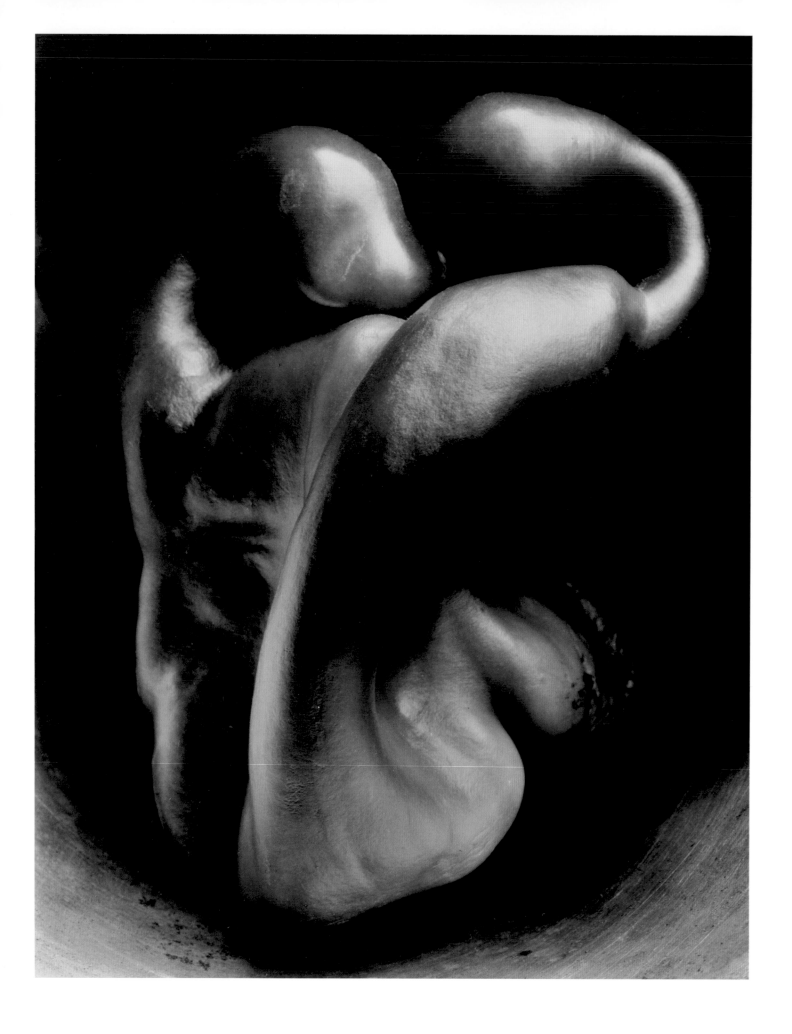

Edward Weston, *Pepper No. 30*, 1930

EDWARD WESTON

The rhythm of form and shadow on the surface of the foods in Edward Weston's photographs transforms them into something altogether more abstract. The natural forms of the pepper resemble human muscles—on what part of the body is unclear—so what's pictured is no longer simply a pepper but a beautiful, sculpted form. Likewise, the gills of the mushroom, when photographed, come to resemble some intricate coral or flower. The way Weston photographed food rendered it beautiful, stately, and almost regal. These close-ups read more like exquisite figure studies rather than still lifes. He created his own method of photographing which, although heavily copied, has never really been surpassed.

Weston chose his subjects not for their art-historical associations or place within the genre of still life, but for their photographic potential and shape—which he then skillfully lit and photographed, in the hope that the picture would capture the essence of the actual thing. He wrote in his daybooks of his famous pepper, "To be sure, much of my work has this quality . . . but this one, and in fact all of the new ones, take one into an inner reality—the absolute—with a clear understanding, a mystic revealment. This is the 'significant presentation' that I mean, the presentation through one's intuitive self, seeing 'through one's eyes, not with them': the visionary." Such high standards and expectations of his own work may sound grandiose now, but his spiritual links with photography and ideas of transcendence were, if not commonplace, certainly an important element of American photographic modernism, of which Weston was a leading figure.

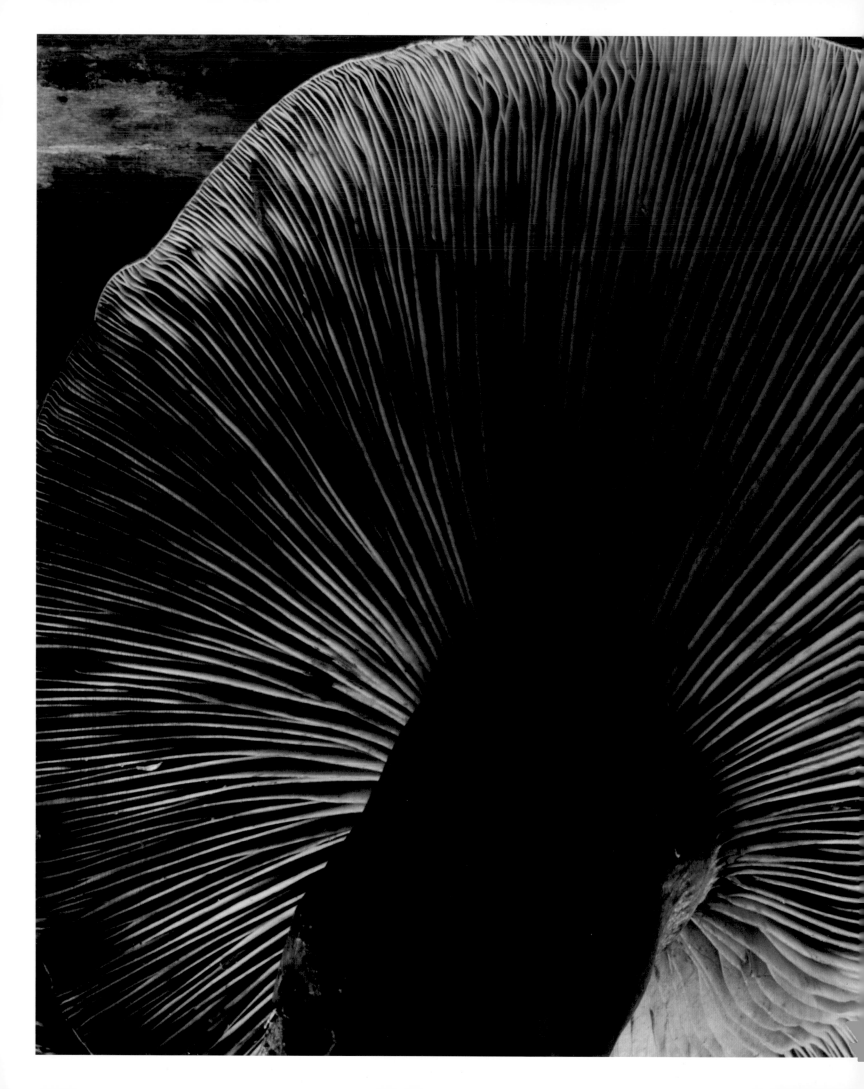

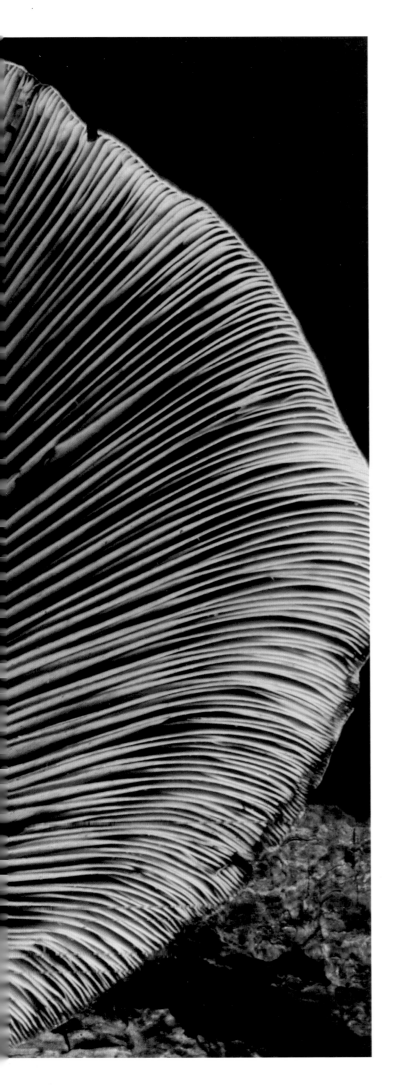

Edward Weston, *Mushroom*, 1931

WEEGEE

During the 1930s and 1940s, Weegee (Arthur Fellig) famously listened in on a police radio to find out what was happening in New York and photograph it before anyone else. With operatic intensity, he captured the chaos and cacophony of a city rife with organized crime and trauma. But he also photographed its everyday rhythms and its inhabitants—and since it is food that punctuates the day and gives it structure, food was photographed, too. Weegee turned to the early-morning delivery of bagels, or the diners where lone customers shoveled spaghetti into their mouths—moments that would have been common when he roamed the streets, but now feel part of a New York that is disappearing through constant cleanups and gentrification.

Weegee turned people into characters when he photographed them, and the young children at the birthday party (ca. 1953, p. 77) are no exception. Standing behind a table with cake, they seem unsure of the photographic act. Should they not seem happier? The act of documenting birthdays was already a ritual in the early twentieth century, and the fact that Weegee was a professional photographer implies that he might have been hired for the job. These children were unaccustomed to posing for the camera and would more likely have preferred to be eating the cake than standing behind it. Documenting food and the rituals that surround it is firmly established in vernacular photography as well, and the birthday-cake image is probably one of the most repeated; when we think of photographs of children's parties, it is not the games or even the presents that come to mind, but the gathering of children and blowing out of candles on the cake. The ritual is one of familiarity, of safety and belonging. Food as ritual can also be seen in the image of the Hanukkah feast (ca. 1946, p. 76), where an uneaten cake remains in the debris of the meal.

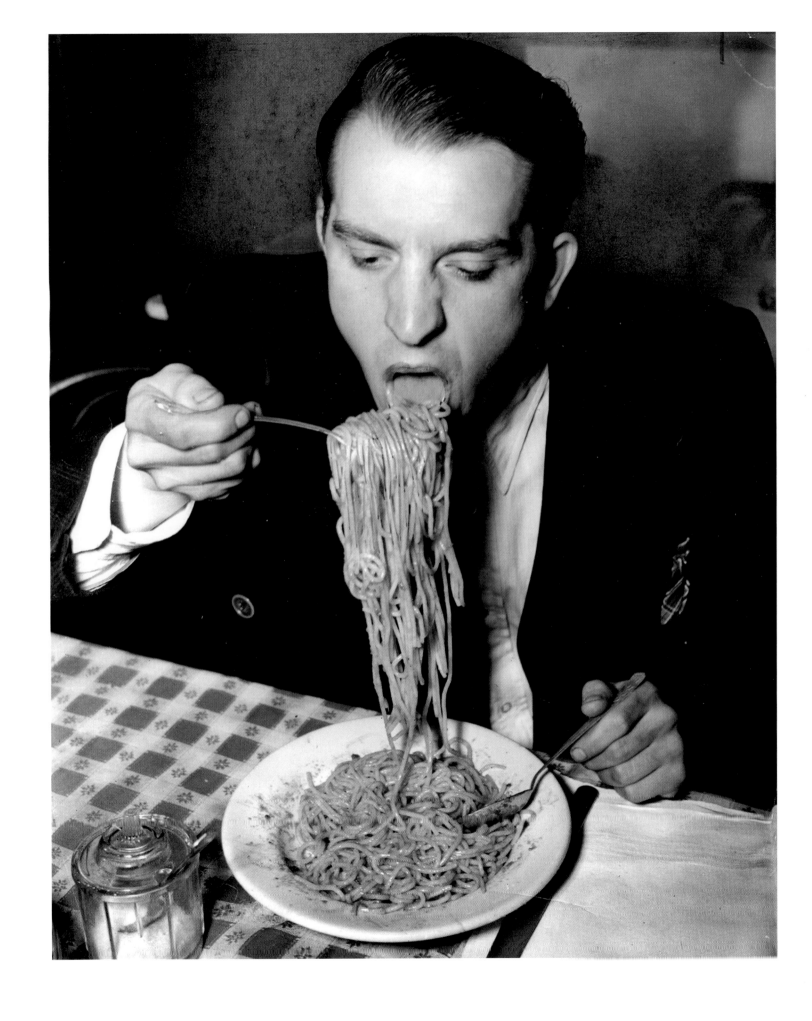

Weegee, [Phillip J. Stazzone is on WPA and enjoys his favorite food as he's heard
that the Army doesn't go in very strong for serving spaghetti.], 1940

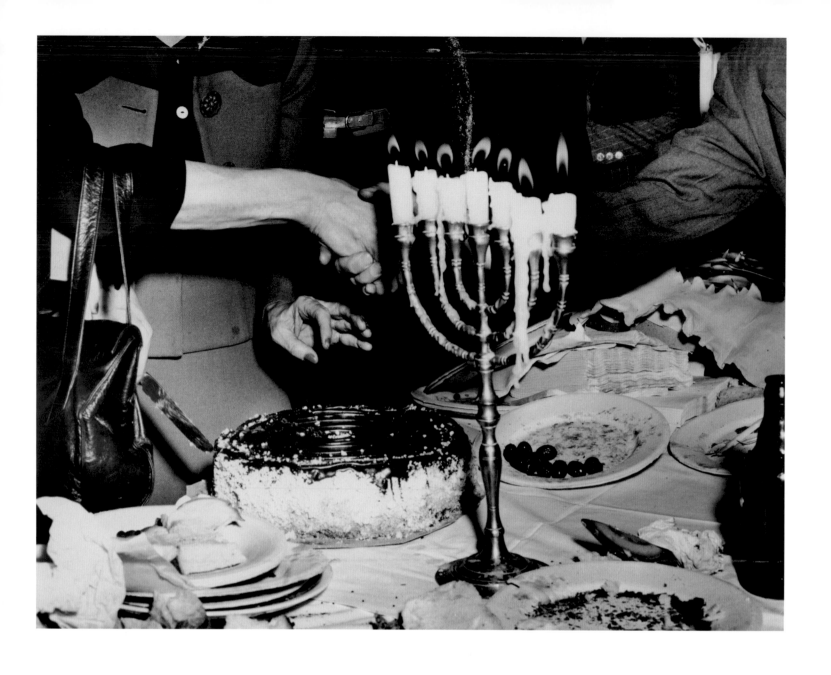

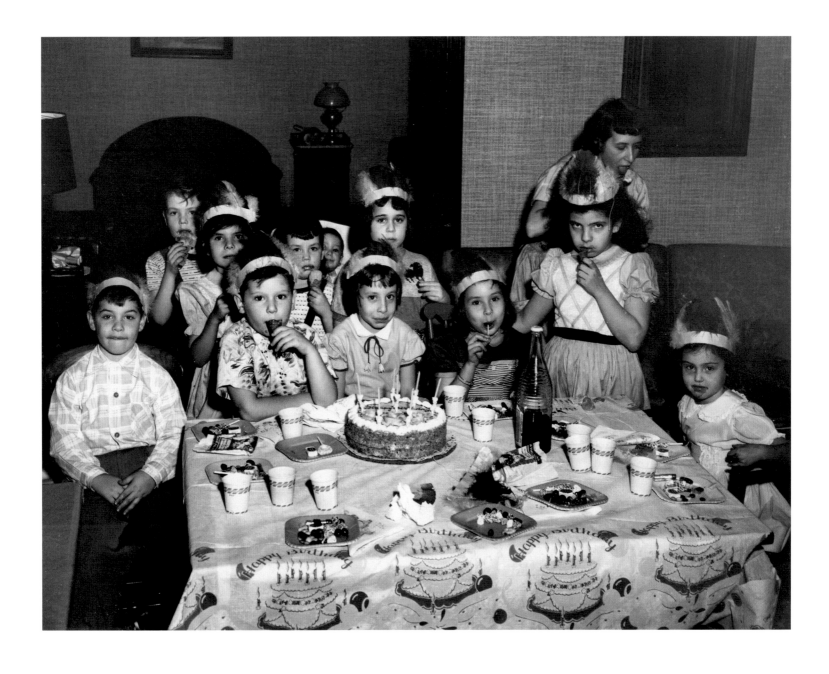

↖ Weegee, [Menorah and cakc], ca. 1946
↑ Weegee, [Birthday party], ca. 1953

VICTORY IN AN EGGSHELL

The two filmstrips shown here were prepared by the US Farm Security Administration. They are grandly titled: *Victory in an Eggshell* (1942) and *Today's Storage Is Tomorrow's Dinner* (1942). The photographs were taken by various FSA photographers, such as Marion Post Wolcott, John Vachon, Russell Lee, and John Collier, then combined to make a narrative accompanied by a spoken voiceover.

Today's Storage Is Tomorrow's Dinner was designed to educate the public about preserving, canning, growing, and curing food as America entered the Second World War. It promoted a lifestyle where nothing was wasted, at a time when the food supply was limited. The photographs also encouraged a positive mood of austerity—one that made you a better person, able to enjoy feasts if you worked hard and deserved it. They made the case that people were contributing to the war effort overseas though their home food production and behavior. *Victory in an Eggshell* differs slightly, as it concentrates on promoting better egg production for farmers. Both films, however, were aimed directly at rural communities, and were most likely shown with other teaching material commissioned by the FSA in schools, libraries, and FSA offices around the country.

These differ dramatically from earlier photographs associated with the FSA from the 1930s; they were not presented in order to carry the message of the rural poor to an urban or suburban audience during the Great Depression, but instead were intended as teaching aids. In this respect, the photographs appear very staged and artificial. With the US entering the war, there was a shift from commissioning images about rural poverty to more instructive photographic messaging about winning that war, and these photographs highlight this change. The photographs have none of the emotional power of images such as those of Pie Town, for example (pp. 82–85), and feel heavy-handed and didactic.

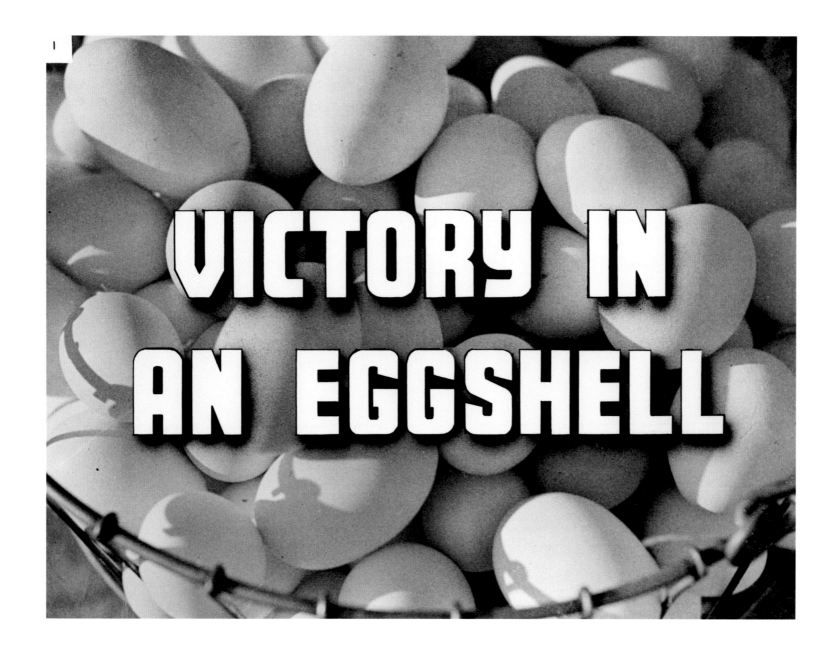

Farm Security Administration, photograph from
Victory in an Eggshell, 1942

Farm Security Administration, photographs from
Today's Storage Is Tomorrow's Dinner, 1942

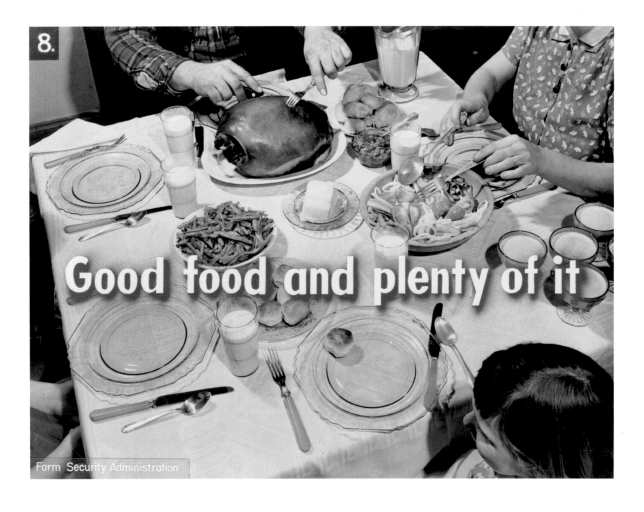

8.

Good food and plenty of it

Farm Security Administration

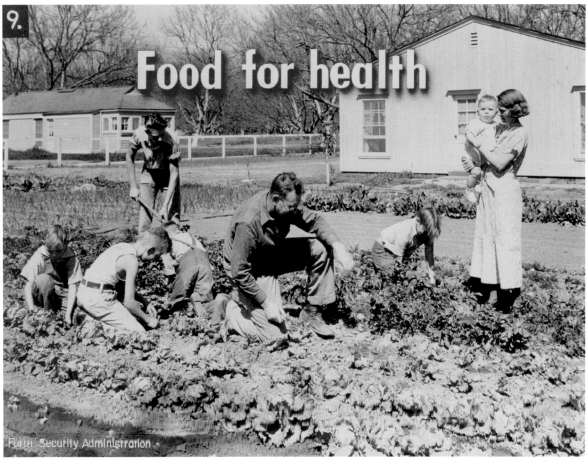

9.

Food for health

Farm Security Administration

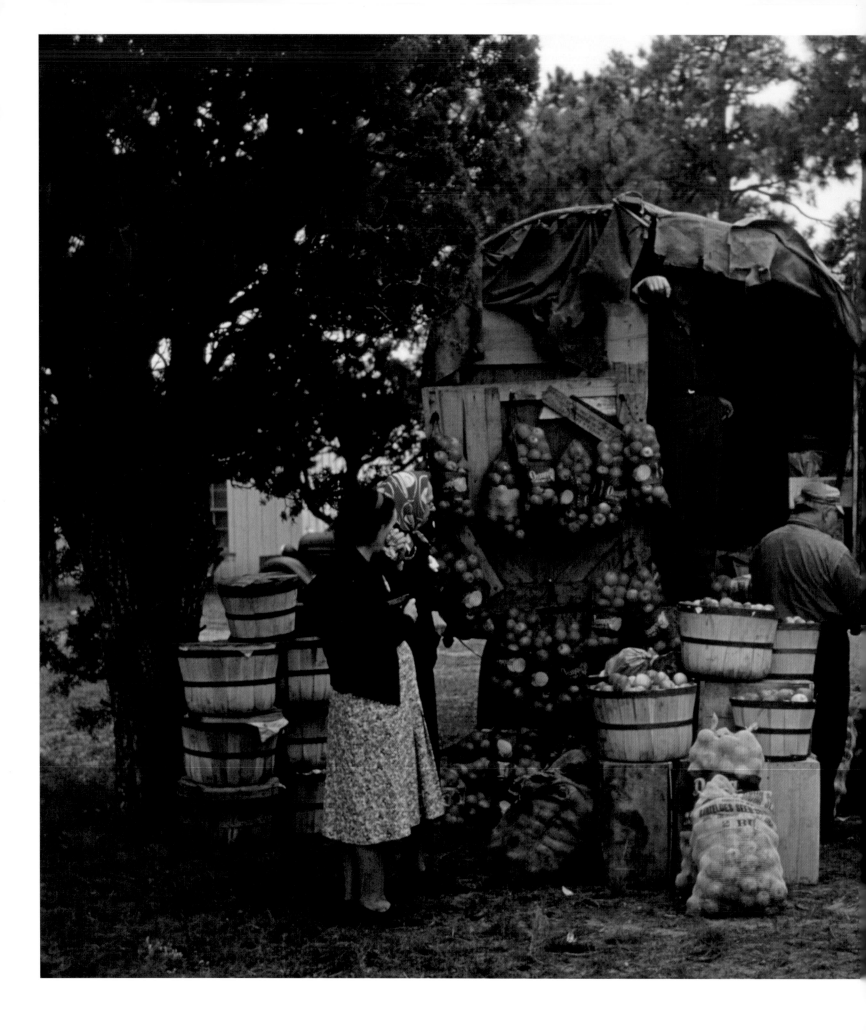

Russell Lee, *Fruit Wagon at the Pie Town, New Mexico Fair*, 1940

RUSSELL LEE

At the end of the Depression and the very beginning of World War II, Russell Lee was working for the Historical Section of the FSA, a New Deal photography project to promote government revitalization of the agricultural economy. His visit to Pie Town, New Mexico, yielded extraordinary color photographs centered around the production and sales of food in a community barely scraping by.

In comparison with the FSA propaganda in *Victory in an Eggshell*, these photographs show a more authentic picture of small-town American life. When comparing the table scenes, the discrepancies between these families' harsh reality and the more constructed propaganda are made startlingly obvious. Pie Town (thus named due to its reputation for baked goods) is shown to be a place where community is strong and food is shared. Color photography at this time was associated with commercial fantasy, as can be seen in the work of Victor Keppler and Nickolas Muray (pp. 96–99 and 100–105), and these photographs of Lee's were little-known at the time. The bright oranges and vibrant patterns of the people's clothing seem at odds with an era so associated with black-and-white documentary photography in the American collective memory.

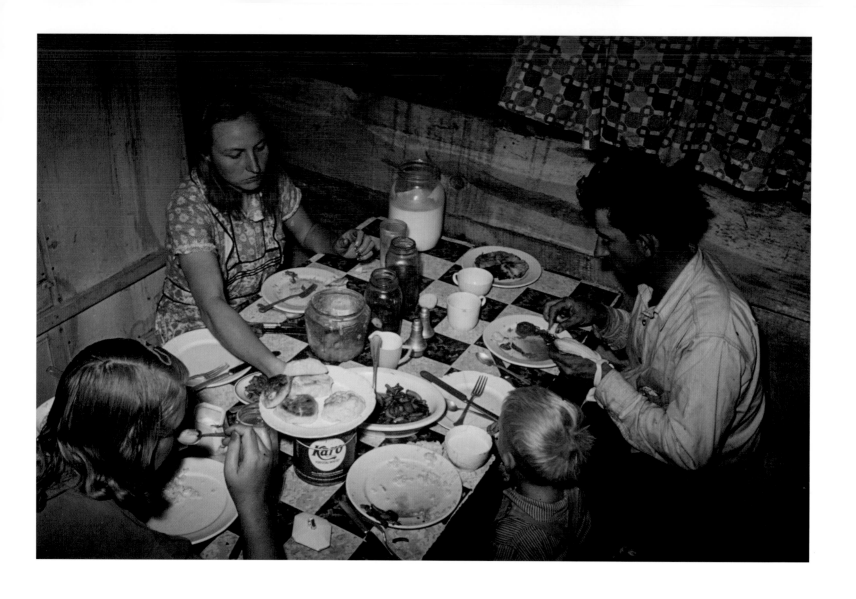

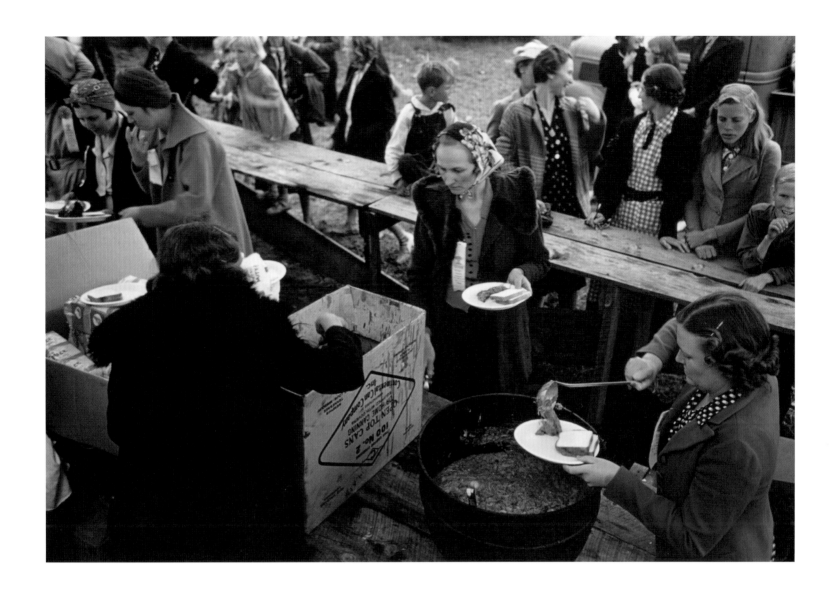

↖ Russell Lee, *The Faro Caudill [Family] Eating Dinner
in Their Dugout, Pie Town, New Mexico*, 1940
↑ Russell Lee, *Serving Pinto Beans at the Pie Town,
New Mexico, Fair Barbeque*, 1940

COOK-BOOKLETS

Recipes have long been carried into homes through free "cookbooklets" published by brands—of both ingredients and kitchen appliances—that featured their product. But these cheerful, heavily illustrated booklets are clearly selling more than just the brand; they're also selling a lifestyle, often relying heavily on stereotypes of race, family, femininity, and domesticity. They introduced often-unfamiliar products alongside recipes and serving suggestions, and because they were primarily pieces of advertising, photographs were dominant.

Three American examples of these cookbooklets were published by Aunt Jemima, Crisco, and Knox Gelatine. Aunt Jemima, part of the Quaker Oats Company, is the most problematic: like another American household name, Betty Crocker, Aunt Jemima is a fictional character. The name comes from the minstrel song "Old Aunt Jemima," which was popular in the nineteenth century. Jemima is depicted as a stereotypical black Southern servant—imagery which can also be found on the packaging for other brands, such as Uncle Ben's rice from the same period. Originally known for its pancake mix, Aunt Jemima is now synonymous with imitation-maple pancake syrup. The brand's brochure presents food, such as waffles, that are associated with Southern cooking. *Aunt Jemima's Magical Recipes* (1954, pp. 90–91) contrasts greatly with the later *Cooking with Soul* cookbook (pp. 136–39), which showed real food being made by an African American community, rather than white people's fantasies about people of color.

On the cover for *New Recipes for Good Eating*—produced by Crisco, a brand of vegetable oils and shortening used for baking, in 1949 (pp. 88–89)—a photograph represents a vision of America that reverberated through much of how food was photographed in commercial settings. The cook is the mother, who happily feeds her perfect nuclear family homemade doughnuts, which she expertly deep-fries without any concern about two young children being nearby. The quantity of doughnuts suggests a country of abundance, and a time when feminism had not yet dismantled domestic myths.

Knox Gelatine's *On-Camera Recipes* comes from 1963 and shows the continuation of branded cookbooks and recipe brochures. It also shows the growing relationship between television and photographs, as well as the popularity of cooking for large audiences. In this case, the photographs were taken as a television show was being filmed—as if this made them more real and authentic than if they had just been taken for a book. Inside, the demonstrations are black and white, while the finished dishes are shown in color. Again, this shift in tones is meant to suggest reality in some way. *On-Camera Recipes* shows home cooks how to achieve spectacular gelatin dishes that look ready for both the camera and the table, as well as registering a shift in how the presentation of food at home had become just as important as the quality of the meal. The proliferation of gelatin recipes from this period is somewhat baffling to contemporary palates, as it is now a foodstuff reserved for the pleasure of children and invalids.

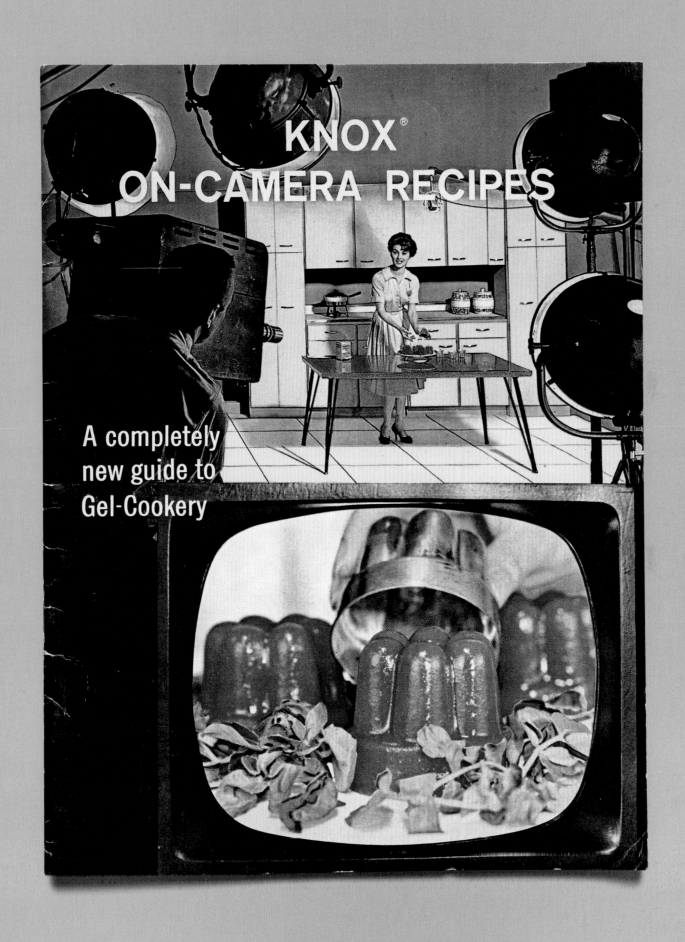

Photographer unknown, cover of *Knox On-Camera Recipes*, 1963

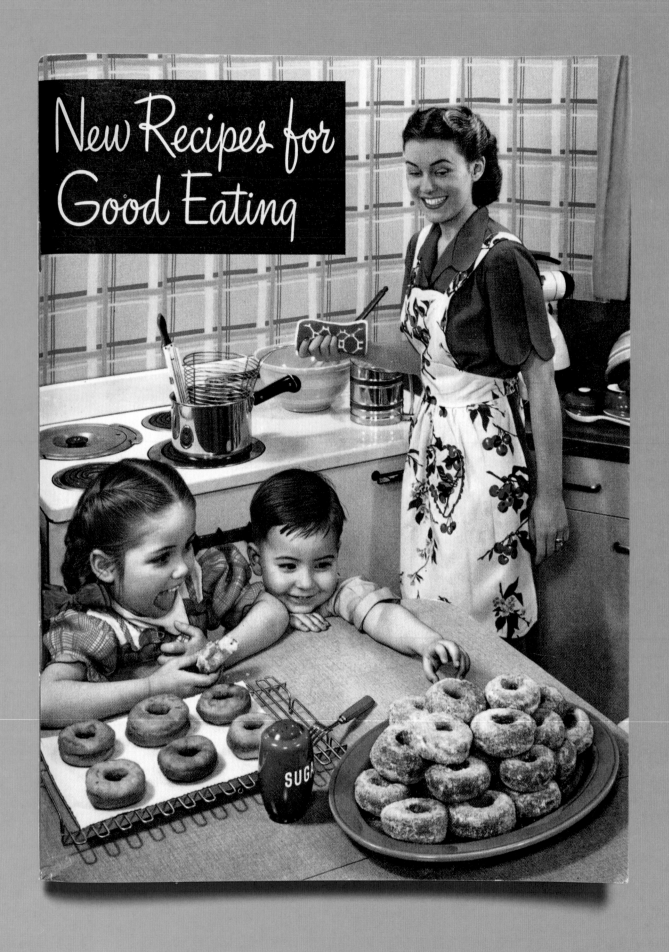

Photographer unknown, front and back covers
of *New Recipes for Good Eating*, 1949

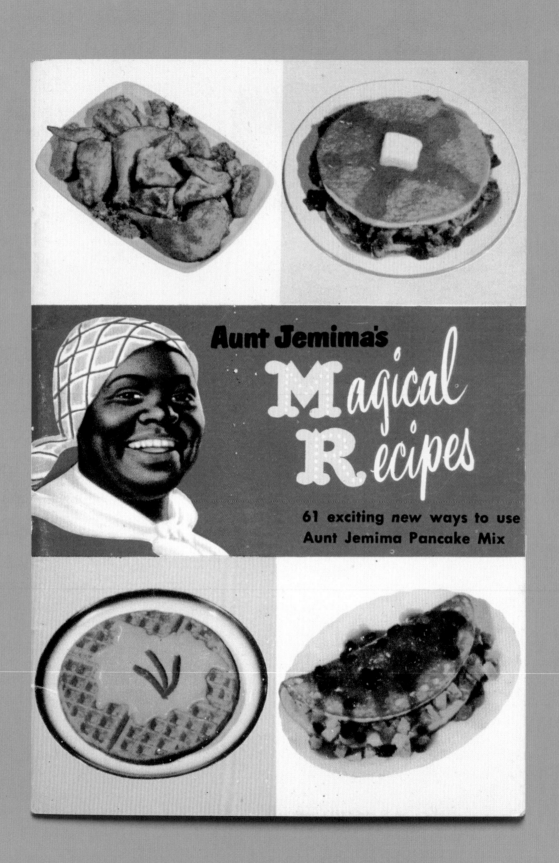

Photographer unknown, front and back covers
of *Aunt Jemima's Magical Recipes*, 1954

AJBR-1954

John Hinde, *Blancmange with Tinned Fruit*, 1941

JOHN HINDE

Produced to illustrate a book about canteens commissioned by Britain's Empire Tea Bureau, *The Small Canteen: How to Plan and Operate Modern Meal Service* (1947), these pictures seem muted and the dishes quaint in comparison with the way John Hinde's American counterparts used color to photograph food at this time. But these photographs were not selling a fantasy; instead, they were made to illustrate the preparation of mass quantities of food for an office, factory, or school. Hinde's approach was dynamic for such a commission, at a time when black-and-white photography still dominated. He combined photojournalistic instinct and an advertising eye for a seductive scene with high craftsmanship and a passion for color, to make food look— if not entirely appetizing— certainly intriguing.

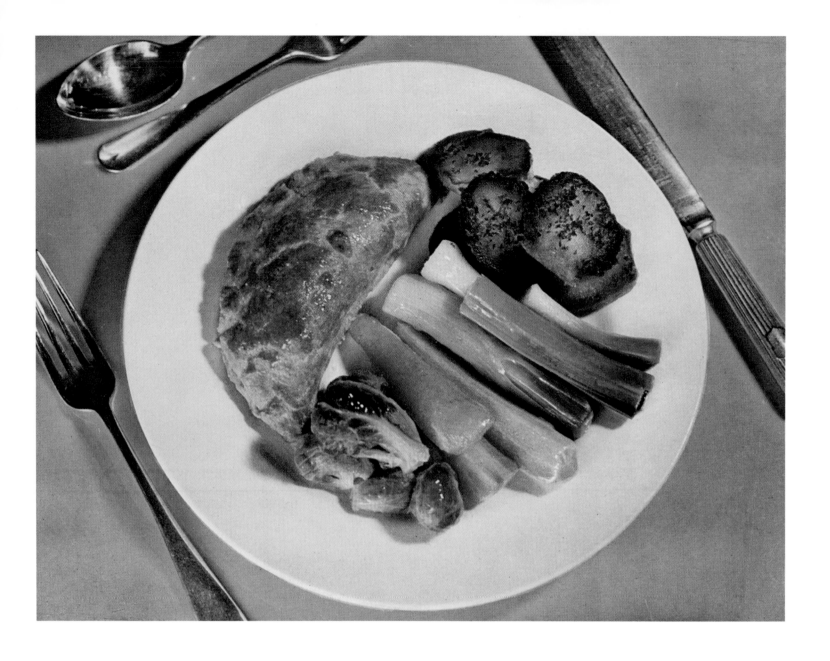

Like Nickolas Muray (pp. 100–105), Hinde utilized the diagonal and photographed food from above. It was carefully arranged and styled to highlight Hinde's use of color; the green of the vegetables and salads was interspersed with the other colored vegetables to give the photographs vibrancy. The food illustrated includes a blancmange (a dessert) and rollmops (a pickled-herring dish)— both of which were new to Britain at the time. Hinde greatly influenced the later food photography of Martin Parr (pp. 238–45).

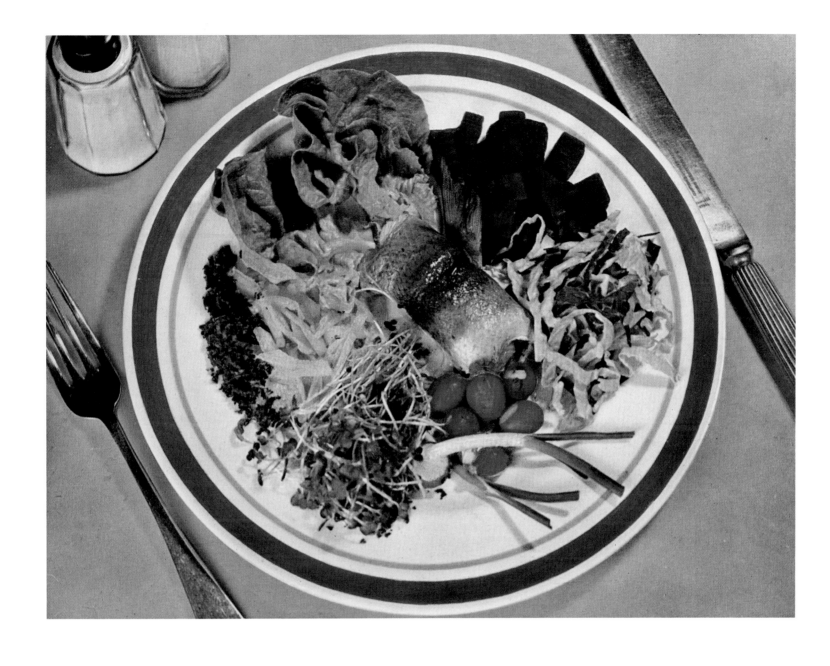

↖ John Hinde, *Pasty with Potatoes and Associated Vegetables*, 1941

↑ John Hinde, *Plate with Fish Surrounded by Vegetables*, 1941

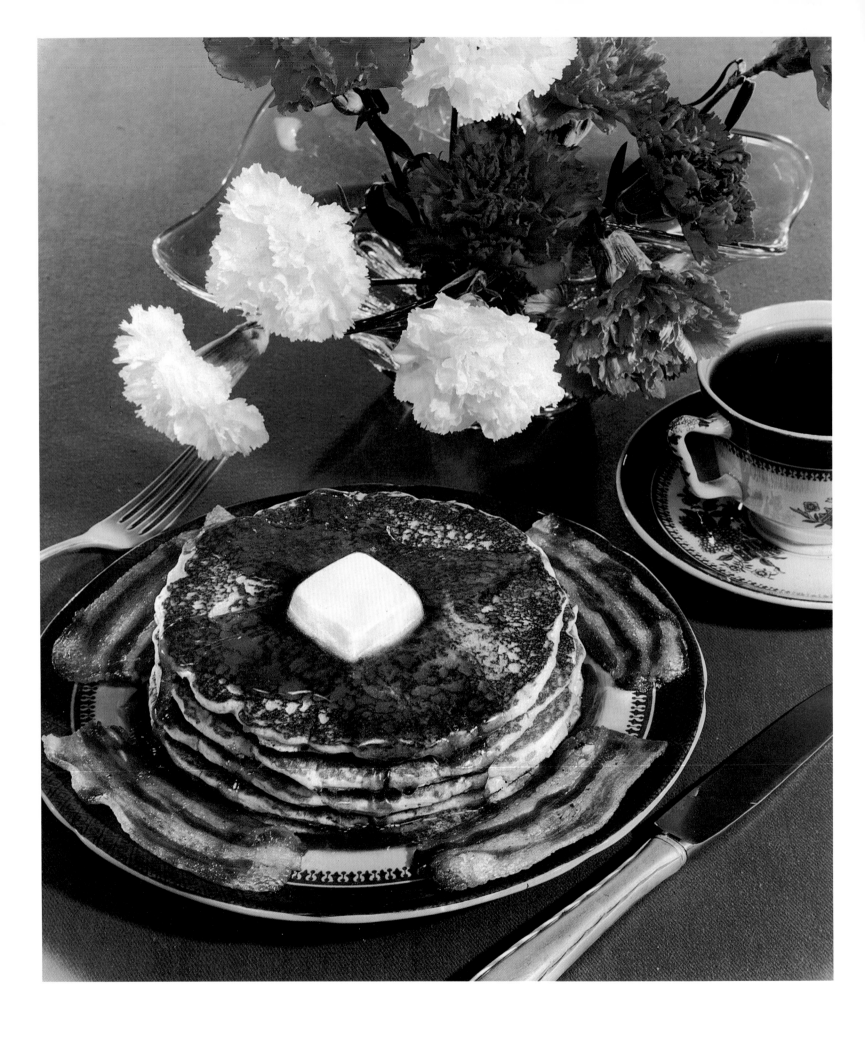

Victor Keppler, *Pancakes*, ca. 1940s

VICTOR KEPPLER

A contemporary of Nickolas Muray, Keppler was an early adopter of color, quickly realizing its potential in advertising. He once claimed, "Color photography makes commonplace objects look glamorous, and glamorous subjects even more enchanting." Such a claim stands true for the sumptuous red apple in the Pyequick advertisement (1947, pp. 98–99), where just four colors stand out from one another. The pancake picture (ca. 1940s, left) is equally effective, with bold use of red and white carnations and a blue tablecloth that manages to highlight the almost-luminous golden pat of butter. This technique, characterized by vivid, color-blocked areas of contrasting hues, is typical of Keppler's food photography. The relative simplicity was especially effective in ads and food packaging where the emphasis is on consumption, with both the eye and the wallet. Keppler emphasized the product rather than concentrating on elaborate tables and sumptuous feasts, understanding a message needs to get across to the viewer quickly and seductively in order to sell. The ad for General Mills' product Apple Pyequick also managed to deftly tap into the heart of American identity. What is more American than apple pie? Perhaps one made with Apple Pyequick for modernity and efficiency?

Victor Keppler, [General Mills advertising campaign—
Apple Pyequick], 1947

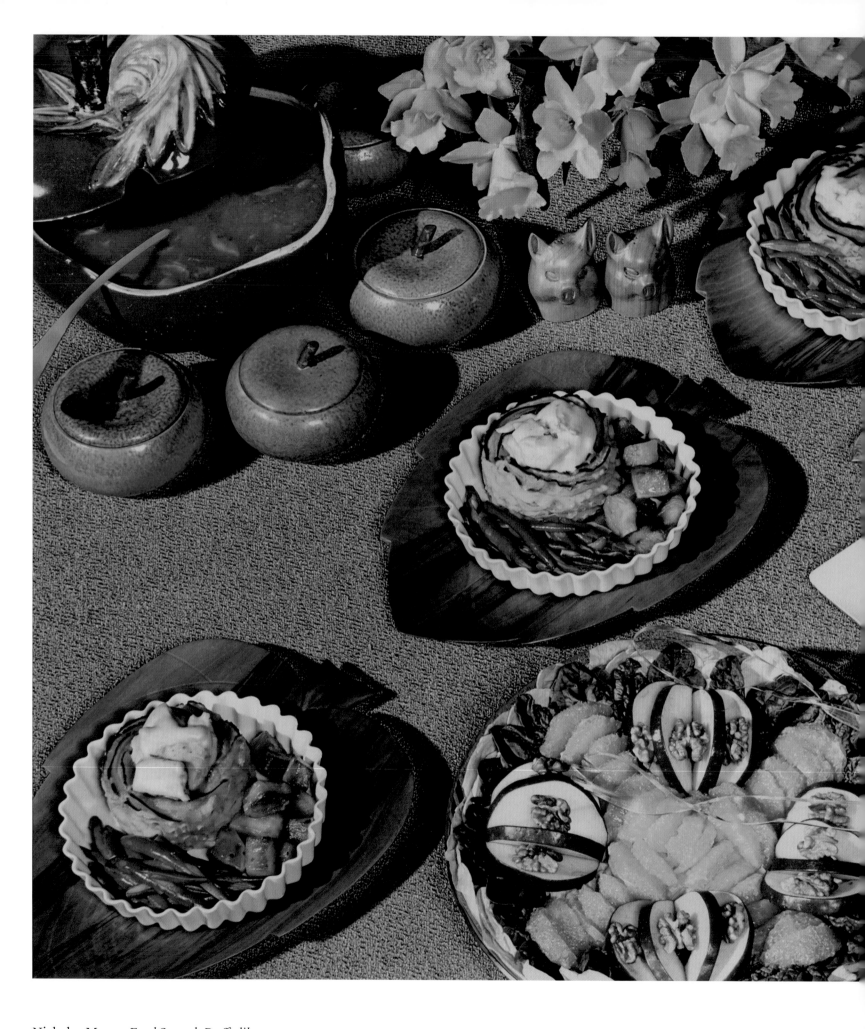

Nickolas Muray, *Food Spread, Daffodils,*
McCall's magazine, ca. 1946

NICKOLAS MURAY

Nickolas Muray's photographs are spectacular: characteristically bright, rich, almost luminous. A master of color photography, he worked for over four decades across fashion, portraiture, and advertising. It was in food photography that he really excelled, and in the late 1930s he was hired by *McCall's* magazine to produce food spreads for their homemaking and cooking pages. Over-the-top, even somewhat vulgar to modern eyes, his food photographs are elaborate tableaux of staged props and food. They represent a land of plenty—a bountiful and idealized America, freed from the food restrictions and hardships of the New Deal.

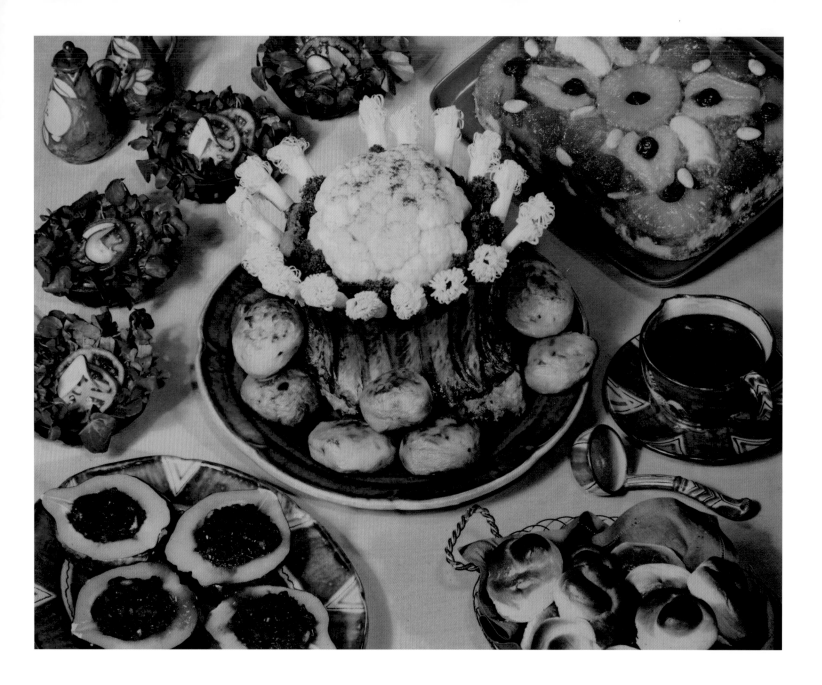

The fantasies of in-house entertaining and idyllic suburban living are symbolized by the tabletops of baked ham and creamed spinach, which revealed a new way of looking at America. They were bold and radical, using color that echoed an explosion in new photographic techniques and new ways of seeing in the interwar period. This was especially so in the commercial sector, with a growth in advertising and public relations companies. In addition, there was the arrival in both Britain and America of émigré photographers fleeing Europe, who brought a more avant-garde aesthetic and new vitality to both art and commercial photography.

Muray was born in Hungary, and he carefully honed his European vision to represent a fantasy of American life, echoing color advancements in Hollywood movies at the time and their version of ideal living. His influence on food photography is undeniable; many contemporary still-life photographers have

Nickolas Muray, *Crown Roast of Lamb and Other Food on Table*, *McCall's* magazine, 1948

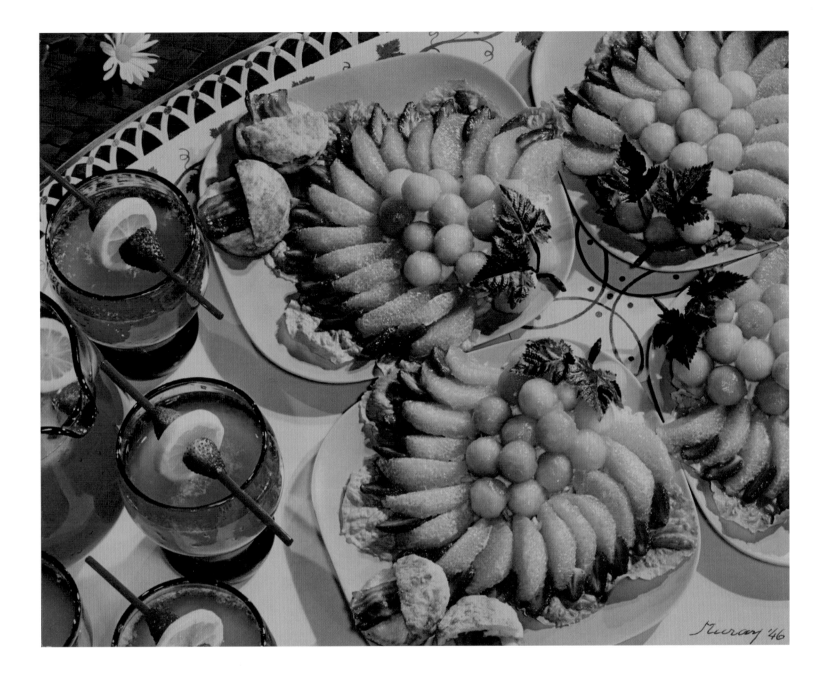

returned to food photography from this period through the 1970s and reworked it with an ironic twist. What is crucial to the images here is not only the photographer, but his collaborative relationship with food stylists. Elaborate food-styling tricks and tips were needed in order to make the food look as it did, maintaining an aura of freshness under hot studio lights.

The food here is piled high and has a somewhat epic quality, whether it's for a picnic or a dinner spread. Glasses of iced tea jostle for room with a ham with orange-and-glacé-cherry topping; a basket of bread sits among flowers, salad, dessert, and condiments. They are artfully laid out with an emphasis on the diagonal, which adds jaunty dynamism to the rectangular magazine page. This is not food to eat, but food to be looked at and dreamed about. These photographs are statements about America's status and taste, as well as the establishment of a national identity for the masses. They suggest generosity, plenty, and wholesomeness.

Nickolas Muray, *Lemonade and Fruit Salad*,
McCall's magazine, ca. 1943

Nickolas Muray, *Food Spread*, *McCall's* magazine, 1941

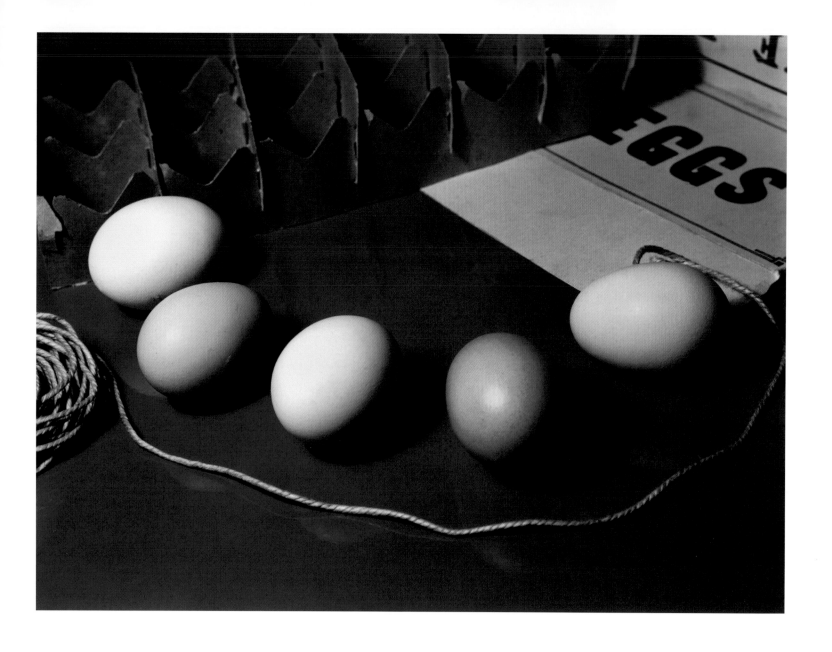

Imogen Cunningham, *Five Eggs*, 1951

IMOGEN CUNNINGHAM

This rare color photograph by Imogen Cunningham has an unusual setup. With the attention on the subtle shades of eggs and the delicate craquelure of their shells, it's easy to overlook the odd construction of the image—with its string, the word *eggs* (if we were in any doubt), and the cardboard box. This was not the only still life Cunningham took of eggs; like Josef Sudek (pp. 124–25), she found it hard to resist their oval shape in various guises. In some respects, the egg has become a cliché in photographic still lifes. It was not carried over as a motif from painting, but due to its delicate, smooth shell and asymmetrical shape, it is a deceptively difficult foodstuff to light, place, and photograph. Therefore its inclusion in still lifes becomes a symbol of the prowess of the photographer, rather than carrying any symbolic message (besides its obvious associations with fertility).

A pioneering modernist, Cunningham was renowned for her ability to capture astonishing detail in simple subjects. There is a sensuous, elegant sweep to the way she approaches her subjects that concentrates on form rather than subject matter. She is often associated with Edward Weston (pp. 70–73) as they shared a similar photographic style, photographing form in exquisite detail. Both were members of the f/64 group in California—a collection of photographers who pioneered a "straight" aesthetic of sharp focus, as opposed to a pictorialist soft focus, which was still popular among many photographers making fine-art prints.

HAROLD EDGERTON

Taken using a stroboscope in 1950s and '60s, these stop-motion photographs have the seeming ability to stop time. The device issued quick bursts of intense light so the camera could capture movement too fast to be seen by the naked eye. Harold "Doc" Edgerton made these photographs while working as a professor of electrical engineering at MIT, and they now sit between science, art, and public wonderment. Crucial in technical developments of photography, they don't feel very scientific, due to the vivid colors and the arbitrariness of the experiments and foodstuffs used; one wonders why he needed to shoot both a banana and an apple to prove his point. The titles also take them out of the realm of science and into something more subjective. The final edited pictures are exuberant and have become iconic in the history of photography, as evidenced by the reworking of the *Milk Drop Coronet* by Vik Muniz (p. 233). The legacy and influence of these photographs cannot be underestimated; variations on them can be seen regularly in advertising, and even in films such as *The Matrix*. These pictures captured food as it had never been photographed before, catching the mood of progress and speed that America was experiencing on a more cultural level. In an atomic age, these photographs represented endless possibilities for the future, as well as a faith in science to make the world a better place.

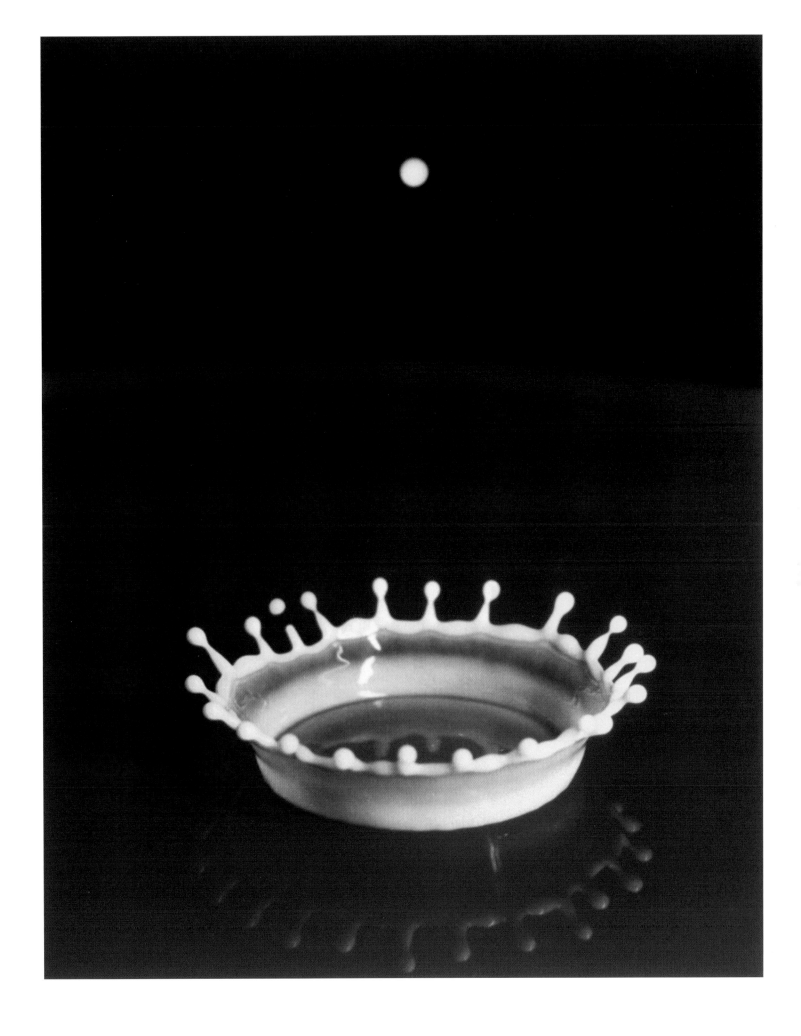

Harold Edgerton, *Milk Drop Coronet*, 1957

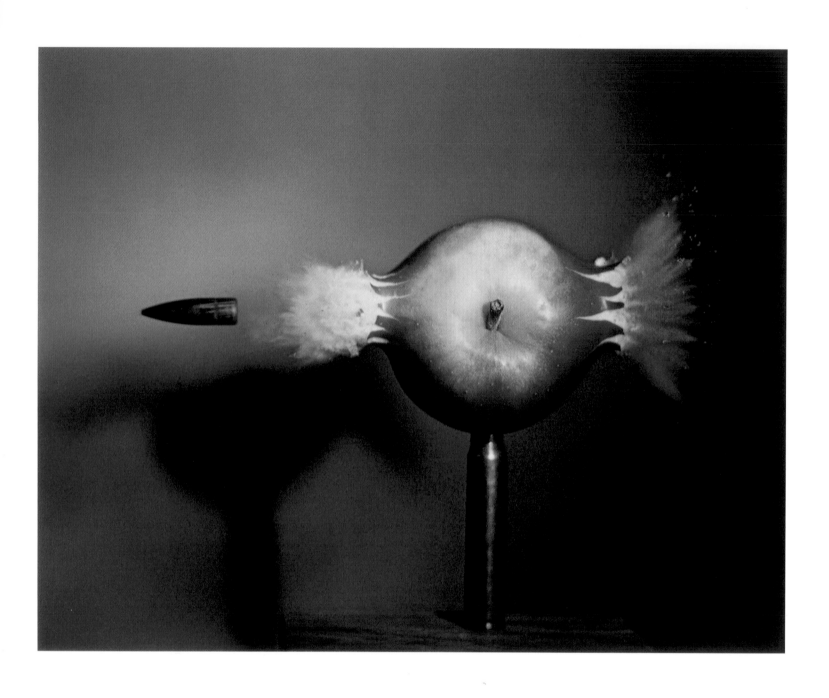

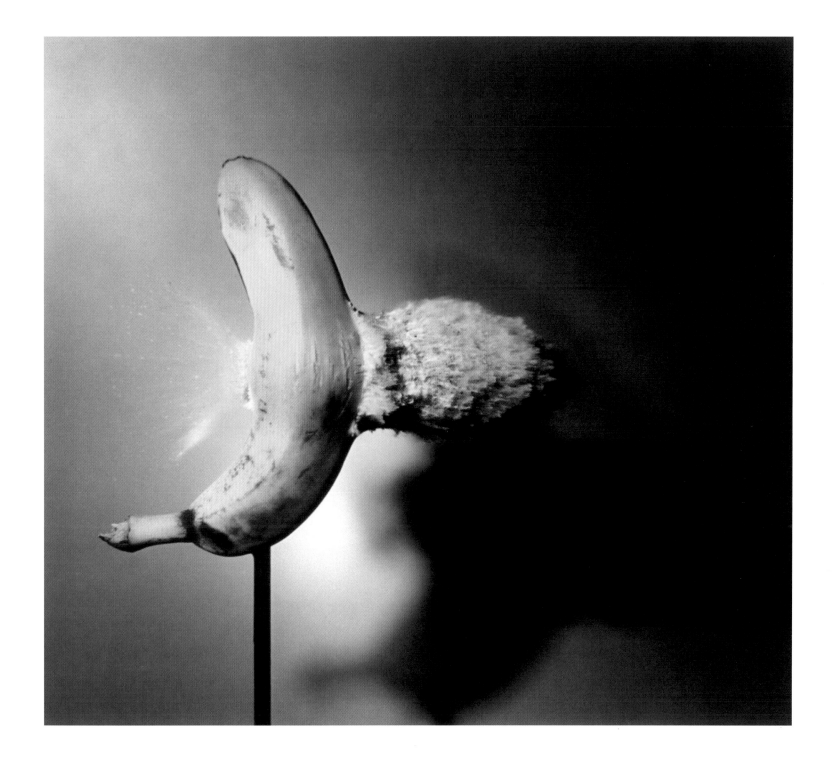

↖ Harold Edgerton, *Bullet Through Apple*, 1964
↑ Harold Edgerton, *Bullet Through Banana*, 1964

THE BOOK OF TASTY AND HEALTHY FOOD

First issued in 1939, *The Book of Tasty and Healthy Food* was produced by the Institute of Nutrition, at the Ministry of Food Industry in the USSR. Pictured here are photographs from the 1955 edition. In a country still struggling with food shortages after the war, this book served many purposes—not all of them successfully. It tried to modernize the image of food in the USSR, moving it away from the land to promote canned goods and processed food. It did this while simultaneously suggesting that the country was a land of abundance and plenty. In this respect, it is not terribly different from *Betty Crocker's Picture Cookbook* (pp. 118–23), published a little later in the US. The propaganda may be more blatant in *The Book of Tasty and Healthy Food*, but the messaging is similar: their respective countries are ones of progress and agricultural bounty, albeit with very different political ideologies and an unrealistic understanding of agricultural realities.

We can see here that the cookbook is a carrier for all kinds of aspirational fantasies, both individual and collective. This book also promised to lighten the load of women in the kitchen, but keep them there—a divisive strategy, and one that is still apparent in many cookbooks today. The photographs offer a fascinating contrast with the American equivalent: the progress and aspirational qualities are not centered on the individual, but on the country—see the collage of cheese and the montaged cans of fish, both reminiscent in intention to socialist realist paintings, which carried similar messages of a collective nationhood that was "joyous," "abundant," and "cultured." The similarities between this and the earlier publication *Food Industry* book (pp. 66–69) are striking.

Whereas in the Betty Crocker book food is piled into the frame, these images are much more pared-down, with the emphasis on a single item of food. They are dramatically and heroically lit, using vivid colors that resemble beauty or product shots rather than food photography. The ears of corn wrapped in green cellophane are particularly striking for their oddity. Another device, also seen earlier in *Food Industry*, is that of montage. Here, canned goods move diagonally up the page in color, while a black-and-white ocean and boats fill the background, suggesting advertising for Soviet canneries and fisheries.

There have been many editions of this book, as it was sold to each of the fifteen Soviet republics. With over eight million copies printed, each edition changed slightly to reflect the political situation of the time, but the mythic qualities of abundance and happy, collective socialist living remain constant throughout.

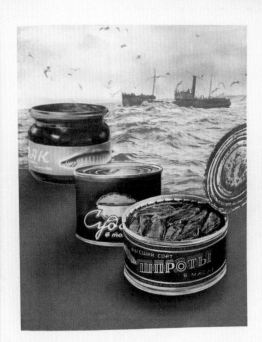

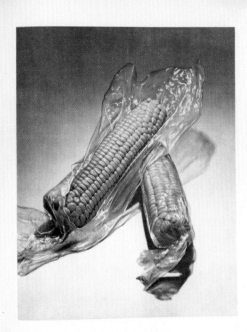

Photographers unknown, pages from *The Book of Tasty and Healthy Food*, 1955

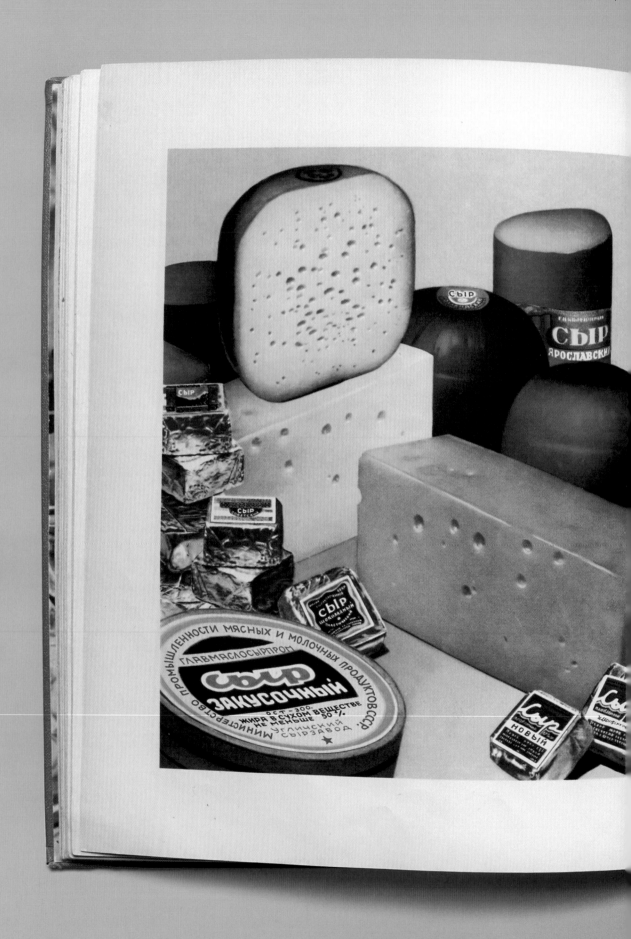

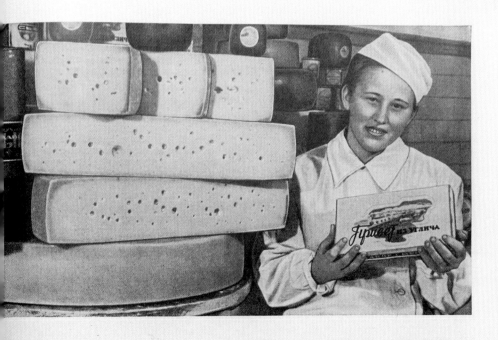

СЫР

Расскажем о сыре, о его замечательных достоинствах и разнообразнейшем ассортименте, о тончайшем его вкусовом и ароматическом букете.

Различных групп, видов, сортов сыра много. Есть крупные круги сыра весом до 100 кг и совсем маленькие сырки в 30—50 г; есть сыр квадратный, прямоугольный, овальный, круглый, цилиндрический, конусообразный, сыр окрашенный и неокрашенный (т. е. сохранивший естественный цвет), обернутый в ткань, в парафиновую бумагу, и вовсе без обертки; с сухой коркой, со слизистой коркой и совсем без корки; сыр с разнообразной яркой плесенью и без плесени; сыр острый, нежный, ароматный; твердый, мягкий и полумягкий; соленый, сладкий, рассольный; терочный, плавленый, деликатесный сыр в керамике и просто деликатесный.

Сыр в среднем содержит до 32% жира, 26% белка, 2,5 — 3,5% органических солей,

витамины А и группы В, а главное, в процессе созревания сыра его белок становится растворимым и поэтому почти полностью (на 98,5%) усваивается организмом. Эта особенность сыра делает его одним из самых лучших, самых полезных и ценных пищевых продуктов. А то, что он один из вкуснейших пищевых продуктов, об этом знают все.

Процесс созревания обусловливает не только растворимость сырного белка, но сообщает также сыру вкусовой букет и рисунок поверхности его разреза («глазки»). Хорошо созревший, в меру выдержанный сыр дает на разрезе «слезу» в «глазках».

Некоторые думают, что сырная «слеза» есть прозрачный жир. Это неверно. «Слезы» в сыре — капельки воды, насыщенные солями молока и поваренной солью — и ничем больше. Выступают они и проникают в «глазки» в результате сложных биохимиче-

10⁵ Книга о вкусной и здоровой пище

73

Photographers unknown, pages from *The Book of Tasty and Healthy Food*, 1955

ЖАРЕНАЯ РЫБА

Рыбу можно жарить с небольшим количеством жира или погруженной в жир. Чтобы рыба равномерно прожаривалась, рыбное филе или же крупную рыбу нарезают на куски не толще 3 см, так как у толстого куска верхний слой может пережариться раньше, чем он весь будет готов. Мелкую рыбу жарят целой. Снимать кожу с жирной рыбы перед обжариванием не следует. Некоторые сорта рыбы вкуснее зажаренными в коже. Жарят рыбу на растительном масле, маргарине и на коровьем масле.

Очищенную, вымытую и нарезанную рыбу за 15—20 минут до обжаривания замочить в молоке, смешанном с солью и перцем (¼ стакана молока, ½ чайной ложки соли), и обвалять в муке или сухарях.

При жарении в жире его наливают в неглубокую кастрюлю или на сковороду в таком количестве, чтобы рыба была погружена в жир на половину. Опустив рыбу в горячий жир, ее обжаривают сначала с одной, а затем с другой стороны. По окончании жарения жир следует процедить и слить в чистую посуду с крышкой.

Лучше всего жарить рыбу на чугунной сковороде, которая прогревается равномерно. Сковороду сильно разогреть, положить масло, а потом уже рыбу. Обжаривать рыбу надо до образования золотистой корочки — сначала одну сторону, затем другую. Если рыба еще не готова, то сковороду, накрыв крышкой, ставят в духовой шкаф на 5—7 минут или на слабый огонь.

РЫБА ЖАРЕНАЯ, С ГАРНИРОМ

Подготовленную рыбу посолить, посыпать перцем, обвалять в муке и обжарить на сковороде с маслом. При подаче на стол полить рыбу маслом и посыпать мелко нарезанной зеленью петрушки или укропом. На гарнир дать жареный картофель, кашу гречневую, ячневую или салат из квашеной (либо красной) капусты, огурцы (свежие, соленые), помидоры.

На 750 г рыбы (или 500 г готового филе) — по 2 ст. ложки масла и муки.

ОСЕТРИНА ЖАРЕНАЯ, С ПОМИДОРАМИ И ЛУКОМ

Подготовленные куски рыбы опустить в молоко, смешанное с солью и перцем, обвалять в муке и поджарить. Отдельно поджарить в масле свежие или консервированные помидоры, разрезанные пополам, подсоленные и посыпанные перцем. Лук, очищенный и нарезанный кольцами, также подрумянить на сковороде в масле.

При подаче на стол уложить рыбу на подогретое блюдо, на середину каждого куска положить кучку жареного лука, а по сторонам — две половинки помидоров. Полить маслом из-под рыбы и посыпать мелко нарезанной зеленью

КАМБАЛА

Камбаловые — морские донные рыбы, относительно мало известные на рынках Советского Союза.

Однако улов камбал будет значительно расти, главным образом, за счет рыбной промышленности Дальнего Востока.

Интересной особенностью камбал является плоское и несимметричное строение тела: одна сторона окрашенная, на ней размещены два глаза, другая сторона бесцветная и слепая. Большинство камбал имеет очень нежное, белое и вкусное мясо.

Некоторых из камбал отличает специфический морской иодистый привкус. Ослабить или вовсе устранить этот привкус, а также специфический запах, издаваемый иными камбалами при жарении, можно путем предварительной разделки рыбы; следует одним движением ножа, начиная от затылочной части, наискось удалить голову и брюшную часть рыбы, затем удалить внутренности, после чего снять кожу с окрашенной (глазной) стороны. После этого рыбу промыть, панировать и жарить.

В наших морях имеется много видов камбал. На Черном море встречается к а л к а н — крупная камбала, достигающая 1 м длины и до 10 кг веса; мясо калкана невысокой жирности (до 3%), белое и вкусное. В водах Баренцова моря и на Дальнем Востоке, в северной части Берингова и Охотского морей встречаются несколько различных видов крупных камбал — п а л т у с о в, отличающихся относительно высоким содержанием жира и хорошим вкусом. Значительную часть уловов камбалы у западного побережья Камчатки составляет так называемая желтобрюхая, или четырехбугорчатая камбала, одна из наиболее вкусных и ценных дальневосточных камбал.

Жареная камбала — очень вкусное, нежное и полезное кушанье.

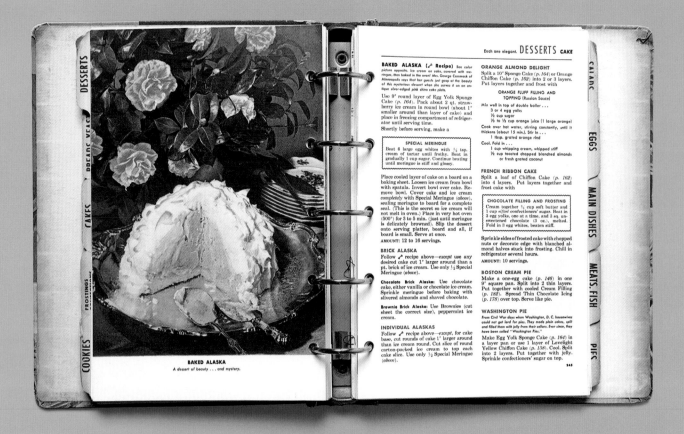

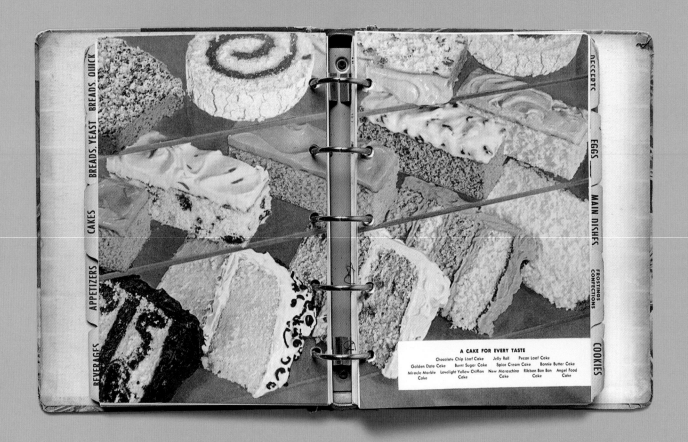

Photographers unknown, pages from *Betty Crocker's Picture Cookbook*, 1954

BETTY CROCKER'S PICTURE COOKBOOK

Betty Crocker herself is famously fictional, but the brand represented a new America after the war—one that was about progress, the American dream, and convenience. Now recognized as an American icon, Betty Crocker offered housewives valuable shortcuts to home entertaining. With food production becoming more industrialized, canned goods and packaged food featured heavily in these early editions of the picture cookbooks, often in bizarre combinations. Although many of the dishes are puzzling to contemporary eyes and tastes, when *Betty Crocker's Picture Cookbook* first appeared in 1950, the recipes and, more important, the photographs offered an exuberance and spirit which opposed the penny-pinching, storing-and-preserving relationship to food of the New Deal and wartime eras.

This cookbook became an essential gift for American brides as they set up house in the ever-expanding suburbs. America was on the up, the country was booming (for some), and the way the food was photographed reflected this. Theatrical and spectacular photographic spreads celebrated abundance by showing a cornucopia of food, again representing the myth of an American utopia and all things modern. Why have one dish when you can have ten? Why just show one cake when a whole stack of them is better—especially with each one frosted in a different color?

Betty Crocker represents the "atomic age" of food photography, and the lavish spreads can be read as a riposte to the perception of regulated, limited food in the Soviet Union. Space-age appliances such as the waffle iron represent modernity and sophistication. Betty Crocker offered opulence and marvel, compared with the perceived dreariness of Eastern Bloc countries. The photographs encased within these famous binders did so in glorious Technicolor, with epic styling: the baked Alaska sits on a silver platter, with blooming camellias offsetting the garish pink ice cream sheathed in meringue.

At the time, many of the products sold by Betty Crocker, such as canned frosting, offered women a way to save time. This was progress, of a kind: it took tasks away from the drudgery of daily cooking for the family. These photographs offered a way forward, suggesting the homemaker could easily reproduce a banquet in her home. Such feasts may never happen, but the pictures offered a chance to dream.

RIBBON LOAF

Cinnamon, sugar, and butter make attractive ribbon effect.

Use ½ White Bread dough (*p. 106*) or ⅓ Rich Egg Bread dough (*p. 108*). After dough rises, roll out into oblong, 15x12".

Brush with melted butter and sprinkle with mixture of . . .

 ½ cup sugar
 2 tsp. cinnamon

Fold over in thirds to make a strip, 15x4". Cut dough into 20 equal parts. Stand on end close together in 2 rows in a greased 8 or 9" square pan.

Cover and let rise in warm place until double (about 1 hr.). Bake until browned. Cover with paper the last 10 min. of baking if loaf browns too quickly.

TEMPERATURE: 425° (hot oven).
TIME: Bake 25 to 30 min.
AMOUNT: 1 loaf.

ROUND SANDWICH LOAF

It looks like a Paul Bunyan Hamburger Bun. Slice and serve. Or make it into a sandwich loaf (see below).

Use ½ White Bread dough (*p. 106*) or ⅓ Rich Egg Bread dough (*p. 108*).

After dough rises, shape into a round, slightly flattened loaf. Place on greased baking sheet or in 9" round pan. Cover, let rise in warm place until double (about 1 hr.). Bake until golden brown. Cool and store until next day before slicing.

TEMPERATURE: 425° (hot oven).
TIME: Bake 25 to 30 min.
AMOUNT: 1 loaf.

All you have to do—

To make a sandwich loaf: slice round loaf crosswise into thirds. Butter each layer, spread with Ham Filling (*p. 105*) on one and Egg Filling (*p. 105*) on the other. Wrap loaf in damp cloth, refrigerate overnight. Let come to room temperature before serving. Or brush with butter and reheat in mod. oven (350°) about 10 min. Serve in wedge-shaped pieces.

112

OATMEAL MOLASSES BREAD

Moist, delicious, and crusty! Made without kneading.

Stir together in mixing bowl . . .

 1½ cups boiling water
 1 cup rolled oats
 ⅓ cup shortening
 ½ cup light molasses
 1 tbsp. salt

Cool to lukewarm.
Combine, stirring to dissolve . . .

 2 pkg. active dry yeast
 ½ cup warm water (not hot—110 to 115°)

Stir into lukewarm oatmeal mixture. Mix well.
Add . . .

 2 eggs
 5½ cups sifted GOLD MEDAL Flour

Mix thoroughly. Cover; let stand 15 min. Place dough in 2 greased 9x5x3" loaf pans and pat into a loaf shape. Let rise in warm place (85°) until double (1½ hr.). Bake until brown.

TEMPERATURE: 350° (mod. oven).
TIME: Bake 1 hr.
AMOUNT: 2 loaves.

COTTAGE BREAD (Baked in a Casserole)

Old-time favorite. Deliciously moist. Somewhat coarser than many of the modern breads.

Measure into mixing bowl . . .

 2¾ cups warm water (not hot—110 to 115°)

Add, stirring to dissolve . . .

 2 pkg. active dry yeast

Stir in . . .

 3 tbsp. sugar
 1 tbsp. salt
 2 tbsp. soft shortening
 half of 6½ cups sifted GOLD MEDAL Flour

Beat 2 min. until smooth. Mix in rest of flour thoroughly. Cover, let rise in warm place (85°) until double (30 min.). Beat batter down for ½ min. Pour half into greased 9x5x3" loaf pan, half into 1½-qt. baking dish. Let rise (20 to 30 min.). Brush with melted shortening. Bake until brown.

TEMPERATURE: 375° (quick mod. oven).
TIME: Bake 40 to 50 min.
AMOUNT: 2 loaves.

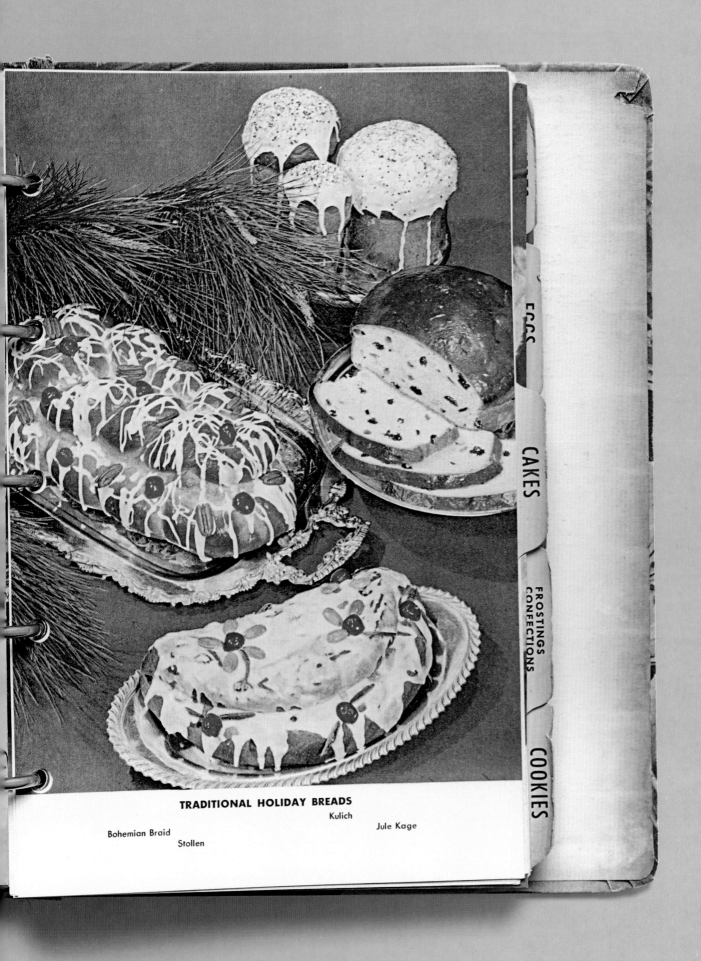

TRADITIONAL HOLIDAY BREADS

Kulich

Bohemian Braid

Jule Kage

Stollen

ECCS

CAKES

FROSTINGS
CONFECTIONS

COOKIES

Photographer unknown, pages
from *Betty Crocker's Picture Cookbook*, 1954

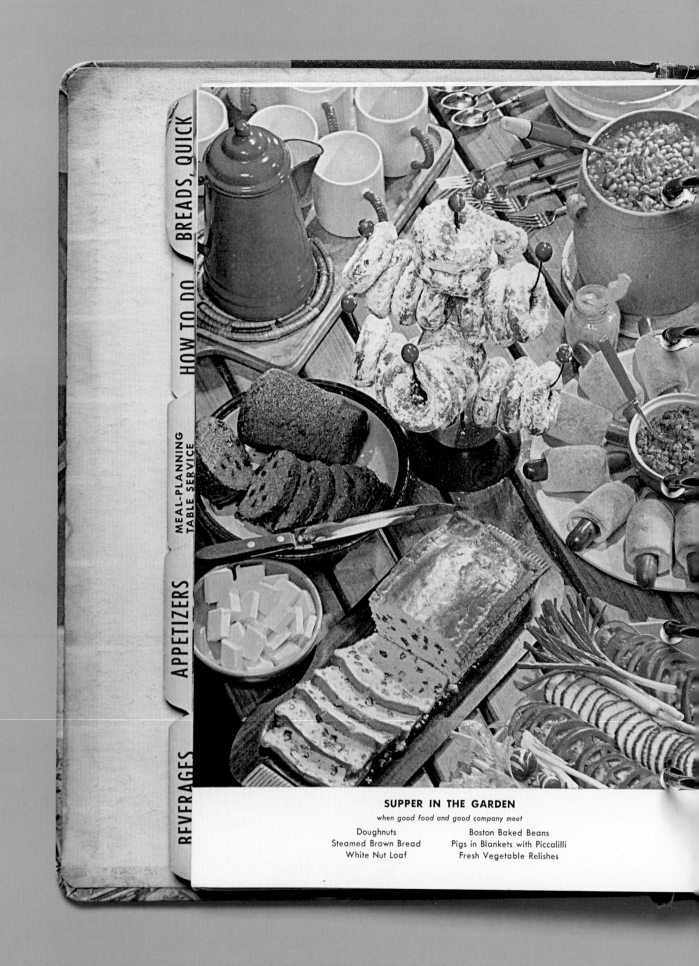

BREADS, QUICK

HOW TO DO

MEAL-PLANNING
TABLE SERVICE

APPETIZERS

BEVERAGES

SUPPER IN THE GARDEN

when good food and good company meet

Doughnuts	Boston Baked Beans
Steamed Brown Bread	Pigs in Blankets with Piccalilli
White Nut Loaf	Fresh Vegetable Relishes

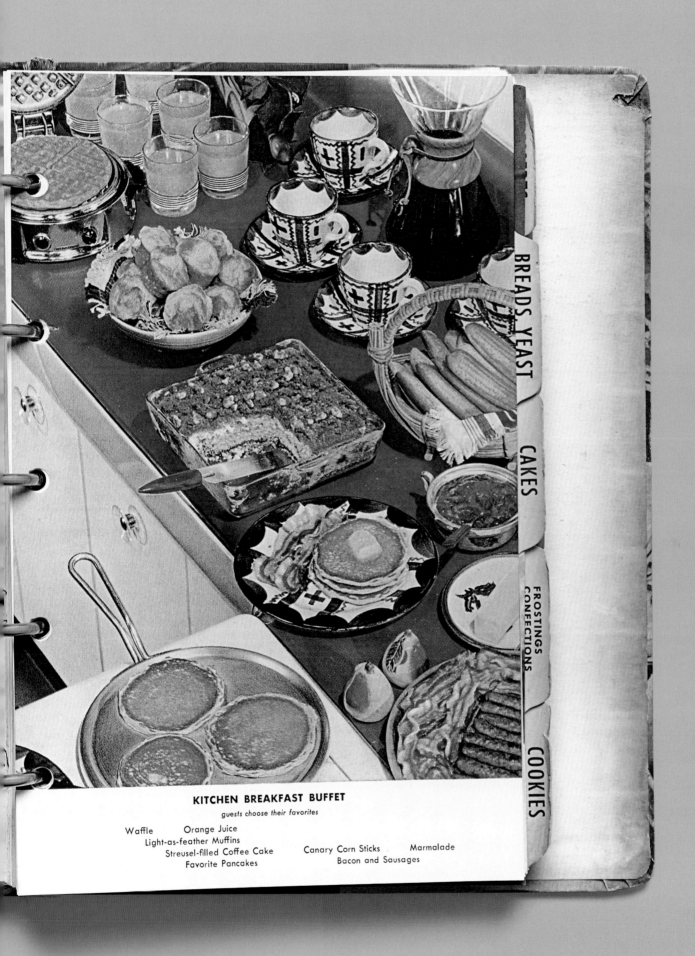

KITCHEN BREAKFAST BUFFET

guests choose their favorites

Waffle Orange Juice
Light-as-feather Muffins
Streusel-filled Coffee Cake Canary Corn Sticks Marmalade
Favorite Pancakes Bacon and Sausages

BREADS YEAST

CAKES

FROSTINGS CONFECTIONS

COOKIES

Photographers unknown, pages
from *Betty Crocker's Picture Cookbook*, 1954

JOSEF SUDEK

There is pleasure in the humdrum and the unremarkable, and Josef Sudek captured this beautifully. Working in Prague, Sudek excelled in the fundamentals of black-and-white photography: capturing light and time, both of which he did with an intimate grace. The way he photographed food offers a gentle example of the major aesthetic concerns of photography in the twentieth century. The way the egg and bread are fractured behind the ridges of the glass has modernist sensibilities. Such a simple gesture suggests the more experimental possibilities of photography at this time, and an ability to photograph food in a way that is not committed to how it appears in nature. The oval of the egg and the texture of the bread contrast energetically with the grain of the wood, turning the picture into one concerned with form and composition, rather than a desire to capture reality. Sudek, with his eloquent gaze, proved it was possible to photograph food with tenderness.

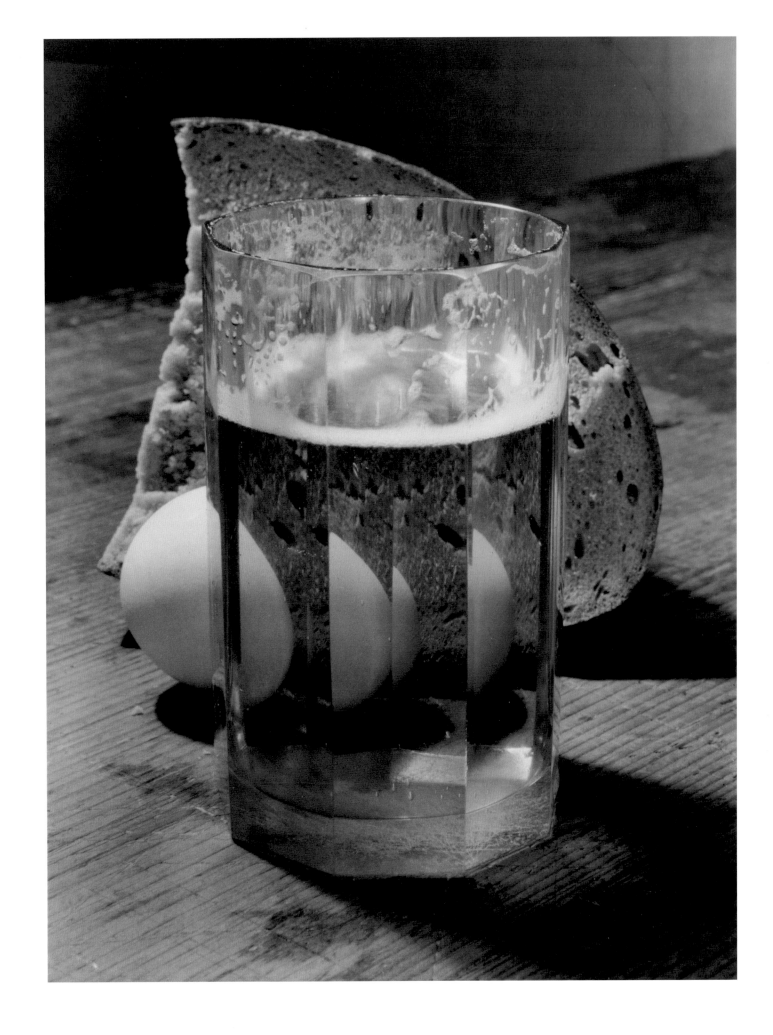

Josef Sudek, *Bread, Egg and Glass*, 1950–54

In the US during the early 1960s, as the civil rights movement gained traction, mealtimes became the site of peaceful protest and an important marker for change. Young black Americans, many of them college students, began to embark on sit-ins at segregated lunch counters across the South that were reserved for white people. Food—or, more accurately, places to eat—became a lens through which to view wider issues that were dividing the country. Here, two African American students from Saint Augustine College in Raleigh, North Carolina, study at a whites-only lunch counter, while two white waitresses watch and refuse to serve them from the other side of the counter. The layer cake sitting in the foreground of the picture becomes a very physical and metaphorical barrier between the young men and the women—between black and white.

Photographer unknown,
February 10, 1960

LUNCH COUNTER SIT-INS

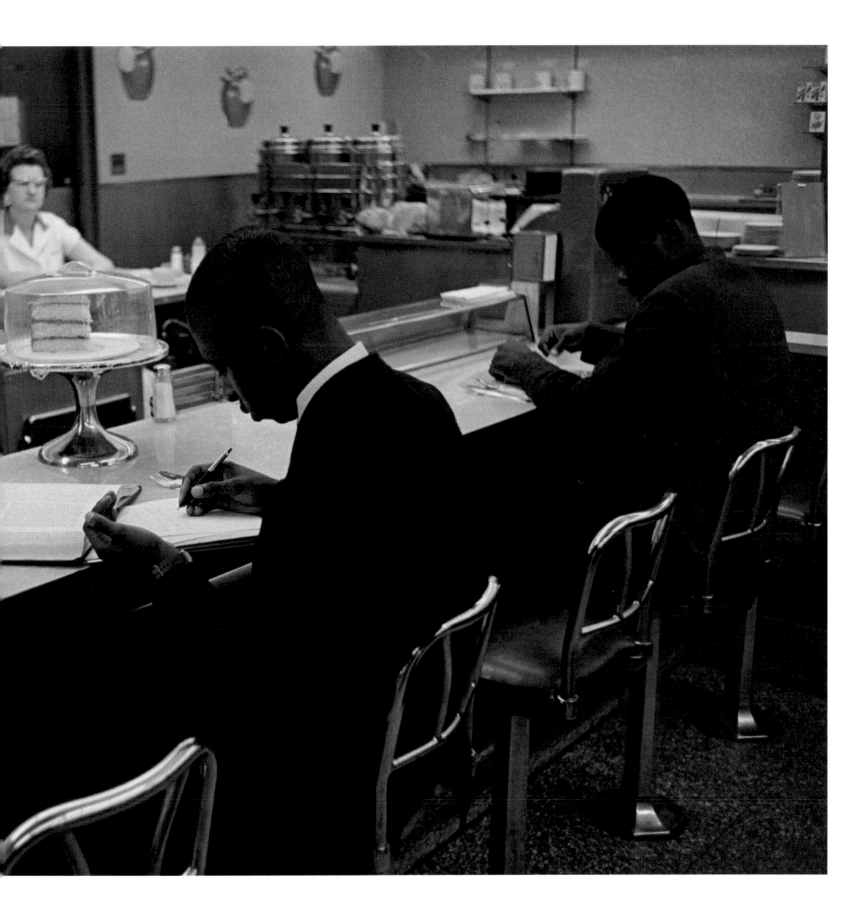

Ed Ruscha, *Sun Maid*, 1961

ED RUSCHA

These images are from Ed Ruscha's series Product Still Lifes (1961), which includes various household products shot from the front against a white background. The shadow cast by each object gives it depth. The products Ruscha chose to photograph were ones that had a huge impact on postwar America, and it is telling that the only foods represented in this series were Spam and Sun Maid Raisins. Both exemplify a country hungry for speed, efficiency, and convenience—not to mention snacks.

Ruscha's photographs are another example of how this new sensibility was imaged, and must be understood in tandem with the photographs found in popular culture, cookbooks, and advertising of the period. The Sun Maid logo represents a bountiful harvest and American myths of agricultural utopia. Spam—canned, gelatinous sandwich meat with added sodium nitrate—contrasts with the apparent naturalness of the raisins, illustrating a country moving forward while also relishing its mythical past. This series has a Pop sensibility that chimes with Andy Warhol's contemporaneous paintings of Campbell Soup cans, and both illustrate fine art's first embrace of commercial foodstuffs. They also show a lack of concern for the apparent hierarchies of commercial culture and art. Also, like Warhol's, Ruscha's series embraces seriality and repetition, something that he continued to explore with expanded rigor. In this regard, Product Still Lifes has one foot in Pop art but is also an important marker in the emergence of the Conceptual art of this time.

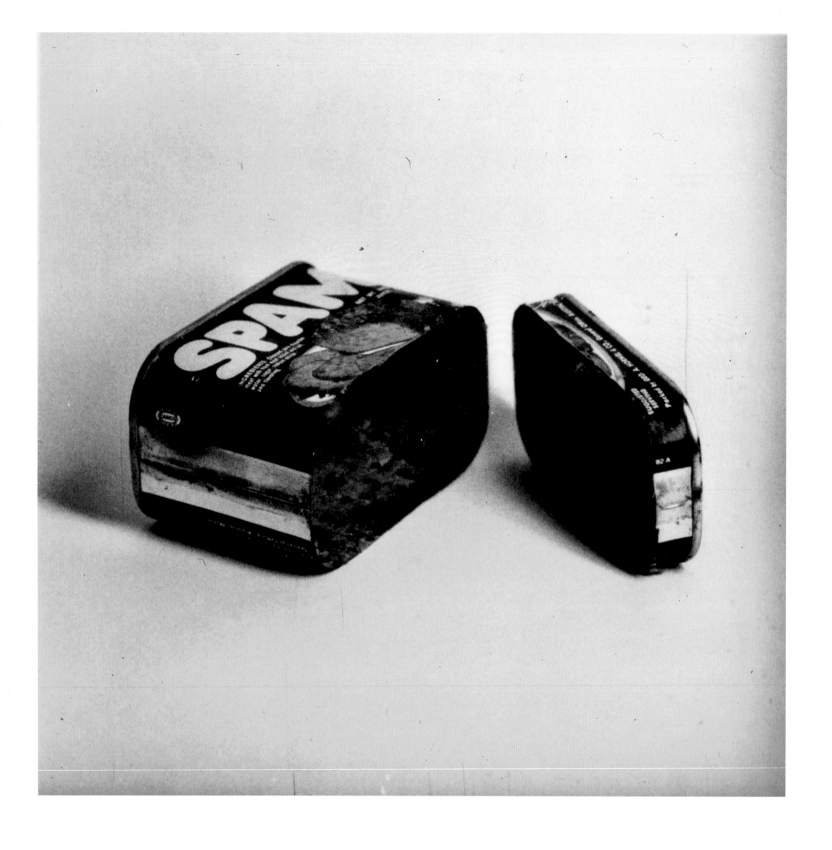

↑ Ed Ruscha, *Spam (Cut in Two)*, 1961
↗ Ed Ruscha, *Spam*, 1961

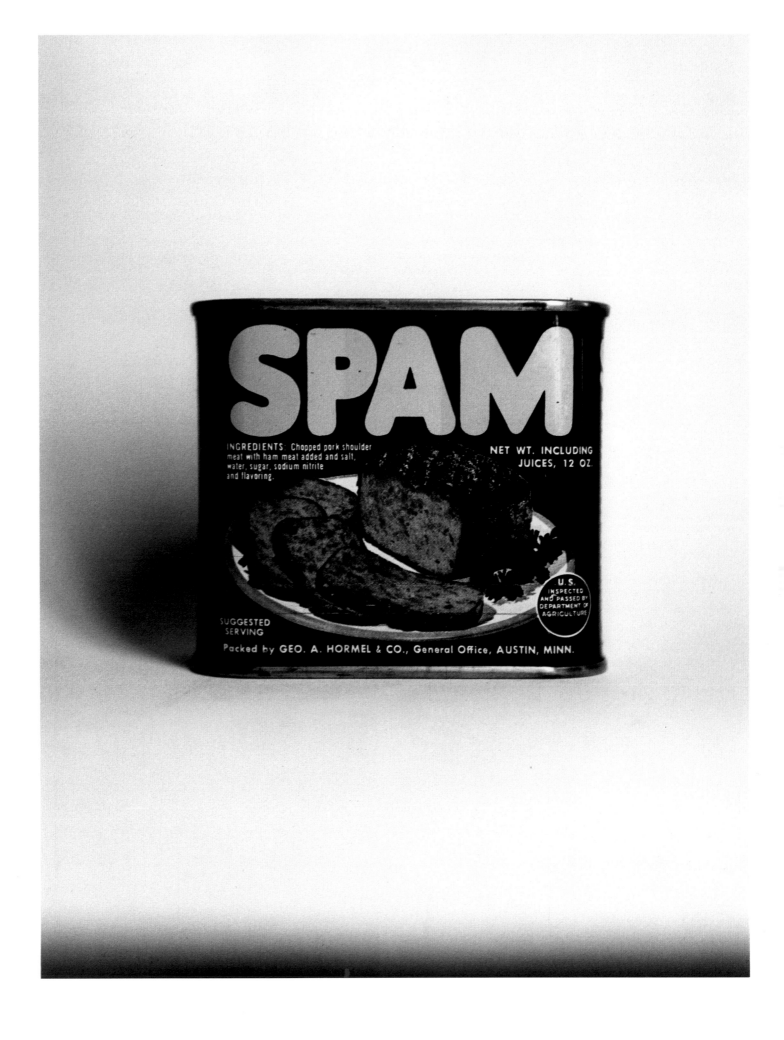

MEAT JOY

In contrast to much of Conceptual art's concerns with systems and structure, feminist art of the 1960s and 1970s often turned to performance, and in particular the female body as a site for radical exploration. Carolee Schneemann's *Meat Joy NYC* (1964) was just one of many groundbreaking performances, reflecting a time of female emancipation in the art world and the culture at large. Food was often used as a motif because of its implicit relationship to patriarchal views on homemaking. Schneemann takes food out of the domestic realm and uses it in a frenzied, fluid, and sexual performance that—as the artist herself has said—"has the character of an erotic rite: excessive, indulgent, a celebration of flesh as material."

This is a celebration of not only human flesh, but also that of animals—in this case, fish, chicken, and pig-sausage, which were rubbed over near-naked bodies in a bacchanalian performance. The effect was an ecstatic wildness that shifted between the comic, repulsive, sexual, sensual, joyful, and repellent. Despite the appearance of abandonment, the piece was quite carefully choreographed. Such behavior is far removed from the implicit family values and controlled food spreads laid down by cookbooks such as Betty Crocker's, which kept women firmly in the kitchen. Instead, what is witnessed here is both women and men in ecstatic ritual with food. The performance was more than visual; food smells, of course, especially when raw, so the audience became included in the experience, and the performance became a collective one.

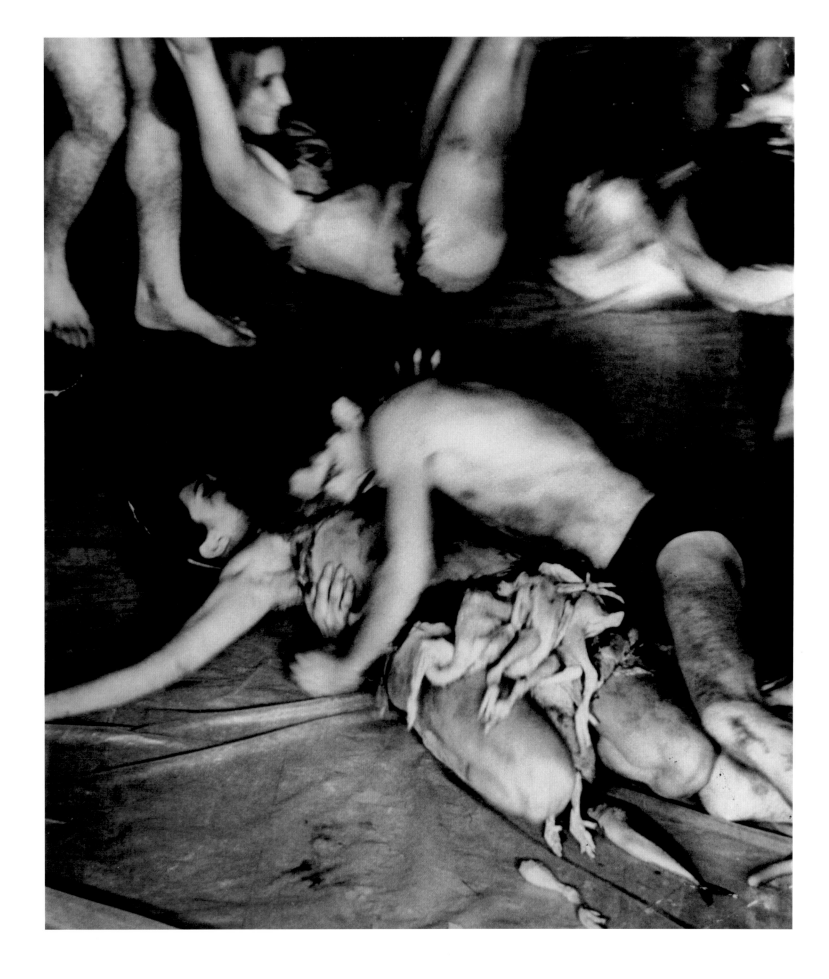

Al Giese, film still of Carolee Schneemann's *Meat Joy NYC*, 1964

Eliot Porter, *Frostbitten Apples, Tesuque,*
New Mexico, 1966

134

ELIOT PORTER

An early proponent of color photography in fine art, Eliot Porter took ineffably beautiful photographs of nature, demonstrating that not all artists using photography at this time were concerned with deconstructing the medium or fighting its modernist legacy. Like Paul Strand (pp. 54–55), Porter got his initial encouragement and desire to pursue a photography career from meeting Alfred Stieglitz, who was the first to exhibit his work. What makes Porter stand out from both his peers and his mentor was his switch to color. Landscape was still prominently photographed in black and white at the time, especially if it was to be considered art. Snobbery about color photography belonging to the commercial world and black and white to serious art photography was still surprisingly ingrained.

Verging on the abstract, the laden tree of frostbitten apples from 1966 would fail as an image if it were not in color. Its success lies in the pop of the orange and the brown of the autumnal leaves that cover the ground. Filling the frame, it is characteristic of Porter's work, which delights in the natural rhythms and synchronicity that nature offers. This, of course, includes food. Food as it appeared in nature became rarer in photography at this time, as concerns became more conceptual and the cultural landscape more political. Like many landscape photographers, Porter would go from being a passive observer of nature to an active voice in land conservation and politics.

COOKING WITH SOUL

These photographs appear in a book titled *Cooking with Soul*, edited by Ethel Brown Hearon, who was chair of the home economics department at Rufus King High School in Wisconsin—a large public school with predominantly African American students. Published in 1968, it is a small, spiral-bound book compiled by the students in Brown Hearon's Family Living class. The purpose of the book was to share the cuisine generally enjoyed by the African American community with a wider audience, and to undermine the idea that soul food was unhealthy. The school's teachers, students, and parents all donated recipes, and, as the introduction states, "The people represented here feel they have something to offer and take pride in sharing it with others." In keeping with its educational context and mission, the book also contains nutritional information, and each chapter includes a short history.

The photographs, taken by Jack Hamilton of the daily paper the *Milwaukee Journal*, show the students in their home economics classroom preparing the dishes and—unusual for the time—feature young men cooking as well as women. The images are unpretentious and create a more personal, local connection to the food. The captions all name the students, a detail which usually slipped out of more commercial publications. In ethos, imaging, and intention, this book contrasts with the stereotype of the black cook that was peddled through the Aunt Jemima brand and its associated cookbooklets (pp. 90–91). Instead, what is presented here is a genuine connection between food and African American identity and community.

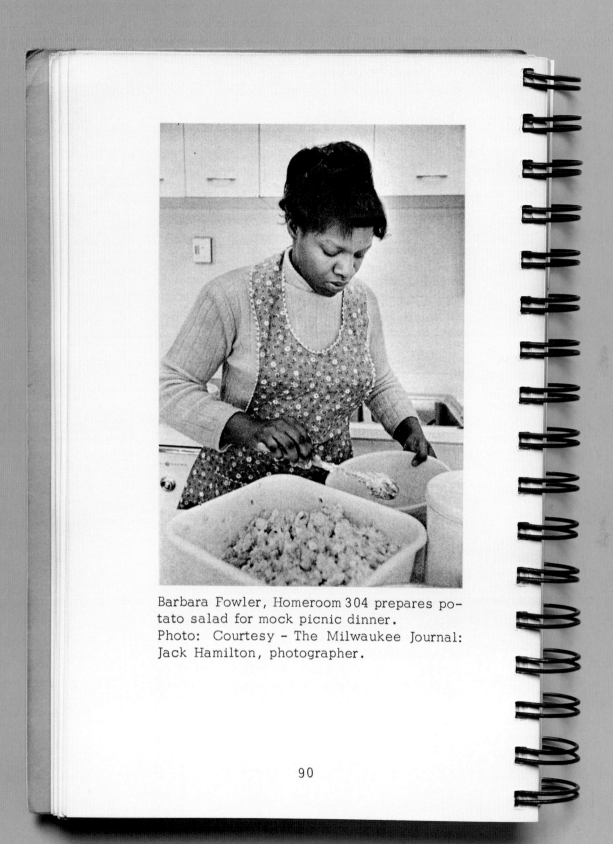

Barbara Fowler, Homeroom 304 prepares po-
tato salad for mock picnic dinner.
Photo: Courtesy - The Milwaukee Journal:
Jack Hamilton, photographer.

90

137 Jack Hamilton, page from *Cooking with Soul*, 1968

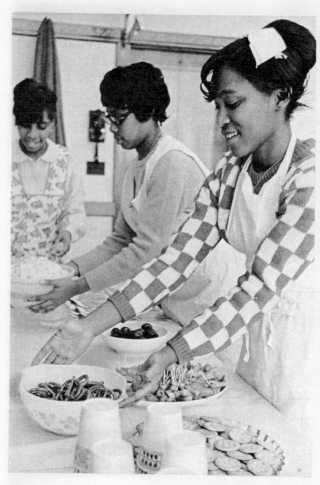

Diane Hill, Homeroom 308; Rose Marie
Parker, Homeroom 228; and LaDonna Banks
of Homeroom 103 are arranging foods on the
table for a mock picnic dinner.
Photo: Courtesy of The Milwaukee Journal
Jack Hamilton, photographer.

177

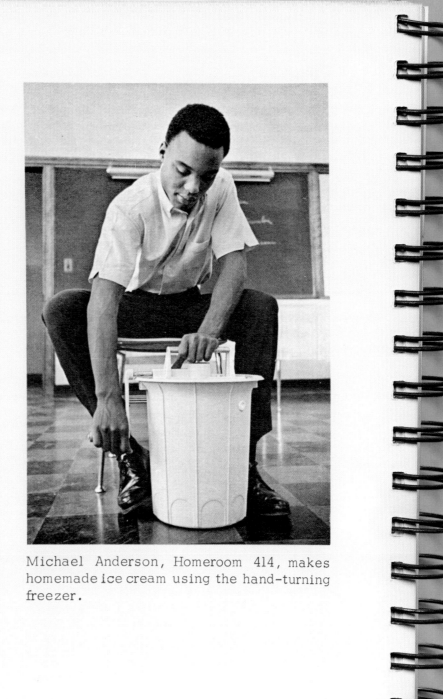

Michael Anderson, Homeroom 414, makes homemade ice cream using the hand-turning freezer.

163

139 Jack Hamilton, pages from *Cooking with Soul*, 1968

TIME-LIFE FOODS OF THE WORLD

Foods of the World was a series of twenty-seven cookbooks that was published from 1968 to 1978 by Time-Life, the book-marketing division of the popular *Time* and *Life* magazines. Following in the wake of the *Time-Life Picture Cook Book* (1958), these books attempted to expand on that success and offer a broad survey of the world's cuisines, cultures, and cooking techniques. They were all available by mail order, and each volume consisted of two books: the hardcover picture book and a smaller, spiral-bound recipe book—presumably one for the coffee table and another for the kitchen.

These books were published during the advent of increased commercial jet travel and access to different countries, a phenomenon that was reflected in fashion photography and television programs of the time. The covers were immediately recognizable by nationality, relying on the same kinds of pictorial codes and signifiers of cultural myth and national identity that Roland Barthes discusses in his 1964 essay "Rhetoric of the Image," about reading "Italianness" in a pasta advertisement: there's glassblower's herring for Scandinavia, a gingerbread house for Germany, and exotic coconut and skewered chicken for the Pacific and Southeast Asia.

It is easy to read these books as culinary colonialism; in them, American writers such as Julia Child and James Beard attempted to make sense of other countries' food and cultures without inviting people from those countries to contribute. But on the other hand, the books also introduced readers in a somewhat isolated country to cuisines they might never have experienced in an accessible way. Inside were documentary pictures that aimed to show the cultures of different regions, as well as recipes and dining situations.

Similar to *National Geographic* magazine, the Foods of the World books can be seen as travelogues, albeit narrated through food. As travel and tourism expanded, these books whetted the American appetite for something different and exotic. Definitely a product of their time, the books are flawed and clichéd, full of sweeping generalizations—but as photographic documents, they are valuable keys to the cultural attitudes, including Americans' expanding desire to see the world.

Fred Eng, cover of *Pacific and Southeast Asian Cooking*,

Time-Life Foods of the World, 1970

Richard Meek, cover of *The Cooking of the Caribbean Islands*,
Time-Life Foods of the World, 1970

Richard Meek, cover of *The Cooking of Scandinavia*,
Time-Life Foods of the World, 1968

ROBERT CUMMING

Robert Cumming's visual deceptions are so enjoyable, and employ such subtle sleight of hand, that they are almost believable. His settings are familiar, and unlike in other Conceptual work from this period, Cumming's pictures feel as if he actually likes the medium of photography; he does not bring in different materials or modes of deconstruction through assemblage or collage, but instead relies on the language of the gelatin-silver print and skillful composition to subvert photography's history and associations with reality. He understands the photogenic qualities of a watermelon, and who's to say it isn't improved by the addition of a slice of bread? Without the addition of the bread, this tabletop setting would be a classic still life, operating successfully in a different context and history.

Like Sian Bonnell (pp. 254–57), Cumming betrays a tenderness in his relationship with food, and his interventions are gentle and surreal, with a love of the domestic. This is the art of the double take, reliant on titles and scrutiny for success. This kind of process-oriented sculpture uses food to investigate visual perception, hierarchy of mediums, and visual puns, providing an oblique analysis of the physical world. Other artists working during this period, such as Fischli and Weiss (pp. 182–85) or Marion Faller and Hollis Frampton (pp. 158–59), use more obvious slapstick humor in their similar Conceptual investigations. Cumming's visual hijinks foresaw the moment we are experiencing now, in which building nonsensical, sculptural still lifes of food and photographing them with humor and irony is almost becoming a visual cliché across both art and commercial photography.

Robert Cumming, *Watermelon/Bread*, 1970

 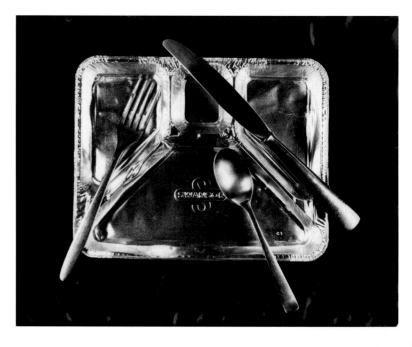

ROBERT HEINECKEN

Like others such as Ed Ruscha (pp. 128–31), Robert Heinecken challenged the hierarchies of high and low culture and enjoyed an engagement with consumer goods, as seen here with his TV dinners. The American desire for progress and speed were taken to their logical conclusion with this invention: ready-made to go in the oven, the whole meal can be consumed immediately in the comfort of your living room, with only the TV for company. There is no glory in this, and Heinecken presents before, during, and after shots. Here, he is both a consumer and a critic of commodity culture; under Heinecken's lens, the aspirations of the American dream have gone bad in these sad trays. He photographs the TV dinners from above against a black background, and adds tiny moments of humor by setting out the cutlery as if he were about to embark on a proper, home-cooked dinner.

Robert Heinecken, T*V Dinner: Shrimp*
#1–#6, 1971

STEPHEN SHORE

Stephen Shore took his famous picture of breakfast (p. 150) on a road trip across America in the early 1970s, as part of his series Uncommon Places. The photography writer Andy Grundberg claims in the book *Yours in Food, John Baldessari* (2004) that he can't recall ever seeing a better photograph of food. Its strength is in its simplicity: its representation of what Shore really did eat for breakfast that morning when he walked into the Trail's Inn Restaurant in Utah, far from his home in New York. Despite the documentary, snapshot approach, it is carefully composed, resembling a still life of classic Americana.

Capturing the overlooked, Shore's photograph revels in the everyday. Shot on the diagonal, there are little reminders of earlier photographs by Nickolas Muray: the paper placemats with cowboy-and-Indian scenes, the two beverages, and the condiments making the table a little too busy. There is no doubt this picture was taken in the US: the fat pancakes dripping with butter and syrup and the fake wooden table hold the romance and promise of a country to be explored—an optimistic embracing of the day. There's even an *American Essays* book on the table in the right corner. Shore's photographs of food, like those by Ruscha and Heinecken, no longer reference the aspirational quality of commercial food photography. By presenting his meals in situ, they are more aligned with how food actually looks. His matter-of-fact recording of them taps into a larger idea of America itself, particularly its fast-food, motel, and diner culture. Shore represents an America on the move, through food that you'll experience once you get out of your car.

These pictures capture the romance and fantasy of the road trip, revealing Shore's capacity to present food as both literal and symbolic at the same time. Fast food such as McDonald's burgers and fries are featured (p. 151), but they look far from perfect: a half-eaten burger sits on a scratched-up tabletop. Once again, food represents the ideas of a culture or nation, but in a completely different way than it does in Time-Life's heavy-handed Foods of the World series (pp. 140–43).

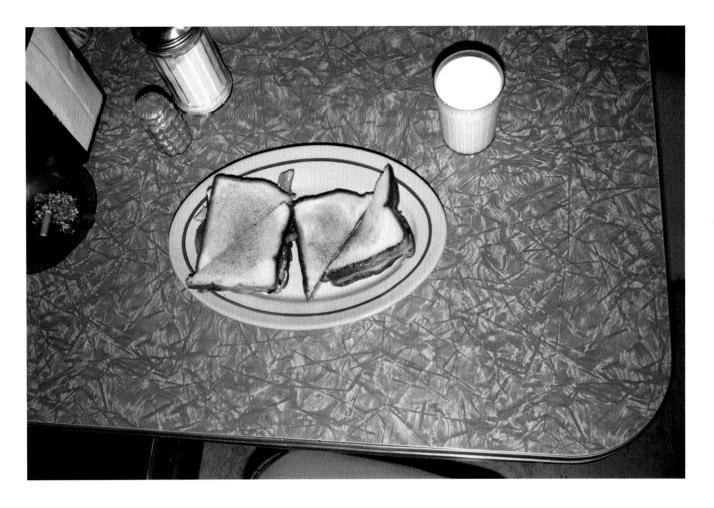

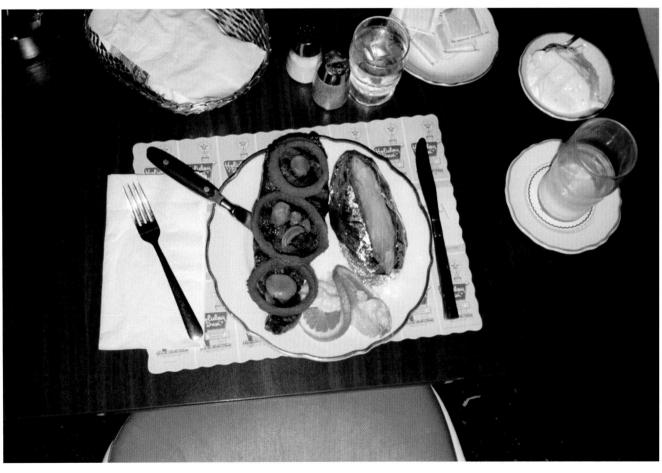

Stephen Shore, *Granite, Oklahoma, July 1972,*
and *Clovis, New Mexico, 1974*

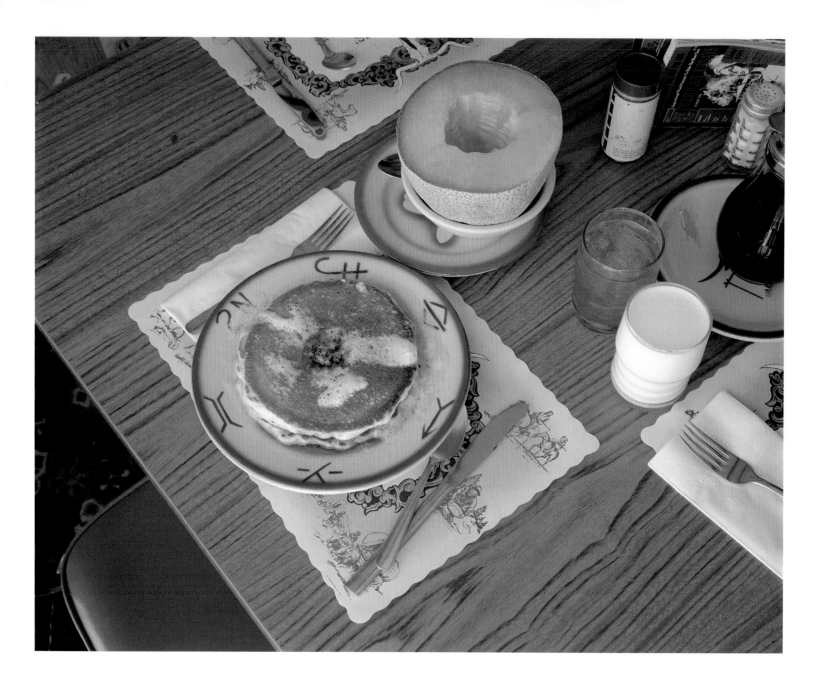

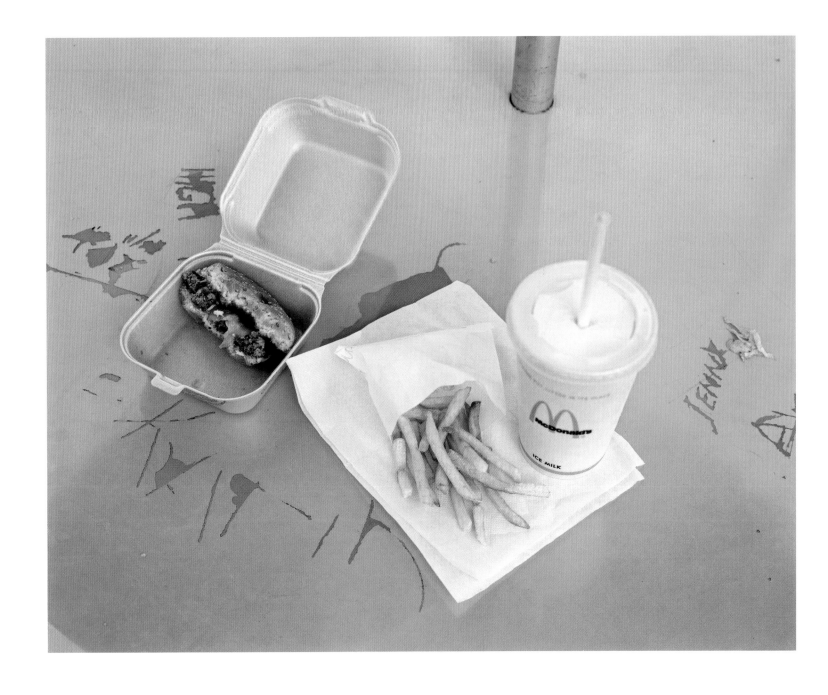

↖ Stephen Shore, *Trail's End Restaurant,*
Kanab, Utah, August 10, 1973
↑ Stephen Shore, *Perrine, Florida,*
November 11, 1977

BE BOLD WITH BANANAS

"Among the extraordinary features of this book are the beautiful, full-page, color photographs of many of the delectable recipes," boasts the back page of *Be Bold with Bananas*, published for the Banana Control Board in South Africa in 1970. Recipes include "Potato and Banana Nests" and "Banana and Egg Salad." Perhaps the most curious, and certainly the most phallic, is the upright banana that simply has mayonnaise dripping down its sides and a glacé cherry on top. In fact, the photographs are anything but beautiful, and on the whole verge on the surreal and unappetizing. However, photographing mashed banana is a challenge, and to make it look delicious is a test for any photographer.

To contemporary eyes, it's hard to know if this book was made in seriousness. However, like *The Relaxed Hostess* (pp. 222–23), one must remember that, during the apartheid regime, South Africans were subject to harsh censorship and international sanctions that often made international communication very difficult. What this meant was that mainstream photography and styling often lagged behind that in Europe and the United States. Recently, this book has enjoyed attention online; Martin Parr even reissued it, adding his own image to the front and a small print inside.

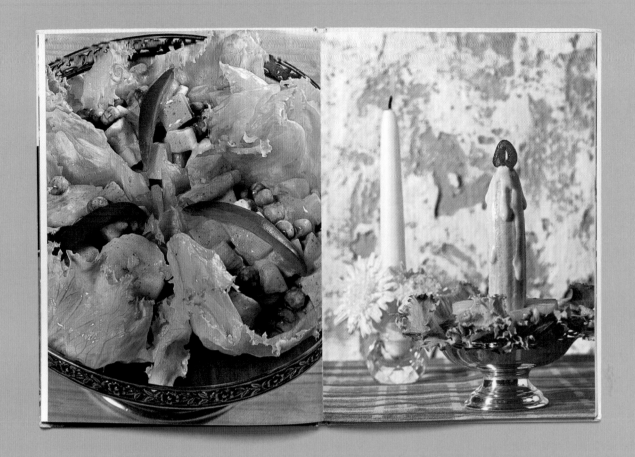

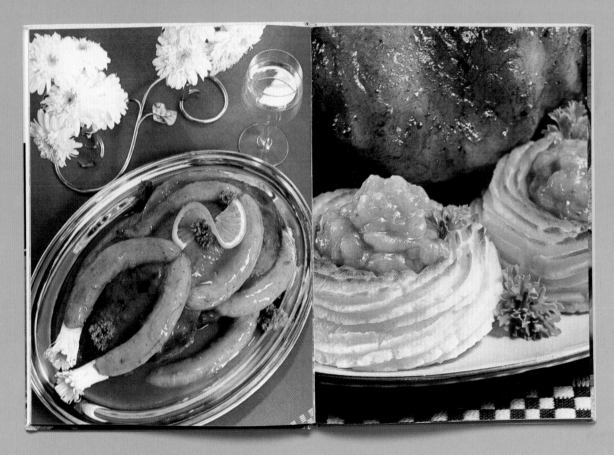

Photographer unknown, pages from
Be Bold with Bananas, 1970

WEIGHT WATCHERS RECIPE CARDS

If it is possible to look past the sheer disgustingness of many of these recipe cards, one will find food styling and props that are as mysterious as the food. Multicolored candles surround the "Inspiration Soup" (p. 157) suggesting a night of hippie relaxing, and ironwork crowds the sumptuous celery log on a bed of curly lettuce (p. 156) Garnishes also play a special role. As objects, the cards are rather confusing; not only are the dishes not really good for you, but the recipes don't contain any nutritional information. In many respects, these cards sum up the very worst (or best) of 1970s food and an increasing desire to control what one ate as a way to control one's body.

Much of this food is round, forced into unnatural shapes by gelatin, and the photographers' desire to fill the frame is executed here to the fullest. These compositions look simple to create, but in reality required a high level of skill and were quite amazingly arranged. They were shot from the perfect angle—not quite overhead—and use exquisite color-blocking and matching. The chicken Kiev sits among a harmonious blend of purple, orange, and green. Even the ornamental ducks seem pleased with it. Under less-skilled photographers, these cards could have resulted in a jumble of clashing tones, rather than their careful juxtapositions of contrasts. Like *Be Bold with Bananas* (pp. 152-53), it is hard to see that these cards were ever taken seriously—but one must remember that Weight Watchers, then a relatively new organization, was rapidly expanding into a successful business following its humble beginnings in 1963, offering women vital support and company in a life that was very much centered around the preparation and eating of food.

GRASSHOPPER

Weight Watchers® Recipe Cards

DESSERT SAUCES

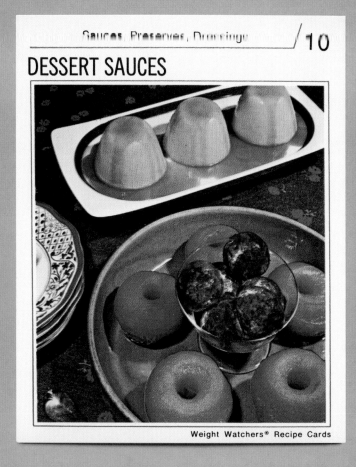

Weight Watchers® Recipe Cards

CHICKEN KIEV

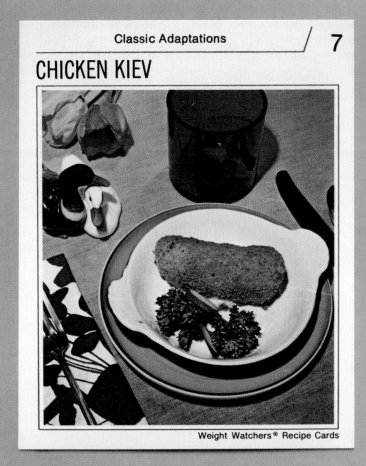

Weight Watchers® Recipe Cards

CHOCOLATE "BROWNIE" DESSERT

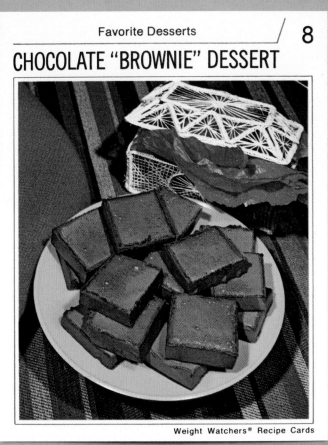

Weight Watchers® Recipe Cards

Photographers unknown, Weight Watchers
Recipe Cards, 1974

MELON MOUSSE

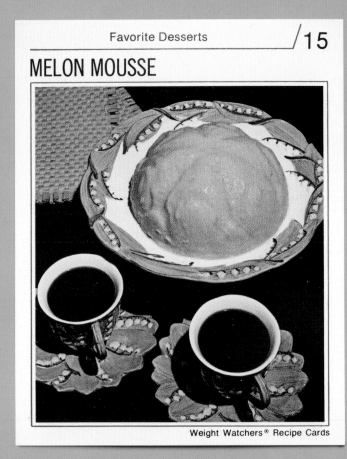

Weight Watchers® Recipe Cards

FRUIT AND CHEESE MOLD

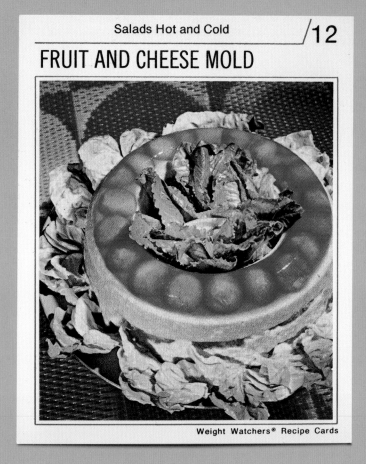

Weight Watchers® Recipe Cards

CHILLED CELERY LOG

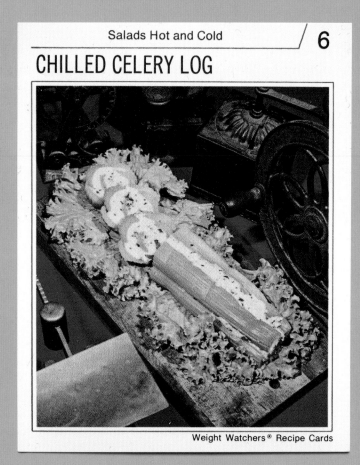

Weight Watchers® Recipe Cards

TUNA PUFF

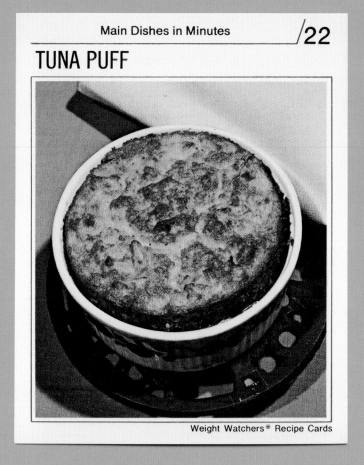

Weight Watchers® Recipe Cards

Photographers unknown, Weight Watchers
Recipe Cards, 1974

FLUFFY MACKEREL PUDDING

Weight Watchers® Recipe Cards

CROWN ROAST OF FRANKFURTERS

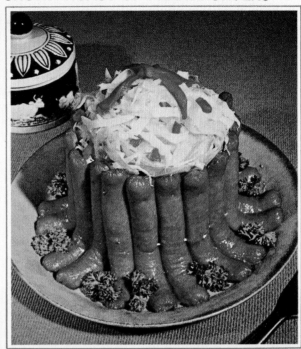

Weight Watchers® Recipe Cards

INSPIRATION SOUP

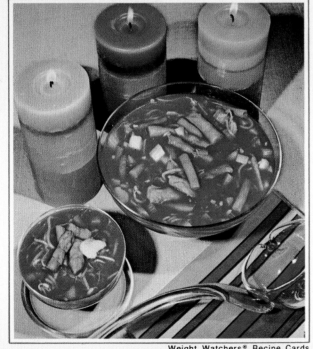

Weight Watchers® Recipe Cards

SLENDER QUENCHERS

Weight Watchers® Recipe Cards

Sixteen Studies from Vegetable Locomotion by Marion Faller and Hollis Frampton is a series of photographs that spoofs Eadweard Muybridge's obsessive Animal Locomotion series of the late nineteenth century. The joke is, of course, that vegetables do not locomote—there is no movement to rigorously capture. Instead, an apple is moved closer and closer to the camera, suggesting an approach, until the last frame is black—or perhaps it's enormous, and the camera is moving further away? The act of photographing it can't prove anything either way.

In others, the actions that the artists perform with the vegetables are violent to the point of comedy: giant squashes are smashed, cabbages are flung, pumpkins emptied of their flesh. The impression is that the artists are trying to control vegetables that may be overtaking them like alien invaders. These implied narratives are at odds with the pseudoscientific gridded backdrop, borrowed from and so specific to Muybridge's work. Faller and Frampton purposefully mimic the false objectivity of photography and the topographical and repetitious nature of Muybridge's studies. These images sit squarely in the frame of Conceptual art—a practice that often took itself a little too seriously—and use food for its inherit ridiculousness.

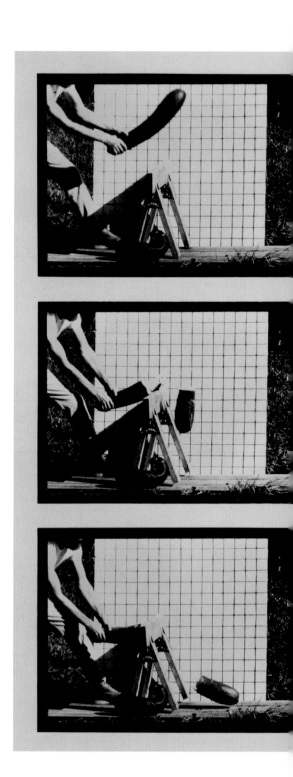

MARION FALLER AND HOLLIS FRAMPTON

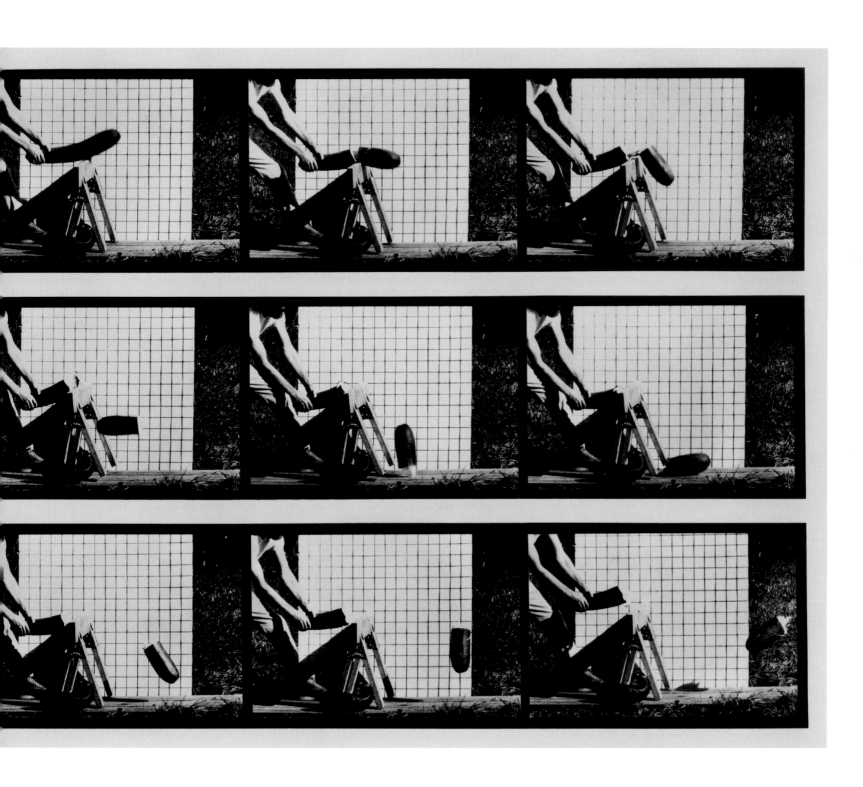

Marion Faller and Hollis Frampton, *33. Zucchini Squash*
Encountering Sawhorse, 1975

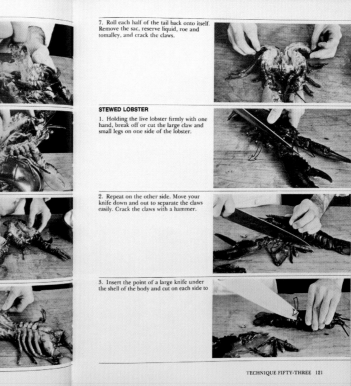

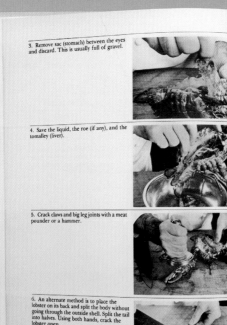

3. Remove sac (stomach) between the eyes and discard. This is usually full of gravel.

4. Save the liquid, the roe (if any), and the tomalley (liver).

5. Crack claws and big leg joints with a meat pounder or a hammer.

6. An alternate method is to place the lobster on its back and split the body without going through the outside shell. Split the tail into halves. Using both hands, crack the lobster open.

7. Roll each half of the tail back onto itself. Remove the sac, reserve liquid, roe and tomalley, and crack the claws.

STEWED LOBSTER

1. Holding the live lobster firmly with one hand, break off or cut the large claw and small legs on one side of the lobster.

2. Repeat on the other side. Move your knife down and out to separate the claws easily. Crack the claws with a hammer.

3. Insert the point of a large knife under the shell of the body and cut on each side to

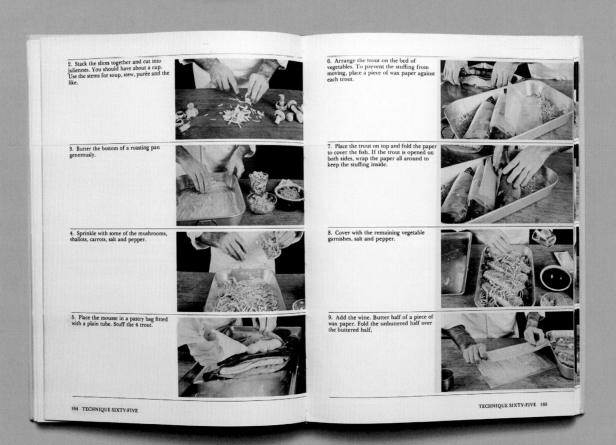

2. Stack the slices together and cut into juliennes. You should have about a cup. Use the stems for soup, stew, purée and the like.

3. Butter the bottom of a roasting pan generously.

4. Sprinkle with some of the mushrooms, shallots, carrots, salt and pepper.

5. Place the mousse in a pastry bag fitted with a plain tube. Stuff the 4 trout.

6. Arrange the trout on the bed of vegetables. To prevent the stuffing from moving, place a piece of wax paper against each trout.

7. Place the trout on top and fold the paper to cover the fish. If the trout is opened on both sides, wrap the paper all around to keep the stuffing inside.

8. Cover with the remaining vegetable garnishes, salt and pepper.

9. Add the wine. Butter half of a piece of wax paper. Fold the unbuttered half over the buttered half,

Léon Perer, pages from *La Technique*, 1976

LA TECHNIQUE

Jacques Pépin's *La Technique* is both a textbook and a reference book for the basic and essential techniques of cooking, and the photographs reflect this. Each technique is laid out in the same structure, with the photographs to the right of the page and the instructions to the left. The food is central, and the photographs, taken by Léon Perer, are closely cropped to show the hands and the food. There is nothing extravagant or elegant about them; they are purely instructional, and feel almost scientific in their monochrome continuity and attention to detail.

The chef Jacques Pépin gained popularity during the 1970s by appearing on television with Julia Child, and his book is an essential primer for those learning to cook. It was one of the first books to use so many photographs to painstakingly show how food is prepared. Of course, other books from this time illustrated technique, but the rigor, detail, and sheer quantity of the photographs in this book (it had over 1,500 pictures) were something different. This is so common now—especially on food blogs, unconstrained by page count—that it's hard to understand the book's importance and influence, especially in bringing French food to a mainstream American audience. However, one might ask how often these techniques were actually used; braising lettuces, whipping up *oeufs à la neige*, and creating lemon pigs are hardly commonplace activities.

2. Stack a few peels together; fold the stack in half and cut into very thin strips. Whether used as a garnish or candied, the julienne should be blanched at least twice to remove the bitterness. Plunge the julienne in boiling water. Return to a boil and let cook for 1 to 2 minutes. Pour into a strainer and rinse under cold water. Repeat this process once more. Keep in cold water until ready to use.

19. Citron *(Lemon)*

THERE ARE INNUMERABLE WAYS of cutting a lemon, from the simple lemon wedge or slice to one of the more sophisticated ways shown below. Lemon is served with fish, shellfish, oysters, meat (veal or chicken), vegetables (such as asparagus, string beans), dessert (fruit salad), yogurt and cheese to name a few. Hence, it is well worthwhile to vary its preparation.

LEMON PIG

1. Choose a lemon with a nice pointed "nose." With the point of a knife, make one hole on each side of the nose and fill it with a black peppercorn or a piece of parsley or olive.

2. Cut a little wedge in the middle of the nose without separating the piece from the lemon to imitate the tongue. Cut both "ears" on each side of the lemon. Curl up a little piece of parsley to imitate the tail and place toothpicks underneath for the legs.

34 TECHNIQUE NINETEEN

Léon Perer, pages from *La Technique*, 1976

OTHER DECORATIONS

1. Cut a thin slice off both ends of the lemon to make a flat sitting surface. Cut the lemon into halves. Cut two strips of peel of equal size from the sharp edge of the half lemon.

2. Fold each strip around and make a knot to secure. Be careful not to break the strips.

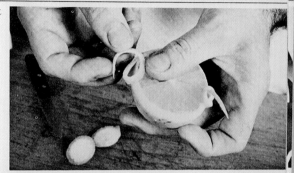

3. Alternatively, cut one long strip of peel from the edge of the half lemon and make a knot with a loop. Place a piece of parsley in the loop.

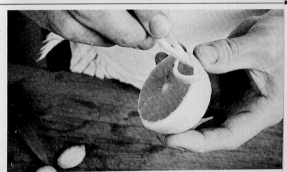

4. For another treatment, cut both ends of the lemon. With a sharp-pointed paring knife (stainless steel is better with lemon), cut "lion teeth" all around the lemon. Cut deep enough to go to the core of the lemon.

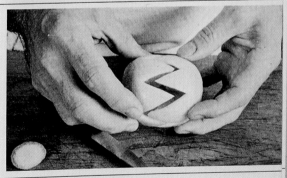

HELMUT NEWTON

Taken twenty years apart, these two images by Helmut Newton show characteristic flair and boldness. They also show Newton as the provocateur that he was. In the beauty editorial from 1974, the model Jerry Hall holds a steak to her eye. The yellow eye shadow—the reason the photograph was taken—mimics what we project is forming underneath the steak. Domestic violence is glamorized and made humorous by the use of an unsightly cut of meat, in close juxtaposition to a beautiful model and in the pages of a glossy magazine—a place where, if food were to appear at all, it would traditionally be found illustrating a recipe.

Newton exploits the same strategy of transposing the beautiful and the gross in the jewelry editorial from 1994: a bejeweled hand rips apart a roast chicken. The idea that somebody would wear Bulgari jewelry to cook is so ridiculous that it's funny. Both these images show an exaggeration of gesture, a device Newton utilized with bravura to create tableaux of fun and fantasy. Along with Guy Bourdin (pp. 186–89) and Deborah Turbeville, Newton reconfigured what a fashion photograph could be in the 1970s. Food here is used to be unexpected, vile, and corporeal in a world of manicured artificiality, giving fashion photography a much-needed visual jolt.

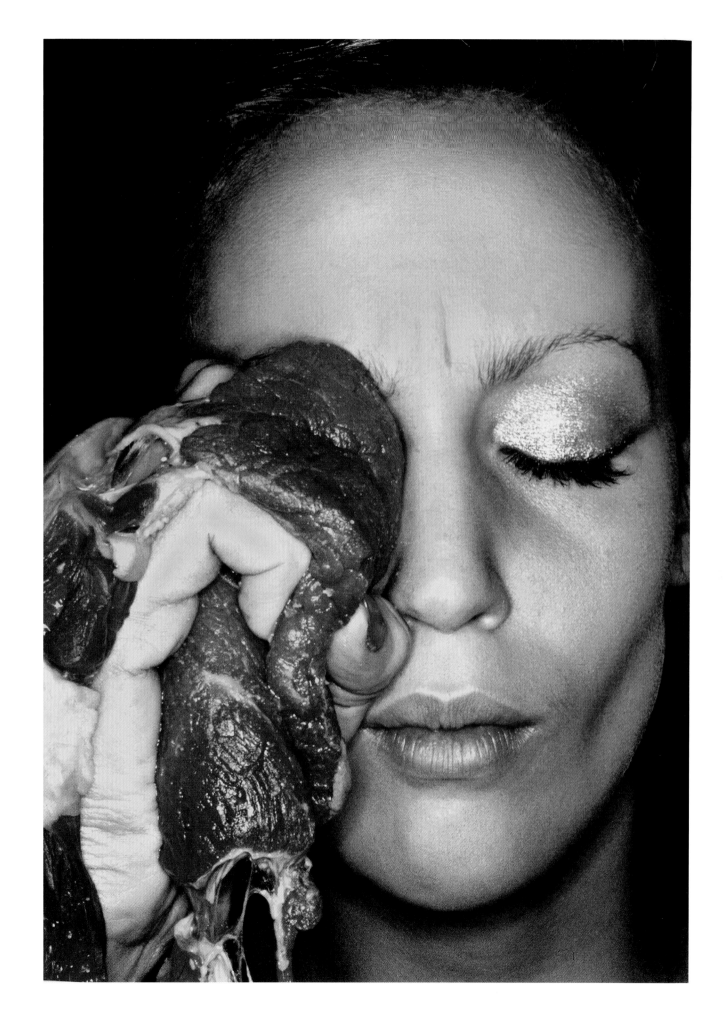

Helmut Newton, *Jerry Hall—Cure for a Black Eye,*
Paris, 1974

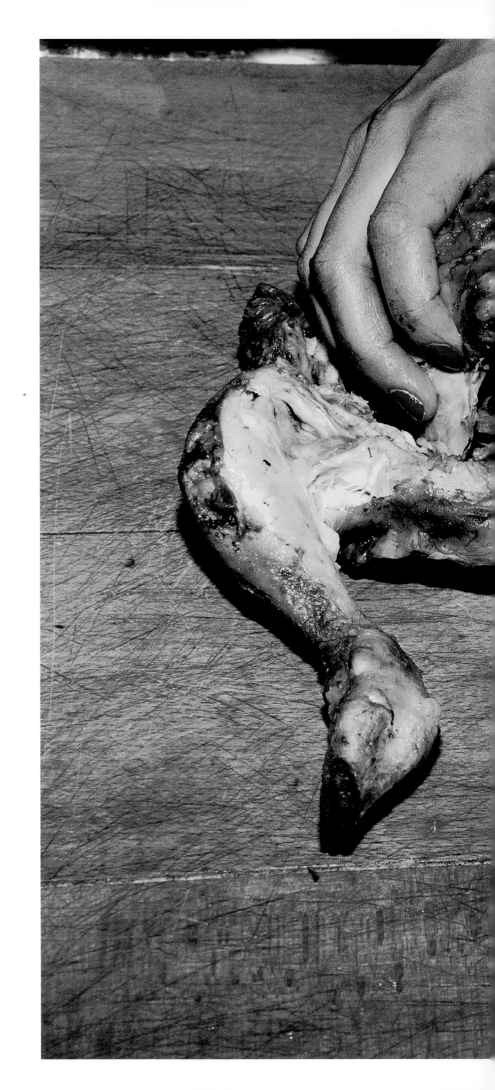

Helmut Newton,
Roast Chicken and Bulgari Jewels,
Vogue France, Paris, 1994

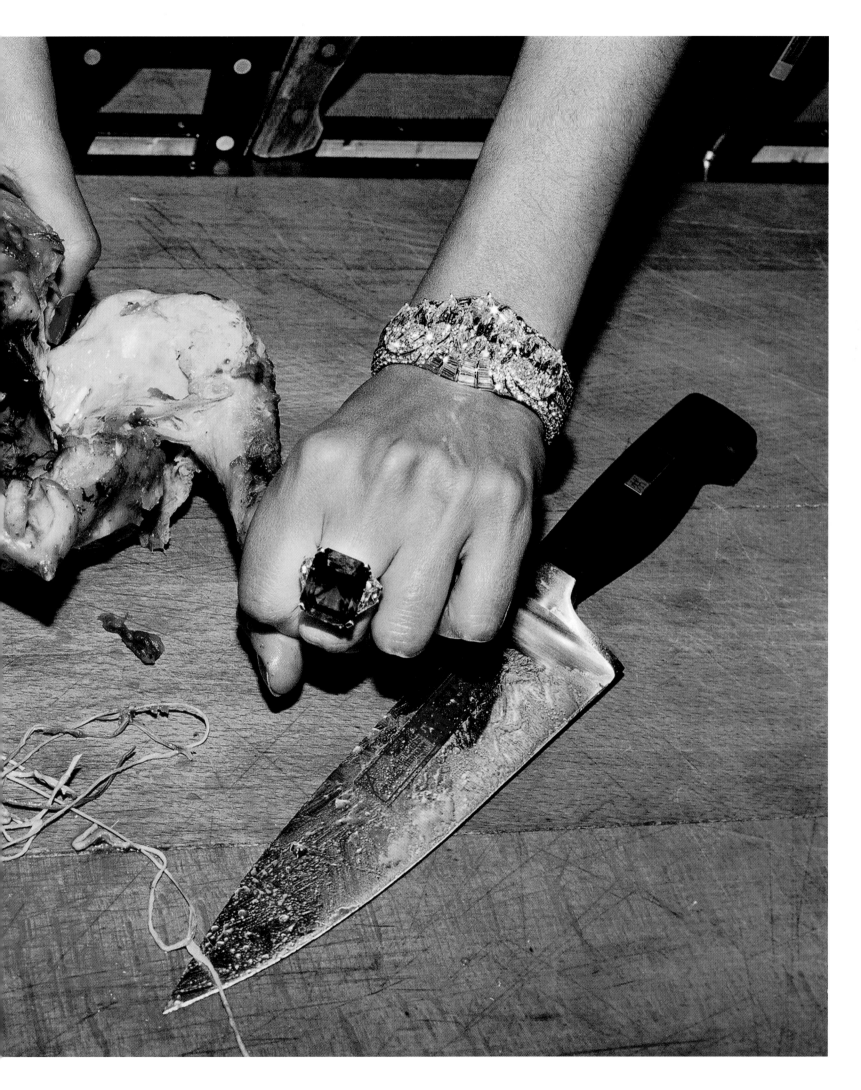

WILLIAM EGGLESTON

In comparison with much of the
Conceptual photography of this period,
William Eggleston is not concerned
with deconstructing or interrogating the
medium of photography, but rather with
capturing the beauty of the everyday.
Foodstuffs, being crucial to the everyday,
feature throughout his work. This kind
of peach sign is commonly found in the
American South, where Eggleston is from.
In real life it might not even warrant
a second glance, but when photographed
by Eggleston, it becomes a stunning
meditation on color: simple oranges
and blues, offset by the diagonal of the
roof and the telephone wires. It is
both wonderfully retro in its typology
and stunningly contemporary. By
photographing it, he reveals it anew,
and it's glorious.

169 William Eggleston, *Untitled*, 1973

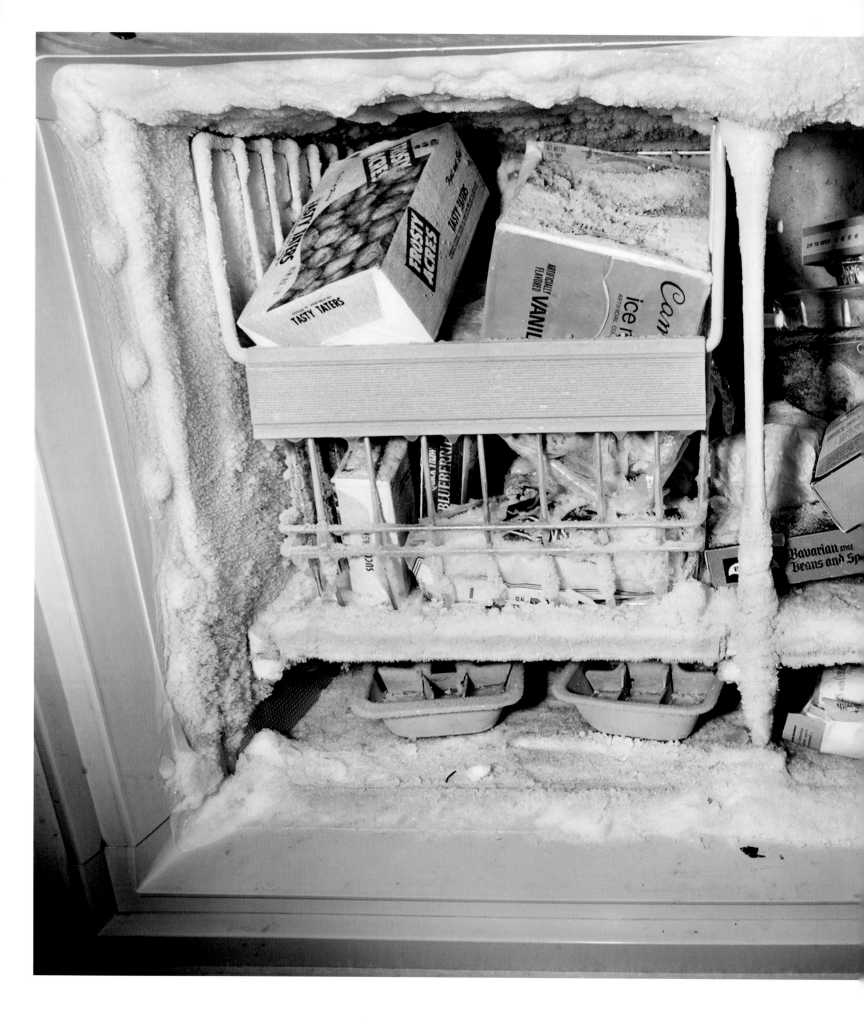

William Eggleston, *Untitled*, ca. 1971–73

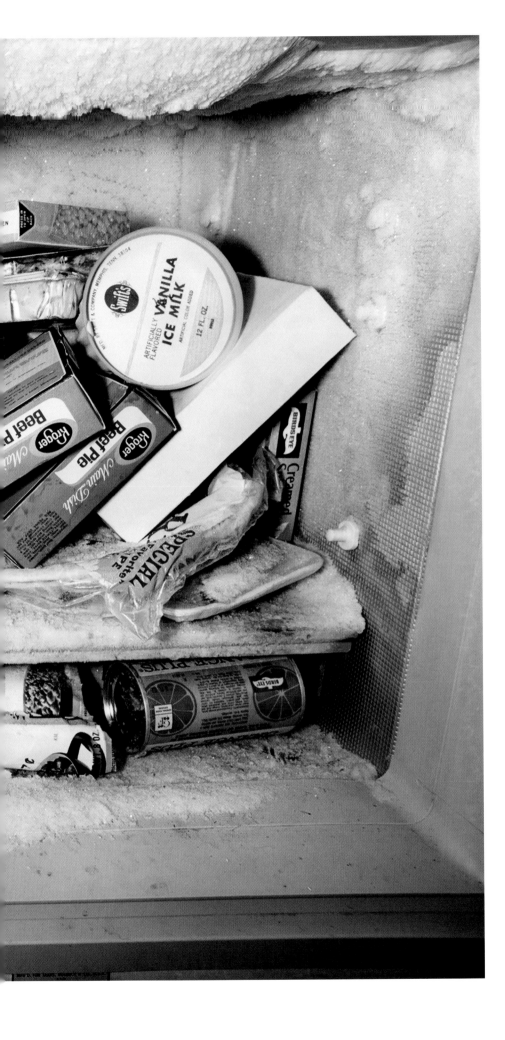

The freezer is a treasure trove of photographs within a photograph. A still life of ice cream, beef pies, and boxes of frozen vegetables acts as a social document of how photography and branding were used on packaging at this time. Eggleston uses more muted tones here; blues are pushed to emphasize the cold. Whereas Irving Penn (p. 173) turned to frozen food and rendered it beautiful, Eggleston's freezer is more abject, revealing a man living among some of the best fresh produce in America who chooses to eat Tasty Taters instead. There is something inherently melancholy about his freezer, and his food gives the viewer an insight into the everyday life of an artist who is able to transform the most mundane into the magical, but does not do so in order to sustain himself. Eggleston's desire to see beauty and worth in the everyday has heavily influenced subsequent generations of photographers.

IRVING PENN

The food photography Irving Penn undertook for *Vogue* magazine was widely influential. Through relationships with the great art directors of the day, Alexey Brodovitch and Alexander Liberman, Penn started to work for the magazine in 1943. There he photographed fashion, still lifes, and portraits, developing a distinctive elegance and simplicity for which he became famous. Early color work such as *Salad Ingredients* (1947, p. 174) show startling modernity, clarity, and simplicity, and appear austere in comparison with other food photographers working at this time, such as Nickolas Muray and Victor Keppler (pp. 100-105 and pp. 96-99). There is nothing kitsch or nostalgic about Penn's work, signaling a new beginning for how food was photographed.

Penn was astutely aware of the subtleties of color and the refinement of craft needed to make a photograph. He completely understood his reader to be a sophisticated person with very different aspirations from those of more mainstream magazines such as *McCall's*. Penn's food photographs do not have any of the elaborate styling of the period, and instead rely on the characteristics of the food to give them their strength, albeit with a quintessential Penn twist: a spill here, an ant there. These are masterpieces of understatement, reveling in texture and form. Each part of the picture is equally important, so the eye flits around the frame, taking in each individual piece of information.

The building of mini sculptures, so popular in much contemporary food photography, can also be seen in *Frozen Foods with String Beans, New York* (1977), in which a wall of frozen foods is carefully stacked by contrasting shape and color for maximum effect. Penn took the photograph at precisely the moment when the food was beginning to thaw, its frost softening and the true colors of the fruit and vegetables beginning to peep through. The effect is utterly delectable, and surprisingly lush for frozen food.

Irving Penn, *Frozen Foods with String Beans, New York,* 1977

↖ Irving Penn, *Salad Ingredients, New York*, 1947

↑ Irving Penn, *Ripe Cheese, New York*, 1992

SANDY SKOGLUND

"I used the subject of food as a means to create a common language," Sandy Skoglund has said of her work from the 1970s. "After all, everyone eats. So, my purpose in working with the subject of food was initially to create a bond with the spectator of my work." However, her choices of food are not always that appetizing, and the lurid artificial backgrounds that mimic the "natural" food may put the spectator off, rather than draw them in.

This relationship between the natural and artificial is key to Skoglund's work, playing on the fact that food is often artificially colored and heavily manipulated when photographed. She draws, and then blurs, the line between what is real and fake, highlighting photography's duplicitous relationship with authenticity. The simplicity of her constructions relies on contrasting colors and shapes, a device that Skoglund went on to develop in her ambitious photographs of constructed interiors. These works may seem contemporary; much of commercial food photography today, as well as a proliferation of food images on image-sharing platforms, follow similar stylistic strategies.

Sandy Skoglund, *Peas on a Plate*, 1978

↖ Sandy Skoglund, *Luncheon Meat on a Counter*, 1978

↑ Sandy Skoglund, *Two Plates of Corn*, 1978

JAN GROOVER

Any narrative is occluded in the work of Jan Groover. Like Paul Strand's images, her pictures become a series of shapes and textures, verging on the abstract and filling the frame. However, Groover's concerns are less modernist than post-modern, and the reflections, light, and shadows become a comment on image-making and construction, rather than challenging the history and traditions of still life. In this regard, she is an important figurehead for contemporary artists who favor abstract and constructed photography.

In this picture, nothing is whole; Groover fragments the pears and cutlery, so much of the scene takes place outside of the frame. In doing this, she insists on a picture being an arrangement rather than "taken from life." Her relationship to food is contrived and created—there is no symbolism at work. Like many other photographers, she turns to the mundane: the food she uses for her photographs in this series was found in the kitchen and arranged and photographed in the sink. Because of this, the work could be read with a subtle feminist subtext, but the main concerns in her work are space, illusion, and challenging the conventions of the photograph to contain and describe.

Jan Groover, *Untitled KSL #78.4*, 1978

FISCHLI AND WEISS

Fantastical and absurd, the Swiss duo Peter Fischli and David Weiss transformed processed meat in their 1979 series Wurst Series (Sausage Series) to create mini-worlds in the way a child might, if given the opportunity. In a series of ten pictures, they had sausages act out scenes that are strangely believable because of the care and focus taken in creating their environments. *Im Teppichladen* (*At the Carpet Shop*) is particularly compelling—if not for the carpets, then for the shoppers. Fischili and Weiss created a family and salesperson (out of gherkins and the top of a parsnip) which seem to exude personality: one bends down to inspect the meat-carpet, while the shop assistant talks to him. Why it's a "him" is unclear, but we take for granted that this is a nuclear family's shopping expedition. The child gherkin even seems a little bored. In *Modenschau* (*Fashion Show*, pp. 184–85), frankfurters line up in front of a mirror, donning glamorous meat creations.

Humor is key to this work, and, as in the Vegetable Locomotion series by Faller and Frampton (pp. 158–59), Fischli and Weiss use the inherent ridiculousness of certain foods to undermine the self-importance of much of the Conceptual art of this time. However, they also question hierarchies and visual perception, and are not as superficial as they might first appear. Creating other worlds with everyday foodstuffs reappears later in the work of Sian Bonnell (pp. 254–57), who also sees the comedic value in processed meat and its artificial shapes. Wurst Series was Fischli and Weiss's first collaboration, and it exemplifies the childlike desire for discovery and experimentation which is also evident across all their later work.

Peter Fischli and David Weiss, *In the Mountains*, 1979,
and *At the Carpet Shop*, 1979; from Wurst Series (Sausage Series)

Peter Fischli and David Weiss,
Fashion Show, 1979; from Wurst
Series (Sausage Series)

GUY BOURDIN

The fashion photography of the 1970s is famously sexually provocative, with photographers Guy Bourdin and Helmut Newton exploiting this focus as much as they could within the limits of editorial and advertising. Shocking, challenging, and overtly sexy, Bourdin's work is situated within the surrealist tradition; he often claimed his art was a manifestation of unconscious desires. His desires are veiled in a very particular aesthetic, heavy with implied meaning—and food, for Bourdin, is a visual shortcut to that.

The frankfurters that two women feed to each other (pp. 188–89) seem like they could not be any more blatant. However, the image is not that straightforward; if it was, then why bother with the large plate of sauerkraut that sits in the foreground of the image? In fact, it shows Bourdin's acute knowledge of how to work a double-page spread: the plate is a formal device that allows each page to be equally balanced when open, echoing the twinning of the two women. The sauerkraut adds a touch of the surreal, ridiculous, and humorous to a sexual image, giving it a lightness of touch while simultaneously making it all the more gratuitous. The melted ice cream picture erases the figure and leaves only legs and shoes. But they are secondary to the dynamic food spill in the foreground, which guides the viewer expertly though a series of flat planes, their different textures all working off one another.

187 Guy Bourdin, *Charles Jourdan*, Fall 1979

Guy Bourdin, *Vogue Paris*,
September 1981

Susan Meiselas, *Breakfast, Rice, Nicaragua*, 1979

SUSAN MEISELAS

Using the frames of the personal, historical, and geographic to orient herself in complicated and dangerous situations, Susan Meiselas often looks to the everyday in order to tell a better-rounded story about those involved in conflict. Her book *Nicaragua* (1981) was one of the first books on war to be photographed in color. Food is an essential part of conflict logistics, and Meiselas concentrates on the necessity of it rather than its role in the politics of conflict—a rarity in war photography. If food is photographed in these situations at all, it tends to concentrate on documenting aid or extreme shortages.

These images, taken in 1979 during the Nicaraguan revolution, demonstrate the slower documentary style Meiselas is known for. Represented here with vibrancy and optimism are young Sandinista guerrillas eating rice for breakfast in a training camp in the mountains north of Esteli; they were preparing for a popular insurrection that would overthrow the Somoza dictatorship a few months later. The second photograph shows a middle-class couple cheerfully providing home cooking in the middle of the front line of the last offensive in Managua. By showing this personal and instantly relatable side of the story, Meiselas presents war and conflict as human rather than epic. The eating, gathering, and philanthropic preparation of food play a vital part in all parts of life, and to represent this in times of conflict emphasizes that life continues in the most elemental and banal ways.

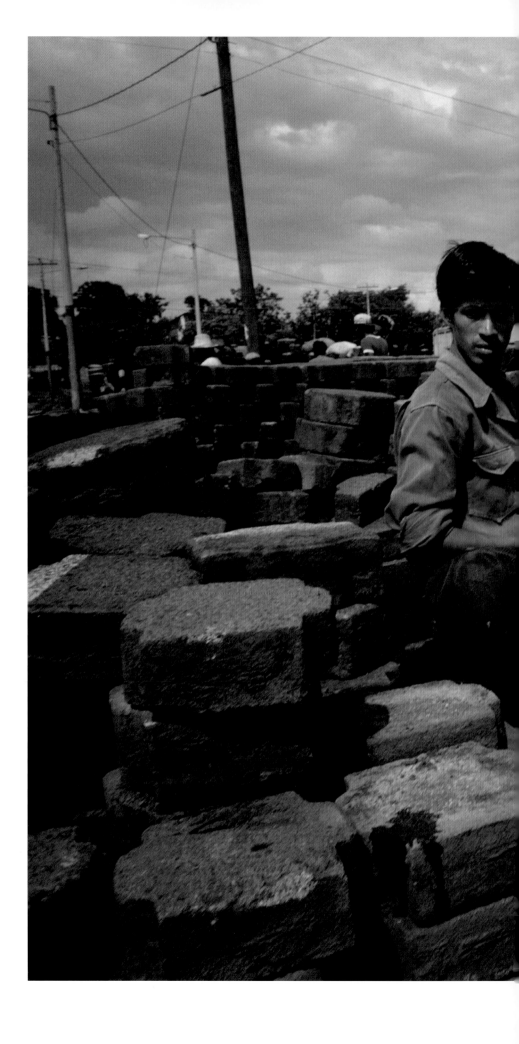

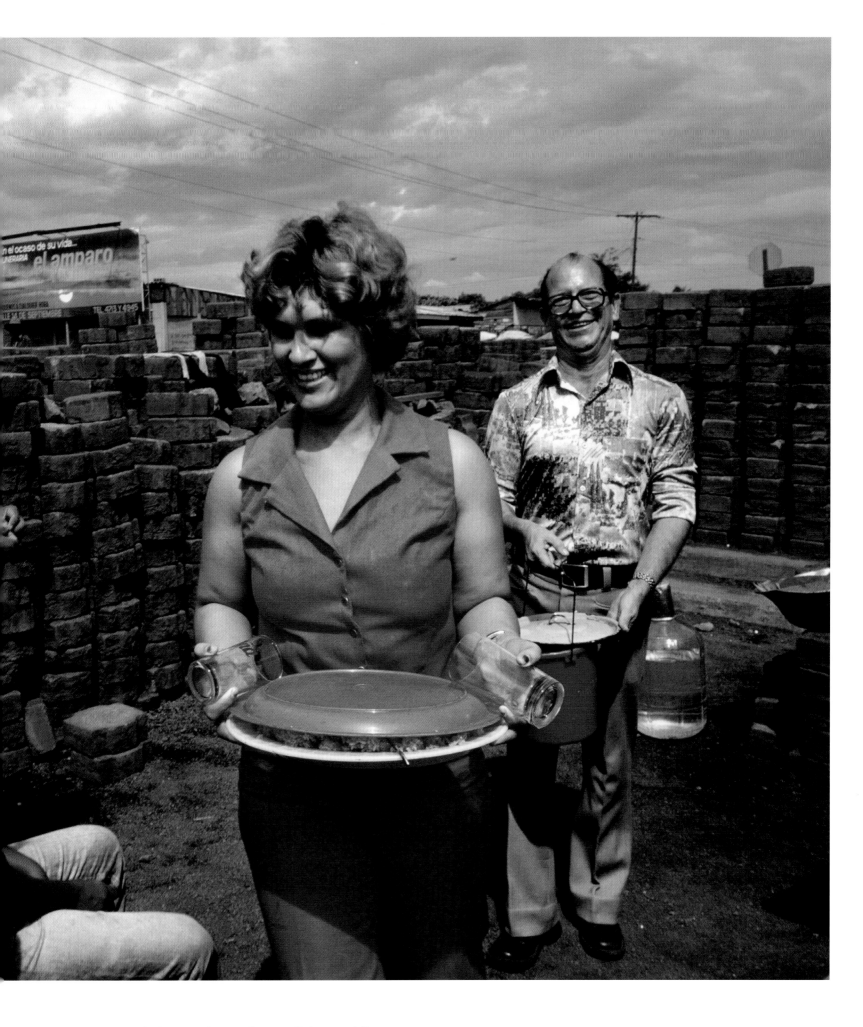

Susan Meiselas, *Serving Food to Sandinistas Holding*

the Barricades in Managua, Nicaragua, 1979

OUKA LEELE

Spanish photographer Ouka Leele came to prominence after Franco's fascist regime, and her colorful, playful images reflect this new period of freedom and exuberance, with its greater artistic possibilities. The work here utilizes zesty colors and a dreamlike scenario, typical of her portraits from this period. The colors are very particular to her practice, since she hand-paints them onto her black-and-white photographs. Influenced by the great masters and commercial photography, she often placed food on the heads of her sitters. This transforms what may appear to be rather deadpan portraits into imaginative narratives, with excessive or surreal twists.

Here, the lemon headdress is reminiscent of the movie star Carmen Miranda's enormous fruit-laden hats of the 1930s and 1940s. This was taken before the age of Photoshop, and the lemons were not placed on the model digitally—she is poking her head through a set made with real, open lemons. This involves an elaborate performance of posing and collaboration between sitter and photographer, as the food would've been uncomfortable and pungent. Taken from Leele's series Peluquería, the picture references the visual language of advertising; one can imagine lemon-lady as a character on a food label or display. However, if this was a commercial, it would fail: the brand has been left out of frame.

Ouka Leele, *Peluquería, Limones*, 1979

THE ROMANCE OF FOOD

The Romance of Food is an extraordinary book. Its creator, the British socialite Barbara Cartland, was best-known for her romance novels (of which she wrote over seven hundred) and her acrimonious relationship with her step-granddaughter, Diana, Princess of Wales. A lover of pink, feathers, and camp, Cartland herself shared startling similarities with this book. Under each photograph—carefully styled using Cartland's personal belongings—she penned love stories, social-climbing anecdotes, and historical snippets to put you in the mood for love. The addition of knickknacks chimes with the food and the presentation, in terms of both color and theme. Leaping porcelain dolphins accompany the salmon *en croûte*, while a shepherd and his flock surround a noisette of lamb. The bold, color-blocked backdrops highlight the kitschiness.

The book's intent appears quite sincere and is in tune with Cartland's public persona. The recipes are from her personal chef, Nigel Gordon, and feature many rich French classic dishes, with nutritional advice for supplements and vitamins. The dietary supplement Royal Jelly (made by honeybees) features prominently, as expected. For Cartland, every food is an aphrodisiac, offering a promise of love forever and a simple way to seduce any man. An example of the text accompanying Noisette of Lamb with Baby Vegetables reads, "What woman does not long to be carried like a lamb in the arms of the man she loves?"

Wild Duck with Cherries (page 97)

"Only a strong man, whom women admire,
can brave the dark and cold to wait for the
dawn flight."

— 106 —

Jugged Hare (page 98)

"One of the fastest wild animals in England,
a menace to the farmers but a spur and a
stimulant to the languid lover."

— 107 —

— 66 —

Filet Mignon Rossini (page 63)

"Beef . . . giving virility and
strength . . . with seductive pâté
enflaming the senses."

Left *Beef Wellington* (page 58)

"England's greatest General who
defeated Napoleon and a plate
worthy of his name in the Battle
of Love."

— 67 —

David Johnson, pages from *The Romance of Food*, 1984

True Love (page 150)

"*For a night to remember, a heart topped with delicious raspberry purée, another with orange mousse and the third with passion fruit.*"

Clockwise, from the left *Mocha Chocolate Cake (page 162), Black Currant Gâteau (page 160) and Meringues (page 161)*

"*An English tea; how many men have been beguiled and captivated by a soft voice offering them a meringue?*"

— 166 —

David Johnson, pages from *The Romance of Food*, 1984

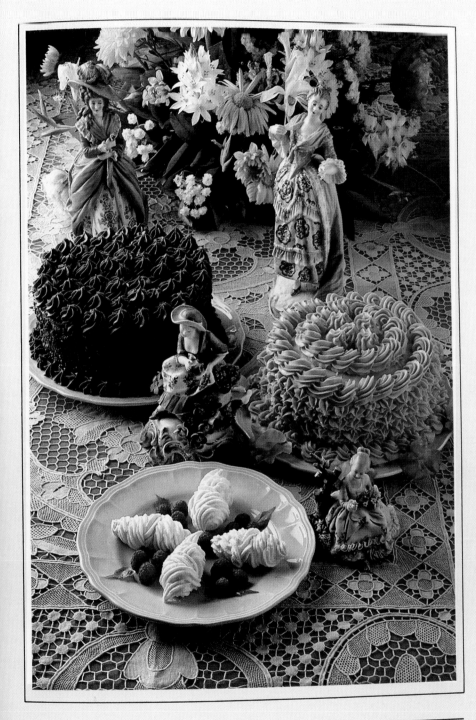

199

GOURMET MAGAZINE

When the word *foodie* first appeared in print in 1980 in *New York* magazine, the American magazine *Gourmet* best represented this phenomenon. Its photographs and exotic editorial stories shot in far-flung countries illustrated where to find the very best bread or the most delicious olive oil, taking food and lifestyle aspiration to a new level of lavishness and desire. That element of luxury and sophistication was there right from the magazine's start, in 1941. First published as America entered the war, it had none of the food-saving tips that its main competitor *American Cookery* promoted. Instead it featured food from Europe, and—most important—did so using color photographs.

During the early 1980s, when it was bought by Condé Nast and Jane Montant was editor-in-chief, *Gourmet's* circulation grew, and it became much more extravagant and international. It was the glossiest and most indulgent of food magazines. Each month's covers were highly anticipated, and faithful customers collected the magazines rather than using them as cooking aids. The minimalist type and full-bleed photographs on the cover represented a more European aesthetic and illustrated a respect for photography that did not have to compete with too much text, smaller photographs, or information telling the reader what was inside. The gorgeous food on the front invited the viewer to sit down, take a breath, and slowly enjoy an imagined lifestyle of exquisite class and quality. Unfortunately, Condé Nast decided to stop publishing *Gourmet* in 2009 as advertising revenue plummeted, keeping *Bon Appétit* instead, which was perhaps better able to compete against the rise of independent food magazines that offered a more relaxed style.

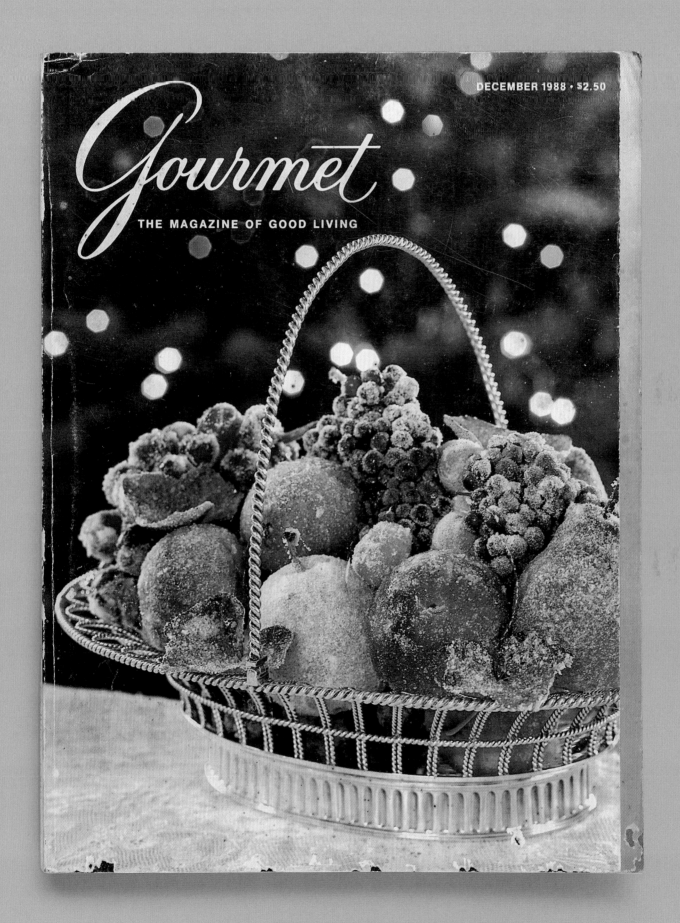

DECEMBER 1988 · $2.50

Gourmet

THE MAGAZINE OF GOOD LIVING

Romulo Yanes, *Gourmet* cover, December 1988

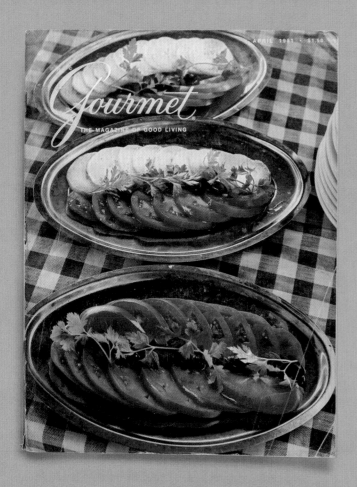

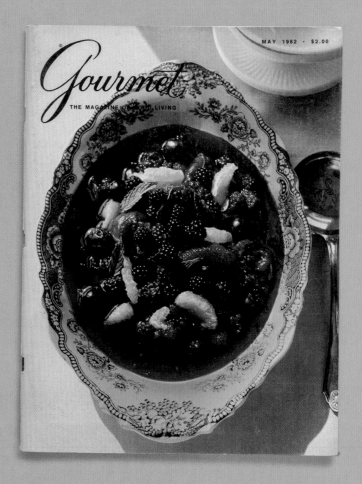

Gourmet covers (clockwise from top left): Ronny Jaques, April 1981; Ronny Jaques, May 1982;
Ronny Jaques, October 1982; Lans Christensen, June 1982

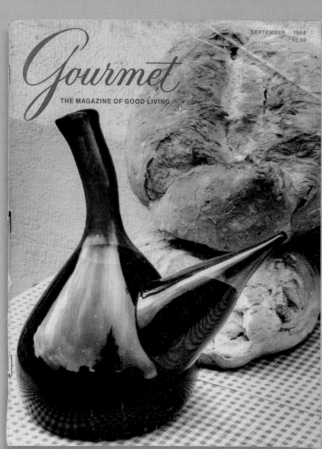

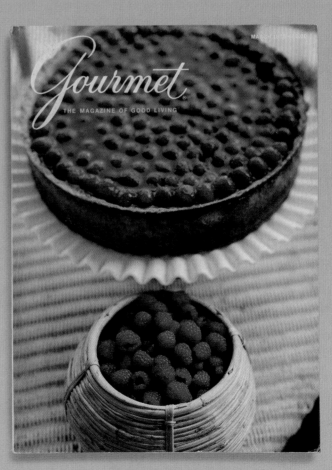

Gourmet covers (clockwise from top left): Ronny Jaques, October 1983; Ronny Jaques, November 1983; Lans Christensen, March 1985; Ronny Jaques, September 1984

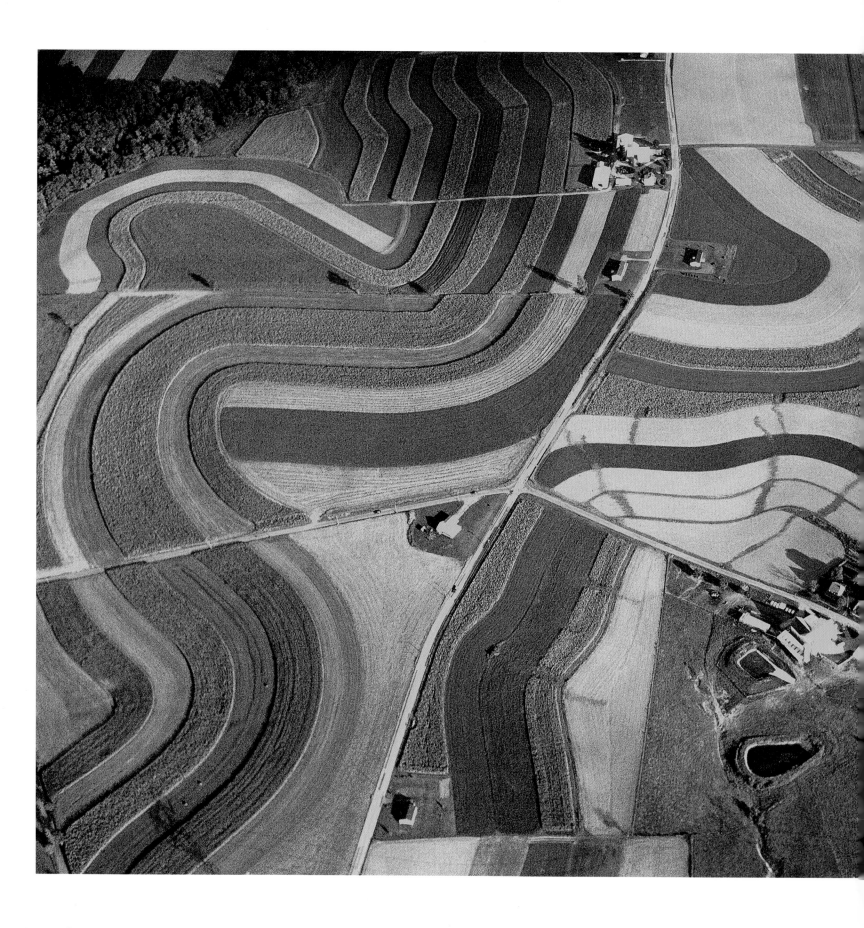

Georg Gerster, *Tilled Fields, Pennsylvania*, 1988

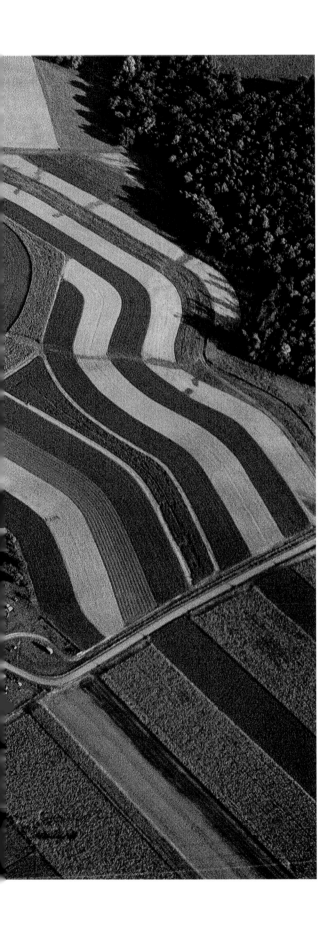

GEORG GERSTER

A pioneer of aerial photography who has shot for over forty years, Georg Gerster abstracts food and farming by shooting their farmed shapes and patterns in the landscape. Crops are reduced to seductive pattern, a mix of swirling shapes, grids, and large, unrecognizable blocks of color. Gerster has created images that question our assumptions about what is natural and—more important—what is nature, as well as what humans' relationship is to it. He has said, "Aerial photography shows you so much more of the world than you ever see from below. For me, it's like a meditational tool." The resulting photographs are also meditative, as the seductive patterns have an almost hypnotic quality.

But this is only half the joy of viewing things from above. The secondary enjoyment comes from finding out what the strange patterns are. These are not just simple meditations on shape and abstraction; they are also important documents of humans' control of the landscape, and of our desire to consume. The way food is photographed here comments on the increased mechanization of farming through monocropping and its associated environmental and political problems, such as soil erosion and the dominance and power of big brands.

CINDY SHERMAN

This picture is from Cindy Sherman's Disasters series which, along with the series Metropolis, represents a time in her work when she turned the focus away from her own body and instead used food as a loaded symbol of body image. In *Untitled #175* (1987), Sherman's torso and tortured face are reflected in a pair of sunglasses that lie amid a landscape of lurid food and remnants of a day by the beach. The woman represented here is not the clichéd babe lying on a beach towel, offering herself up to the sun, nor is she the tidy woman in the kitchen from cooking ads. Instead, Sherman highlights that women's body images can be complicated, riddled with feelings of self-disgust and extreme relationships with food.

The grotesque scenario implies a narrative of consumption and excess, binging and purging. The most basic function of food is to be eaten, of course, but our relationship with it is not always that simple. The vomit-like substance on the right suggests eating disorders such as bulimia; since these disorders are mainly predominant among women, this image is very gender-specific. Sherman shows that although eating disorders are often about regulating the body, there is always a flip side to this: a feeling of being utterly out of control.

Cindy Sherman, *Untitled #175*, 1987

ROTIMI FANI-KAYODE

Rotimi Fani-Kayode, a British Nigerian artist, addressed issues of homosexuality, postcolonialism, the black body, and spirituality through large-scale color photographs during his short, six-year career. The work featured here is from the series Bodies of Experience, which Fani-Kayode made with his partner Alex Hirst. Food and herbs from Nigeria played an important part in Fani-Kayode's work, seen in his intricate headdresses made from local plants and berries in many of the pictures. The photographs appropriate iconography and archetypal motifs such as grapes from Western still-life paintings, while simultaneously layering them with references from his own Yoruba culture, such as masks used in religion and folktales.

With the advent of modernism, art-historical links to food and its attendant symbolism all but disappeared from the photographic act. However, in the 1980s, many artists rediscovered and reinterpreted the rich traditions of premodern art, with a postmodern twist. The body also continued to be used as a political site. In *Nothing to Lose XII* (1989, p. 210), one is reminded not only of the photographic work of Robert Mapplethorpe (with whom Fani-Kayode was friendly), but also of paintings by Caravaggio such as *The Young Sick Bacchus* (ca. 1593). The grapes and peaches echo those held by the young god—but instead of being gripped dramatically in the man's hand, they are placed suggestively on his genitals. Perhaps this is referencing the AIDS crisis, which was affecting many in the artist's community at the time. In the other images, the acts are more ambiguous, the symbolic gestures more theatrical; the food both sustains and suffocates.

Rotimi Fani-Kayode, *Nothing to Lose I*, 1989

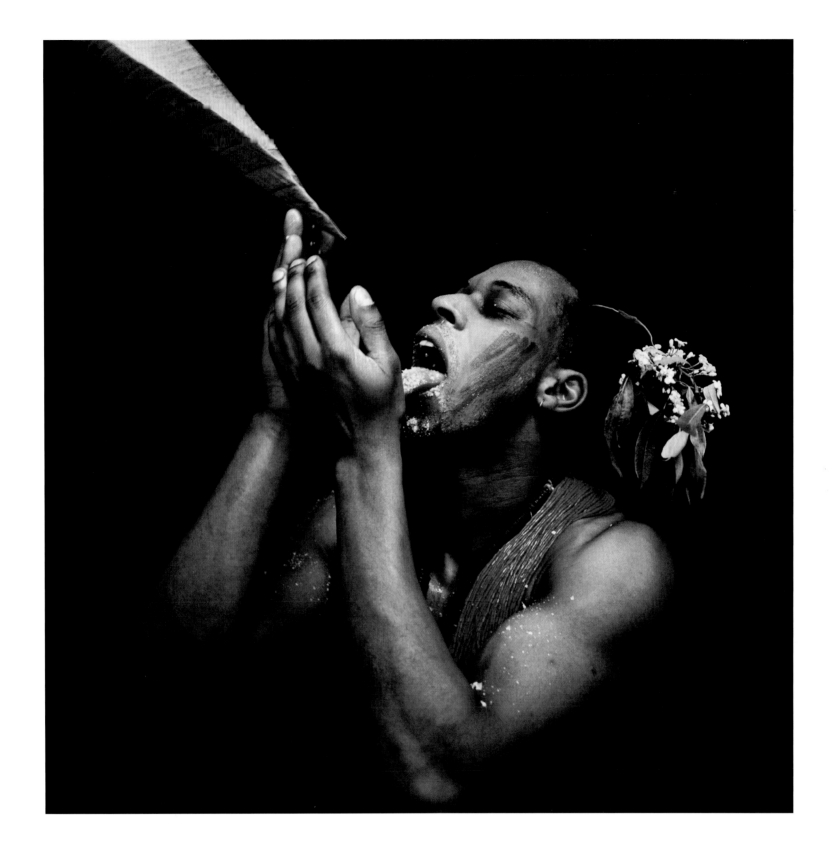

↖ Rotimi Fani-Kayode, *Nothing to Lose XII*, 1989

↑ Rotimi Fani-Kayode, *Nothing to Lose VII*, 1989

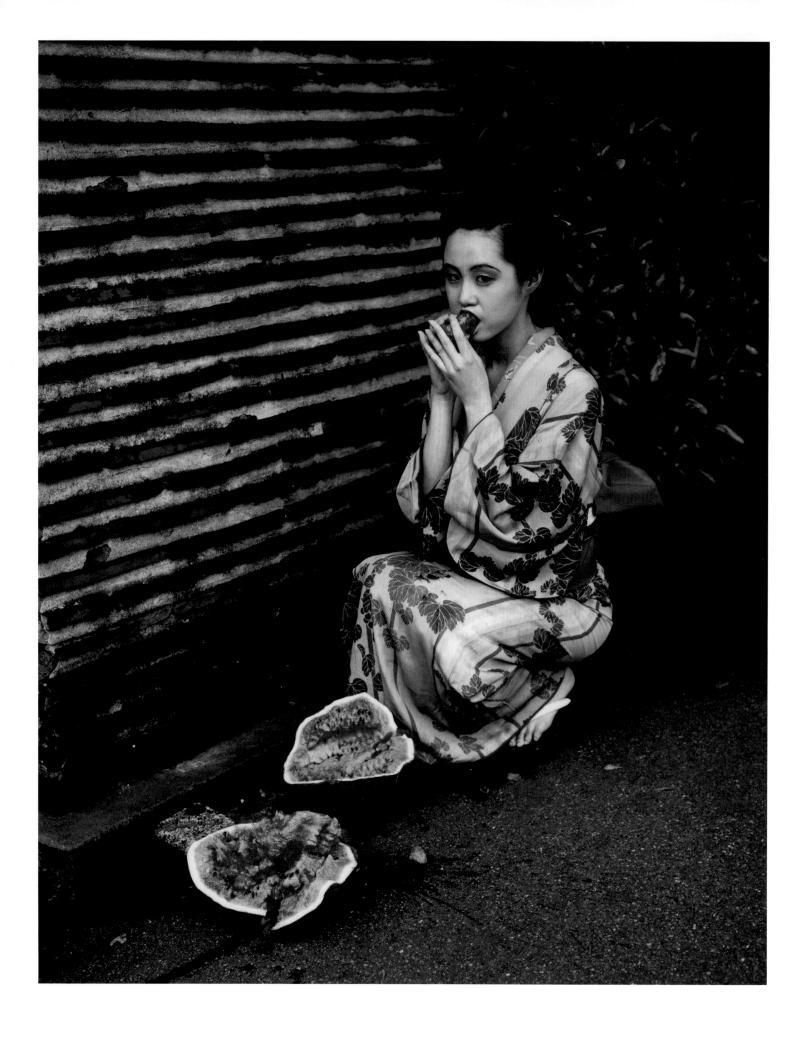

Nobuyoshi Araki, *Colourscapes*, 1991

NOBUYOSHI ARAKI

The young woman sucks on a piece of watermelon, crouching somewhat submissively. The simple palette of Nobuyoshi Araki's photograph makes the delicate pink of the flesh pop, chiming with the obi that ties her kimono. This allows the eye to circle inward to the melon being eaten; the connotation of oral sex is far from subtle. The smashed melon on the floor and its oozing juices exacerbate this. Sexual references have been ingrained in the representation of food from early still-life paintings onward—and the more luscious the food, the stronger its associations with memory, desire, and imagination.

In contrast to this image, Araki's book *Shokuji* (or *Banquet* as it is known in the West) documents food altogether differently. But sex is never far from the surface in this Japanese photographer's work. In the first part of the book, color photographs, which Araki had taken for commercial purposes, ooze out of the page. Food is shot close-up, garish, and harsh, emphasizing the physicality of eating, where pleasure and desire collide. But food can easily shift from delicious to disgusting with only a little lack of self-control, and often these color photographs sit on the side of the latter, a non-too-subtle reminder of human fallibility and greed.

The second part of the book is made up of black-and-white photographs with an entirely different feel. It is only when you know that these are documents of each meal Araki ate with his wife during the last two months of her life that they become more weighted and profound. They are photographs of a life sustained, satiated, by food, and a contiguity to moments shared. They are a tribute to her and to their time together, sharing one of the most ancient of rituals. Going in even tighter, it's often hard to identify the food at all, as it is further distorted by its lack of color. These magnified objects at once reverberate with their own essence, but also act as bodily metonyms for the woman the photographer loves.

Araki's obsession with sex and the work in *Banquet* dramatize the fragility of the division between life and death. Through the act of photographing food, the very fundamental elements that make us human—sex, love, sustenance, and death—can be captured in the same very tangled, complex way they appear in life.

Nobuyoshi Araki, all from the series The Banquet, 1993

Hannah Collins, *Sex 2, Plural/Wet*, 1992

HANNAH COLLINS

As in Araki's work, the connotations of and references to sex continue in this photograph by Hannah Collins. The sensual way oysters are supposed to be eaten, as well as their likeness to female genitalia, their saltiness, and their high zinc content, have long made them a dizzying aphrodisiac. Slick and slippery, they sit in liquid here, abundant and ready to be consumed. The exquisite black-and-white exaggerates the textures of the hard carapace compared with the unctuous meat. By highlighting these opposites, Collins shows the oysters as a rich mass of tactile surfaces.

The way she photographs them with such close attention to detail could be read simply as a meditation on pleasure, but in Collins's work there is always a hint of melancholy, too. She lived and worked in Spain for many years and has said, "Life is very conveniently arranged next to death in Spanish culture, and the passing of life into death is an everyday occurrence and rapidly taken care of . . . sometimes the whole place seems awash with the liquids of both life and death, leaving me free to explore them without guilt or any other negative association."

JO ANN CALLIS

Often setting her food against bright colors, Jo Ann Callis manages to photograph food so that it appears extraordinarily sexual, without making any direct reference to sex. Her treatment of the food is obsessive and tense, relying on saturated, cinematic lighting to create an unknown drama seemingly set in the 1950s or 1960s.

Influenced by Paul Outerbridge (pp. 60–63), Callis uses color in the same fetishistic vein and with a similar emotional temperature. Like so much of the photography of food in this book, it is her concentration on contrast, texture, and color that gives her images their unmistakable edge. The pie would not quite be the same without the dribble of juice coming from the central hole (p. 220), and the pile of sticky, sweet strawberries is so heavily glazed it appears wet (p. 221). Callis's food becomes gendered; both constructions here appear resolutely female, while simultaneously highlighting the clichés of femininity. Her title for this series of still lifes, Forbidden Pleasures, focuses on what is implied. The success of the photographs therefore relies on the viewer's own fantasies.

Jo Ann Callis, *Black Table Cloth*, 1979

↖ Jo Ann Callis, *Untitled*, from the series Forbidden Pleasures, 1994

↑ Jo Ann Callis, *Untitled*, from the series Forbidden Pleasures, 1994

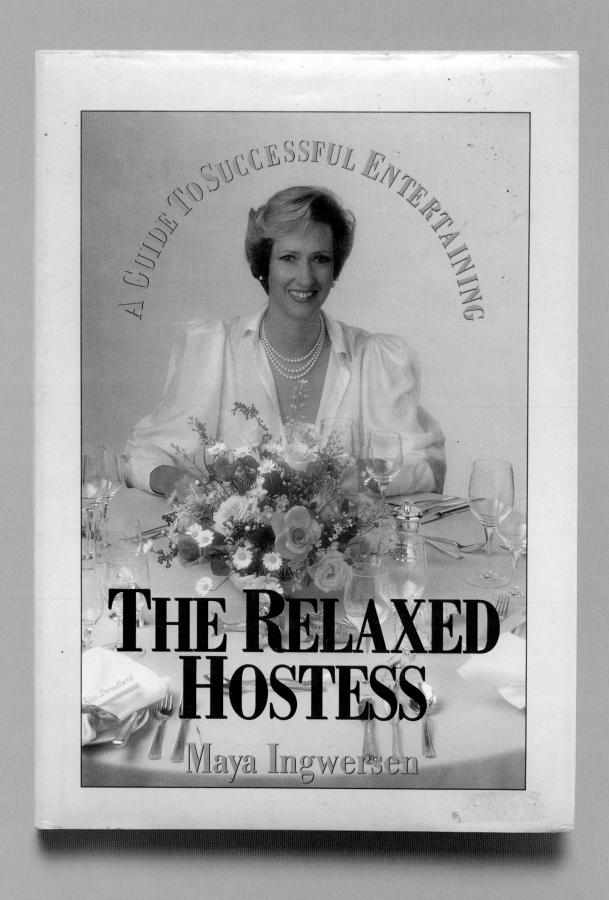

A GUIDE TO SUCCESSFUL ENTERTAINING

THE RELAXED HOSTESS

Maya Ingwersen

Dudley Lawrence, cover of *The Relaxed Hostess*, 1994

THE RELAXED HOSTESS

Maya Ingwersen, the South African daughter of German diplomats, is *The Relaxed Hostess*. Very much reflecting its time and place, this book caters to middle-class white South Africans, who entertained at home more often than Europeans and Americans. Food and catering can very much be a display of status, and this book would have been intended for younger married women, daunted by the prospect of hosting an event. It is not a cookbook (there are no recipes, only menus), but rather a book about domestic entertaining, where styling of the home and table and creating a convivial atmosphere are paramount. Checklists, staff lists, menu plans, and pro formas for recordkeeping sit next to photographs that show elaborate settings for both indoors and out.

Although home entertainment in South Africa had become more informal by the 1990s, *The Relaxed Hostess* is still very much about status: emphasizing the size of the indoor or built-in *braai*, highlighting the obscurity of the Scotch on offer, and illustrating overly fussy attempts at plating food creatively. The photographs (which are anything but relaxed) now appear to suggest conspicuous and vulgar consumption, with an eye to outdoing the last event. Television had taken over this role from books and, as a result, it seems anachronistic even for its time, especially when you compare it to the way many cookbooks were then adopting a more documentary style. The recommendations for events verge on the ridiculous: her tips for a men's luncheon suggest that the hostess should be aware that "men tend to be conservative in taste, so it's best to keep food fairly simple and hearty . . . go for striking colors, and maybe an unusual centerpiece . . . for instance you might borrow a model of a vintage car and surround it with leaves and grasses."

WHITE HEAT

Published in the UK at the very beginning of the 1990s, the book *White Heat* has come to epitomize certain aspects of that decade, such as "lad culture" and "Cool Britannia," which feel especially retrograde in comparison with similar contemporary books on restaurant kitchens, such as *Breakfast, Lunch, Tea* (pp. 258–61). Here, the photographer Bob Carlos Clarke captured the masculine, loud, meaty, and hedonistic kitchen of Marco Pierre White when he worked at Harvey's in South West London in a book which is part memoir, part cookbook, and part documentary. It is shot in reportage style, with a dynamic, urgent feel that wonderfully sums up the possibilities of a new decade when London was to become a cultural capital of the world, and this young chef one of its major players.

At the center of the book is White, creating impossibly intricate French dishes with a precision and affectation that are at odds with the masculine, competitive atmosphere of the kitchen. Fine dining had never been photographed like this before, and the full-bleed black-and-white spreads shook established modes of photographing beautifully plated haute cuisine. Here, cooking is presented as a sport, and White a celebrated athlete. The food critic Jay Rayner has called it "possibly the most influential recipe book of the last twenty years," and in retrospect it anticipates many of the food trends that we still feel reverberating today: the establishment of the celebrity chef and the chef memoir; the rise of what has come to be known as "foodie culture," and, with it, food porn; and, most important here, a shift toward a much more naturalistic, documentary style of photographs for cookbooks and editorial.

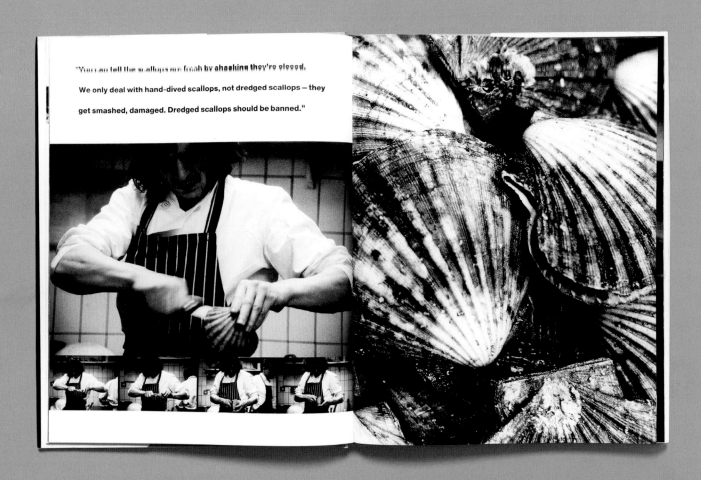

"You can tell the scallops are fresh by checking they're closed. We only deal with hand-dived scallops, not dredged scallops — they get smashed, damaged. Dredged scallops should be banned."

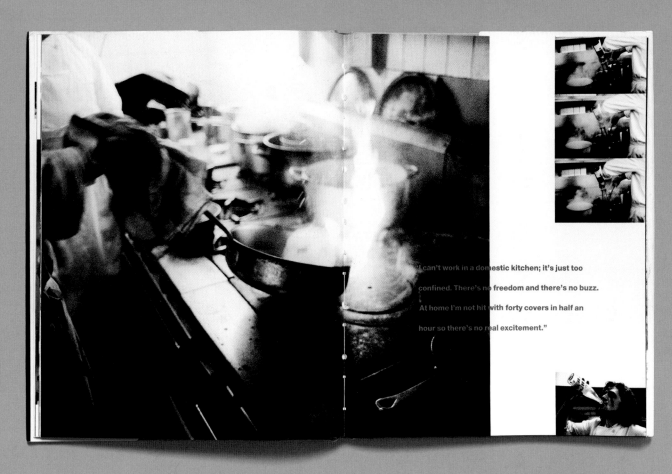

"I can't work in a domestic kitchen; it's just too confined. There's no freedom and there's no buzz. At home I'm not hit with forty covers in half an hour so there's no real excitement."

Bob Carlos Clarke, pages from *White Heat*, 1990

WOLFGANG TILLMANS

The work of Wolfgang Tillmans encompasses a calm sparseness of vision and manner. His pictures imply happenstance, but in fact the objects have been very carefully arranged to create scenes that look as if they occurred naturally. His still lifes isolate motifs of the everyday and call upon art-historical references in a gentle way. The food pictured here is seasonal, following natural rhythms of the year and recalling the slowness of painting; the apples arranged on the mantelpiece by the window are shot at an awkward angle reminiscent of Cubist constructions by Cézanne.

But although those references may underpin these pictures, Tillmans's images could only have been made with a camera. The looseness, relaxed style, and inclusions of human presence—through the old newspaper or the body of the photographer—take these far away from any painting references, acknowledging sensual pleasure. Everything Tillmans photographs is treated the same way; there is a lack of hierarchy between objects. The cigarette lighter is as important as the fruit, and the toucan is no more exotic than its food. His still lifes are casual meditations on the beauty of the everyday. They show the compulsions and rich dimensions of life that lie under the surface of the quotidian.

Wolfgang Tillmans, *Apples*, 2008

Wolfgang Tillmans,
Summer Still-Life, 1995

W

Turner growls back

Courtney Love

P

M 2546 H 25.00 F HD

Experiment in Green

Officials Dole Out Chunks of Riverside Park,
And Corps of Volunteers Pick Up the Pieces

↑ Wolfgang Tillmans, *Untitled (jam)*, 2003
↗ Wolfgang Tillmans, *Tukan*, 2010

VIK MUNIZ

Brazilian artist Vik Muniz uses food to reproduce iconographic images from the history of art and photography. His *Mona Lisa* (p 135) is rendered in peanut butter and jelly, while Harold "Doc" Edgerton's famous *Milk Drop Coronet* (p. 109) is reproduced in a pool of chocolate syrup. With a background in advertising, Muniz acutely understands the graphic power of an image that relies on perception and optics for its success, and he translates these visual theories into his art. In addition, humor is key to communication. By using the medium of food, Muniz takes the most lowly of substances and elevates it to the artistic status of paint.

But this is not just a clever translation of surface into substance. By using food to transform the images, Muniz uses his iconoclastic copies to question canonization in the history of art and photography, as well as the arbitrariness of hierarchies and the obsession with originality and genius. In addition to the photographs here, Muniz has also made portraits of children of sugar-plantation workers using granulated sugar, showing how food can be poignantly linked to subject matter, rather than treated as just another artistic material. He has said, "I think cuisine is a complete art, like cinema: it has a visual component, narrative, taste, and smell." His own photographs are also a complete art, as they cross boundaries between painting, appropriation, sculpture, and photography.

233 Vik Muniz, *Milk Drop Coronet (After Harold Edgerton)*, 1997

↖ Vik Muniz, *Che (Black Bean Soup)*, 2000
↑ Vik Muniz, *Double Mona Lisa, After Warhol, (Peanut Butter + Jelly)*, 1999

SOPHIE CALLE

In the novel *Leviathan* (1992), the writer Paul Auster introduces the reader to an artist named Maria. Maria was based on the artist Sophie Calle, and Auster uses episodes and artistic projects from Calle's real life in factual and meticulous detail. In the dedication, Auster acknowledges this debt, and thanks Calle "for permission to mingle fact with fiction." Calle decided to respond to this and conflate truths and lies by acting like Maria. During one week in December 1997, she set out to eat the food that Maria did in the book. She created what Maria called "the chromatic diet," a regime of restricting herself to foods of only one color on any particular day. But not only did Calle recreate the meals and presumably eat them (which she claims she did on the Sunday of that week, with invited guests—although it's hard to know what is true and what is not), more important, she photographed them and turned them into the series The Chromatic Diet.

The way the meals are photographed interprets the monochrome idea in both the styling and the food; the tablecloths, cutlery, and napkins follow the strict instructions for the day. Still, for Calle, rules are meant to be broken, so she adjusted the menus, adding rice and milk to the white day because she was not satisfied with Auster's menu. She also invented the meal for Friday because it was not included in the book. Every day the table was set in the same way, and although the fictional concept may seem ridiculous, it is not far off from many "real" diets—which might prescribe eating for your blood type or not mixing carbohydrates with protein, for example. Here, food, through literature and photography, becomes witness to a true friendship between fiercely intellectual and creative friends, jousting with the fictional and conceptual underpinnings of life's narrative.

Sophie Calle,
The Chromatic Diet:
Monday Orange,
Tuesday Red,
Wednesday White,
Thursday Green,
Friday Yellow,
Saturday Pink,
1998

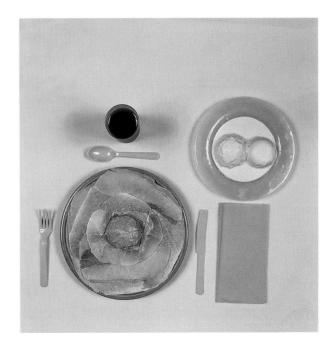

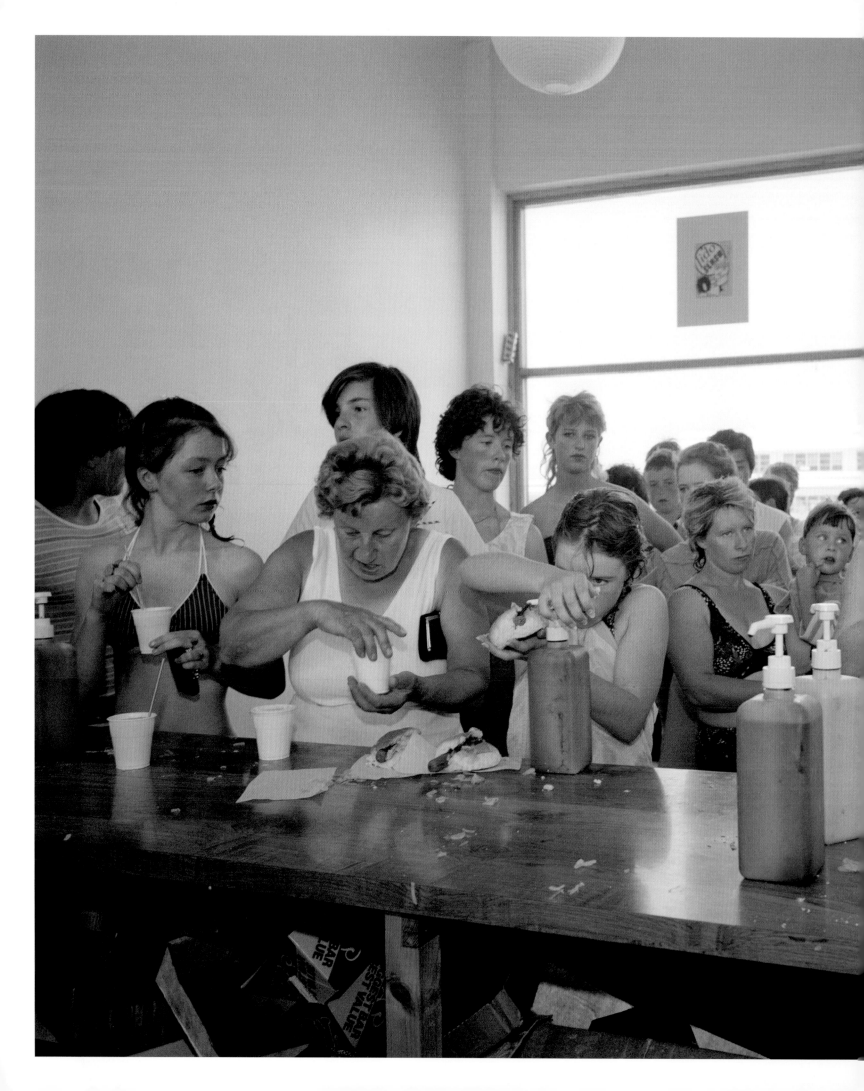

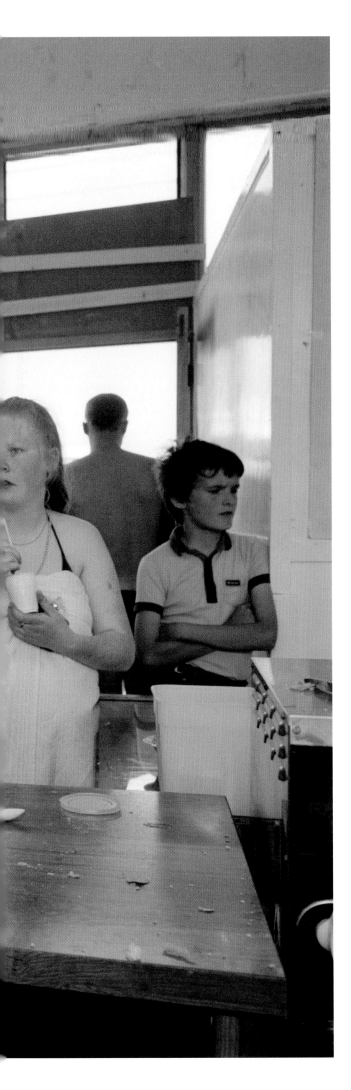

MARTIN PARR

As in much of his other photography, Martin Parr turns to the cliché or stereotype to represent food and comment on national identity. We see fish and chips and think British; doughnuts equal America. The images are often garish, consumerist, and frequently just plain silly. Parr concentrates on what is considered "ordinary" food; this is not the stuff of banquets or weddings, but of church bake sales and butchers' slabs. And the food is not the only victim of his forensic gaze—so are the highly coded willow-patterned teacups, flowery plates, Tupperware, and gingham tablecloths they sit on. It is these ordinary foods, and the way they are presented, that cut to the core of what it means to be British. A village fete and seaside fish and chips represent British nationalism instantly, far away from pomposity, propaganda, and politics: the most ancient of British rituals, defiant in the face of change and progress.

Martin Parr, *Untitled (Hot Dog Stand)*, 1983–85

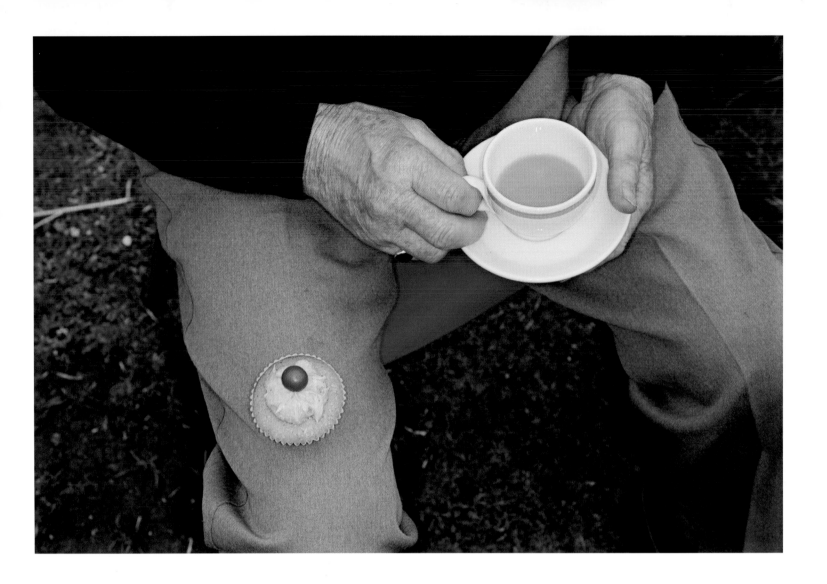

Parr seems to feel a genuine bemusement, curiosity, and fascination as he constantly probes at human preference, taste, and identity—be that personal, national, or cultural. He does not take sides, and everyone and everything is prone to his jabs, which highlight human insecurities, snobbishness, or foolishness. As his work has progressed, issues of consumerism and globalization have become recurring themes and a growing preoccupation. Still, unlike many documentary photographers, he is not driven to make a social point or tell a particular story—he simply wants to make a good picture.

Parr's intense use of color shows his early influences from American photographers such as William Eggleston (pp. 168–71), who in the 1970s held a vivid exoticism for British photographers. But other influences are more humble, including postcards by John Hinde, whose photographs were included in *The Small Canteen: How to Plan and Operate Modern Meal Service* (pp. 92–95). It is the smallness of Britain that is treated slightly differently in some of the pictures here—there is a tenderness not apparent in Parr's other work. Seeing a man drinking tea with a fairy cake balanced on his knee is so immediately familiar to anyone British that it instantly raises a smile of fondness and connection.

↖ Martin Parr, *Wells, Somerset, England*, 2000
↑ Martin Parr, *Wells, Somerset, England*, 2000

→ Martin Parr, *West Bay, England*, 1996

Martin Parr, *Wales, Abergavenny,* 2008, and
Jam and Cake for Sale, Dorchester, England, Puncknowle Fete, 1998

Martin Parr, *Bristol, England*, 2005,
and *Pink Pig Cakes*, 2002

245

HOLGER NIEHAUS

The still-life tradition is continued in this picture, but with a gentle intervention that makes the lushness of fruit seem slightly more clinical. With their peels removed, the fruits' hues become more pastel as they lie naked on a marble slab. In peeling off the layers of the skin, Holger Niehaus is also peeling away the layers of symbolic associations concomitant with the still-life genre. By doing so, he creates something new and wholly photographic, influenced by painting but subverting its history.

Although undoubtedly beautiful, the sliminess of the lychees contrasts with the pith of the citrus, adding a hint of abjectness to an otherwise gorgeous image. Unlike still-life painting and early photographs of food, the background here is resolutely modern and unadorned. Niehaus's pared-down vision is carried across all of his work, which—like that of many still-life photographers—features flowers as well as food. He also utilizes absurd juxtapositions and makes miniature sculptures, but the food still looks appetizing, and there is no irony, critique, or kitschiness to his approach. These are gentle, serious, considered pictures, with a knowledge of the history of art and the symbolism that resonates throughout the history of painting food. One hundred and fifty of his food images were published in Marjoleine de Vos's weekend cooking column in the Dutch daily evening newspaper *NRC Handelsblad* between 2011 and 2014.

247 Holger Niehaus, *Untitled*, 2000

↑ William Yang, *La Choucroute, Strasbourg, France*, 2002
↗ William Yang, *Ruby's Kitchen, Enngonia, New South Wales, Australia*, 2000

WILLIAM YANG

Australian artist William Yang has been taking photos of food since the 1980s and has often included them in his performance pieces. Through this, he discovered that when he showed a picture of food in the context of a narrative, especially mundane food, the audience found it very funny. He made this a specialty of his early shows, including a whole show on food titled *The Fabulous Trifle*, which took place in the early 1990s at the Museum of Contemporary Art in Sydney. Yang still takes photos of food, but with the proliferation of similar images on social media, they have lost some of their comic charge. The work here takes on a more metaphorical or allusive approach to storytelling, which lies at the heart of Yang's work. While traveling internationally to see friends and family, Yang has concentrated his gaze on the ritual of preparing and eating food, which so often binds people together. *Who* the food is shared with and *where* it was eaten are of equal importance to the food itself. Little hints of this are given in the handwritten titles and dates that are characteristic of Yang's work; the conversations shared, jokes laughed at, and intimate moments enjoyed linger effervescently in the photographs. This invisible quality of connection and sharing is not illustrated, but is embedded in the photographs, with the food becoming symbolic of something much bigger and more personal.

In addition, the food photographed also acts like an instant signifier of cultural and national identity. The skinned kangaroo that sits on Ruby's kitchen counter has to be in Australia; the frankfurter and sauerkraut choucroute can only be from Alsace. "Food is part of the ongoing blog of my life," says Yang, "which, since I am into stories, has become my main art form: part performance, part autobiography, part travelogue, part cultural commentary." It is through observation and the act of photographing food and its associated rituals that these works become a rich meditation on sharing meals with loved ones, as well as on the deeper qualities of love and belonging.

RINKO KAWAUCHI

A sleepy grace infuses the work of Rinko Kawauchi. Concentrating on tiny gestures of the everyday and musing on small, fascinating details, her photographs feel like a sigh of serenity in a frenetic world. Often described as visual haikus, her pictures have a spartan elegance. Food is a crucial part of that investigation into the quotidian. Photographed with an undulating perspective, moving in and out of focus, the most simple and delicate of foods—tuna, fish eggs, or melon—become something wholly more substantial, in a way that is void of heavy symbolism and illustrative narrative.

 The food Kawauchi photographs is fragile: the fish eggs could be burst, the tuna squashed, the melon consumed by an insect. This fragility is key to her work, which often explores life cycles, be they of her family or insects that live for only a short while. Her work can appear melancholy and fleeting. The way she has photographed the tuna here (p. 253) differs slightly: by going in close, Kawauchi has abstracted it, relishing the formal patterns and grain of the flesh and its contrasting colors. The gentle shape of the filet appears like a precipitous mountain. These shifts in scale can also be seen with the centipede (p. 252), which appears enormous. The effect is no less fragile, drawing the viewer's attention to details that may otherwise go unnoticed.

Rinko Kawauchi, *Untitled*, 2001; from
the series Utatane

↖ Rinko Kawauchi, *Untitled*, 2004; from the series AILA
↑ Rinko Kawauchi, *Untitled*, 2009; from the series Illuminance

SIAN BONNELL

These pictures, taken from the series Everyday Dada (House Beautiful) from 2005, take food and transform it into the décor of Sian Bonnell's home. Here, slices of processed lunch meat with a boiled egg set inside become a kitchen backsplash, toast becomes a checkerboard floor, a pancake becomes a coaster, and fried eggs surround the toilet like a mat. Such care and attention is taken with these endeavors that they are touching, funny, and almost believable.

The enthusiasm with which Bonnell creates these domestic scenarios shows not only a critique of the mythical obsessive housewife, bound to the home and its upkeep, but also a love of her own home and of food, as she embellishes her own living space in such an eccentric and cheerful way. She describes her practice as "willful amateurism," stating that it "functions within a paradoxical space between sculpture, performance, and photography. It is made manifest through my own lived domestic experience and is fueled by the following characteristics: play, imagination, dysfunction, irreverence, absurdity, chance, and fiction."

In 1861, when the young Isabella Mary Mayson, more commonly known as Mrs. Beeton, suggested in the book *Mrs. Beeton's Book of Household Management* that "cleanliness, punctuality, order, and method" were the ideal characteristics for a housekeeper, it was unlikely that she could have imagined artistic subversions of such ideals. Such obsessions also encourage succinct picture-making, referencing a strong tradition in European sculpture and photography that revels in shifts of scale and environment to give objects an unexpected visual charge; this can also be seen in the work of Fischli and Weiss (pp. 182–85). Bonnell's love of the absurd (and, indeed, of cleanliness, punctuality, order, and method) make her a wonderfully surreal housekeeper of the highest order.

255 Sian Bonnell, *House Beautiful #1*, 2005

↖ Sian Bonnell, *House Beautiful #2*, 2005

↑ Sian Bonnell, *House Beautiful #15*, 2005

BREAKFAST, LUNCH, TEA

Breakfast, Lunch, Tea is the first book by Rose Carrarini, co-owner of and cook at the Rose Bakery, an Anglo-French bakery and restaurant in Paris. One of the challenges of illustrating a cookbook is finding a photographer who matches the ethos and sensibility of the restaurant, chef, magazine, or indeed supermarket. Here, Toby Glanville is perfect: his gentle, unobtrusive images are concerned with the very traditional essentials of the photographic medium—time and light—and the rhythms of the workday are delicately and respectfully imaged. There are none of the histrionics and dynamic, raw documentary style seen in *White Heat* (pp. 224–25). Instead, the kitchen here appears to be one of diligent hard work and honed craft.

 With one hundred photographs, the book is much more than a cookbook, but it isn't an illustrated coffee-table book, either. Instead, it is a tribute to the conventional pleasures of a good life and the everyday workings of the bakery and restaurant: the food they cook, the people who work there, and the suppliers. In among this are little gestures or moments of life in the kitchen, which appear like still lifes in their stripped-down simplicity and peaceful beauty. Photographic books of restaurants and recipes are not new, but the scale of *Breakfast, Lunch, Tea*, the number of photographs in it, and the generosity with which the staff, suppliers, and customers are photographed, mark it as a book of a slightly different nature: a hybrid photobook, cookbook, book about a restaurant, and personal memoir of sorts.

Toby Glanville, *Raymond Pailleau
and Gerard Folliot, Butchers. Paris*, 2005

↖ Toby Glanville, *Still Life with Financiers. Paris*, 2005

↑ Toby Glanville, *Jacob, Kitchen Assistant. Paris*, 2005

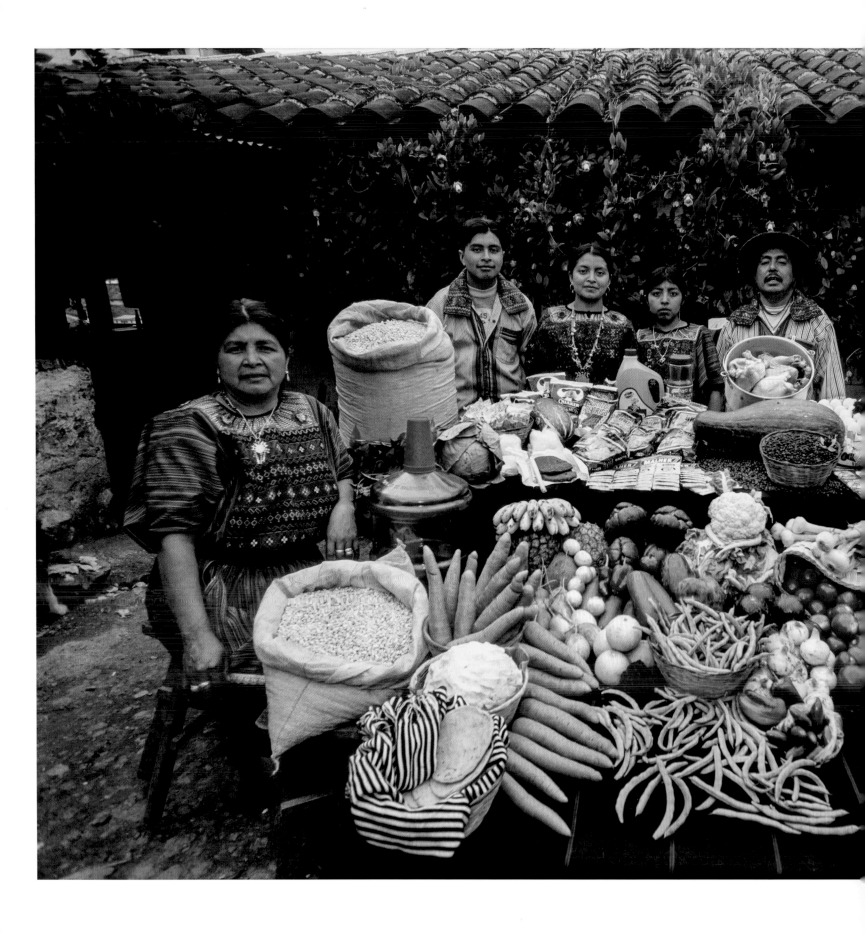

Peter Menzel, *The Mendoza Family, Guatemala*, 2007

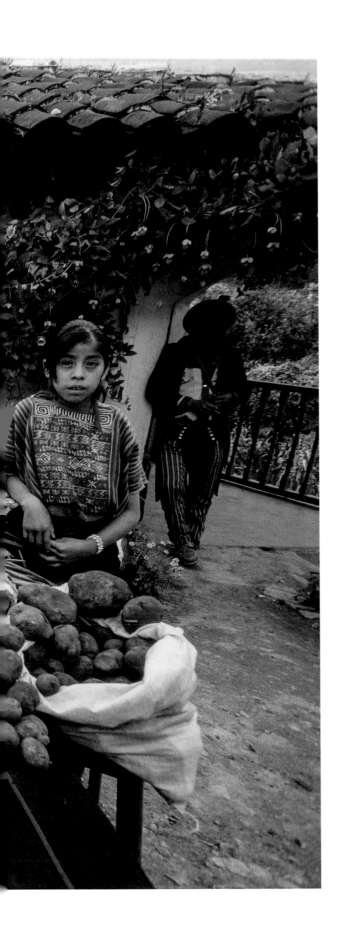

HUNGRY PLANET

Hungry Planet: What the World Eats, by photographer Peter Menzel and writer Faith D'Aluisio, was inspired by a very simple idea: first published in 2005, it presents an overview of what families around the world eat every week, with grocery lists and costs of what they spend on food. Although the book features many photographs of each family in their community, the pictures of them standing behind their week's worth of food laid out for the camera gained the most attention, and have become the images for which the project is best-known.

The project depicts twenty-four countries, and it is a delight to compare and contrast the different families' groceries. Its success relies on the viewer's curiosity, prejudices, and their own relationship to food. Too much bread? Too much meat? In this respect, photographs of food become a highly coded carrier for personal complexities and ingrained attitudes around eating, heath, the body, and consumption.

It's like being given the keys to somebody else's apartment to poke around in, and, as such, the photographs also offer insightful clues as to what people consider to be family, home, and the relationships within those structures.

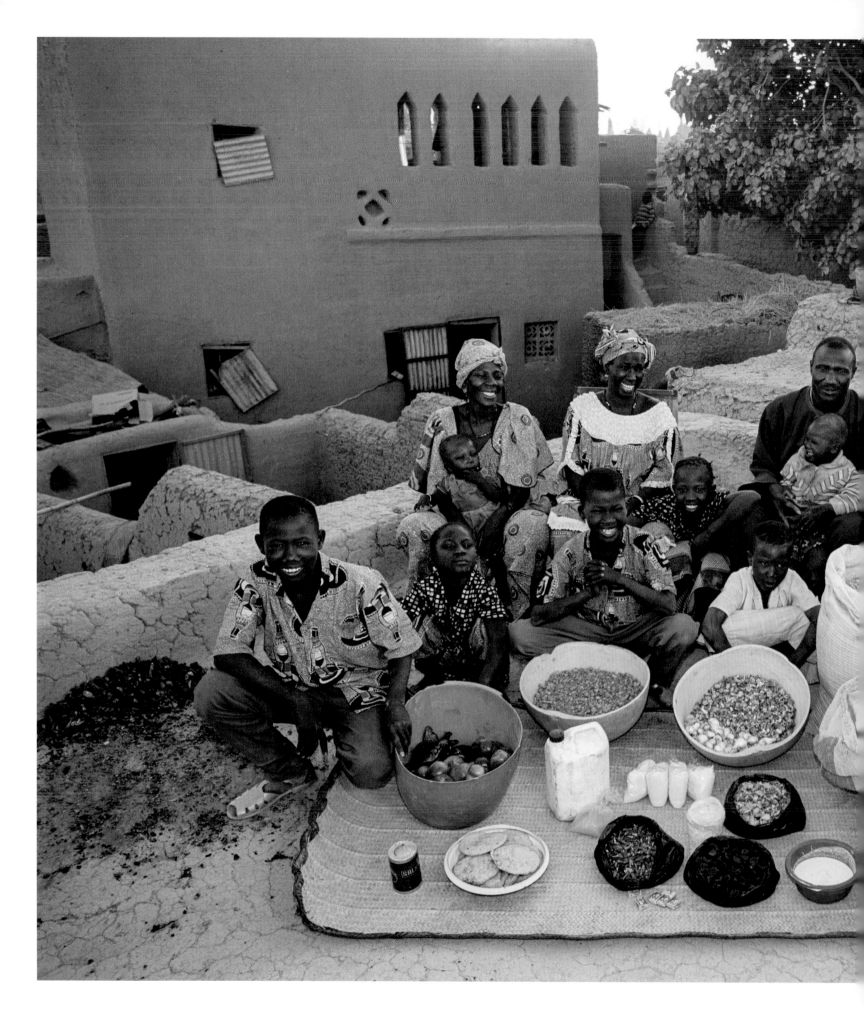

Peter Menzel, *The Natomos Family, Mali*, 2007

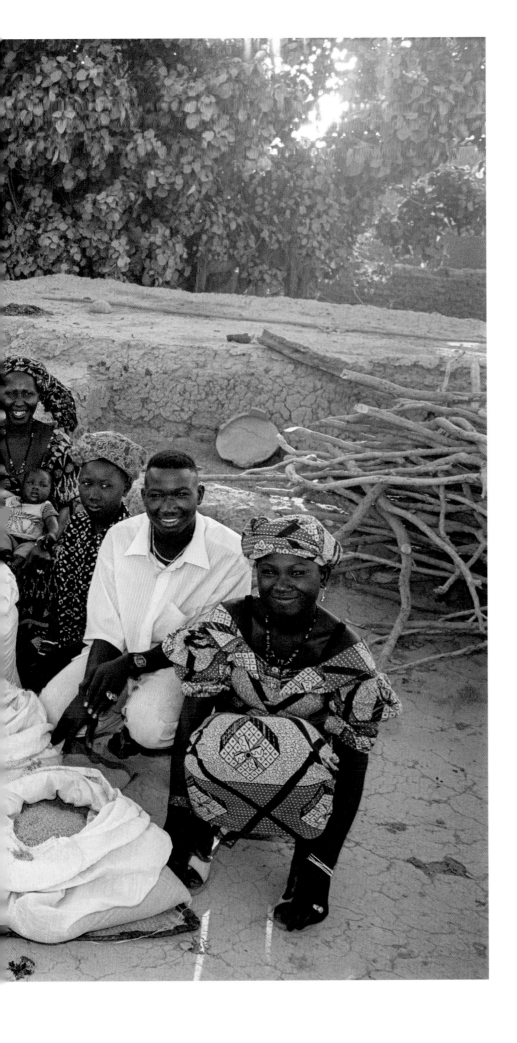

This generalization of culture through food is not without its problems. What is a "typical" family? How can one family represent a whole nation? Does the project just feed national stereotypes? Is this anthropology lite? Similar questions can be, and were, asked of Time-Life's Foods of the World series (pp. 140–43). However, *Hungry Planet* also includes essays by a broad range of authors who try to preempt such criticism and bring the politics of food to the forefront. This contextualization addresses some of the more problematic elements of nationhood and national habits, food politics, and the globalization of processed food and big brands.

DAVID LOFTUS

David Loftus is one of the UK's leading commercial food photographers. His pictures came to personify much of the food culture of the 1990s and 2000s, and he was among the first in Britain to start using techniques that we now associate with good commercial images. As in the work of *Gourmet* photographer Romulo Yanes (pp. 276-79)—albeit with a more relaxed aesthetic—this includes using a more documentary style and shooting in daylight with a shallow depth of field, highlighting crumbs, spills, and stains. Like Yanes, Loftus photographs food as it is cooked, in such a way that it makes you want to eat it. He pioneered showing "food in motion": pasta steams, cheese melts, citrus squirts—and olive oil pours, as can be seen in this picture of Jamie Oliver.

Loftus works best in situ rather than in the studio. As well as shooting for supermarkets, magazines, and ad campaigns, he has become well-known for his books featuring chefs and their restaurants, including Ruth Rogers and Rose Gray at the River Café, Marcus Wareing, Nathan Outlaw, Rachel Khoo, and April Bloomfield. The River Café books are especially important here, as they highlighted the chefs as much as the recipes, for a very mainstream audience—something which is now commonplace, as many cookbooks are overtly personality-led. However, Loftus is best-known for his long-standing relationship with Jamie Oliver. The photographer has managed to create an atmosphere in his photographs that perfectly fit the Oliver brand—from Oliver's early "laddy" books, which emphasized home cooking for friends, through to the chef as the more comfortable, politically enlightened father, who cooks fast, nutritious meals aimed at the family.

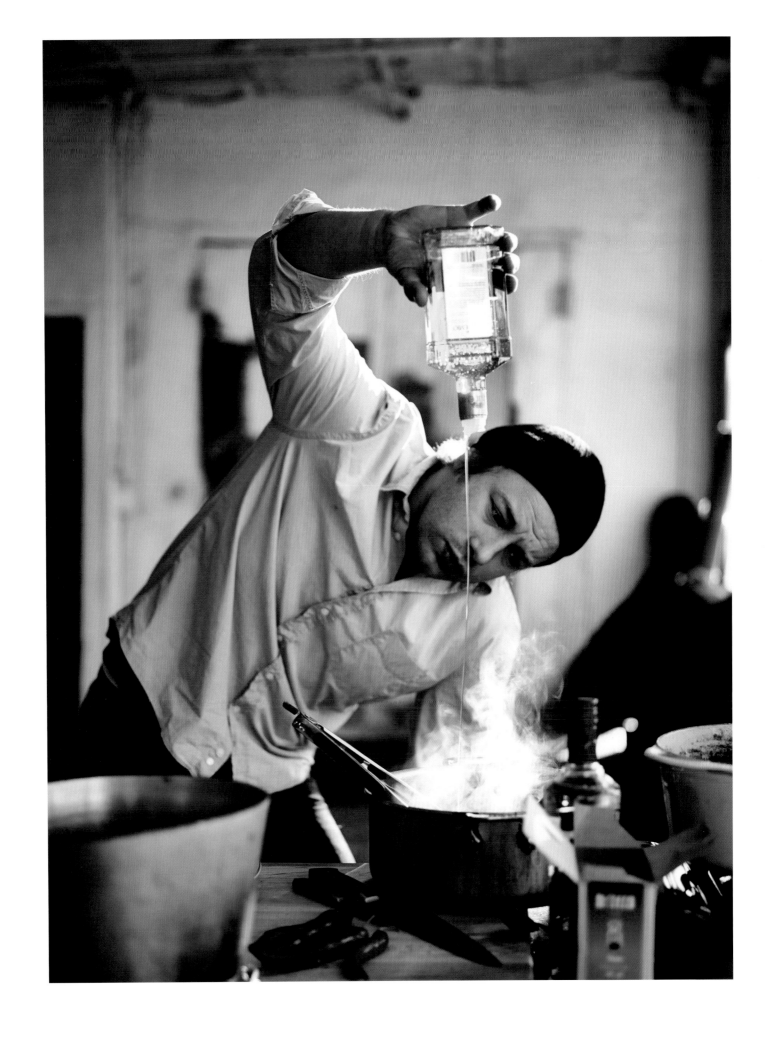

David Loftus, *Untitled*, from *Jamie's America*, 2007

SHARON CORE

The photographs here come from Sharon Core's series Early American, which takes its influence from the American still-life painter Raphaelle Peale (1774–1825)—but they are more than simple copies of paintings. Instead, they are conceptual investigations into the role of photography in understanding and viewing paintings—which many viewers experience through photographic copies of artworks found online or in books anyway, rather than in person. Made from these reproductions, Core's work can then be understood as photographs of photographs of paintings, with all the attendant gaps, reproduction problems, and flattening of color that occur through the process of reproduction. Core painstakingly recreates scenes from the paintings, even growing her own heirloom fruits and vegetables and sourcing nineteenth-century tableware and porcelain. This is a laborious process dependent on seasonality, and so the natural rhythms of nature mirror the time that would have been taken to create the painting. The genre of still life in the history of art—and indeed the history of photography—is an enduring one; this contrasts with the temporary, fragile nature of real fruits and vegetables, which are often shown in a state of decay, symbolically suggesting human mortality.

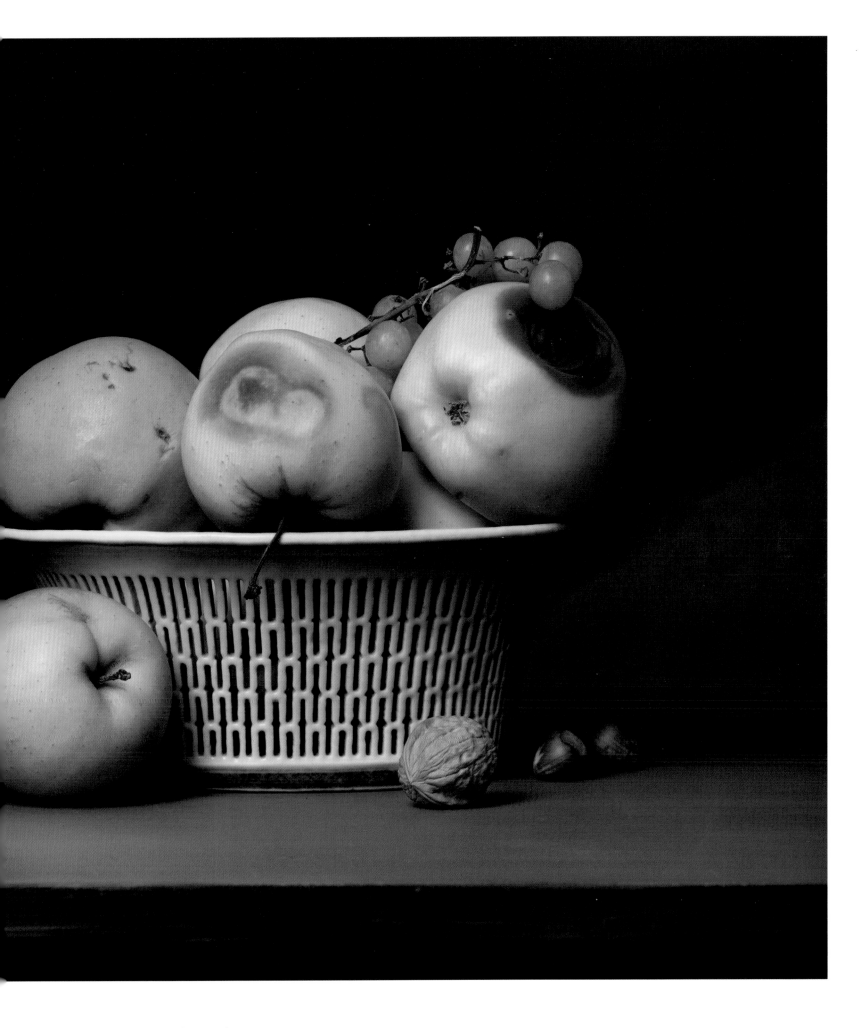

Sharon Core, *Early American—*
Apples in a Porcelain Basket, 2008

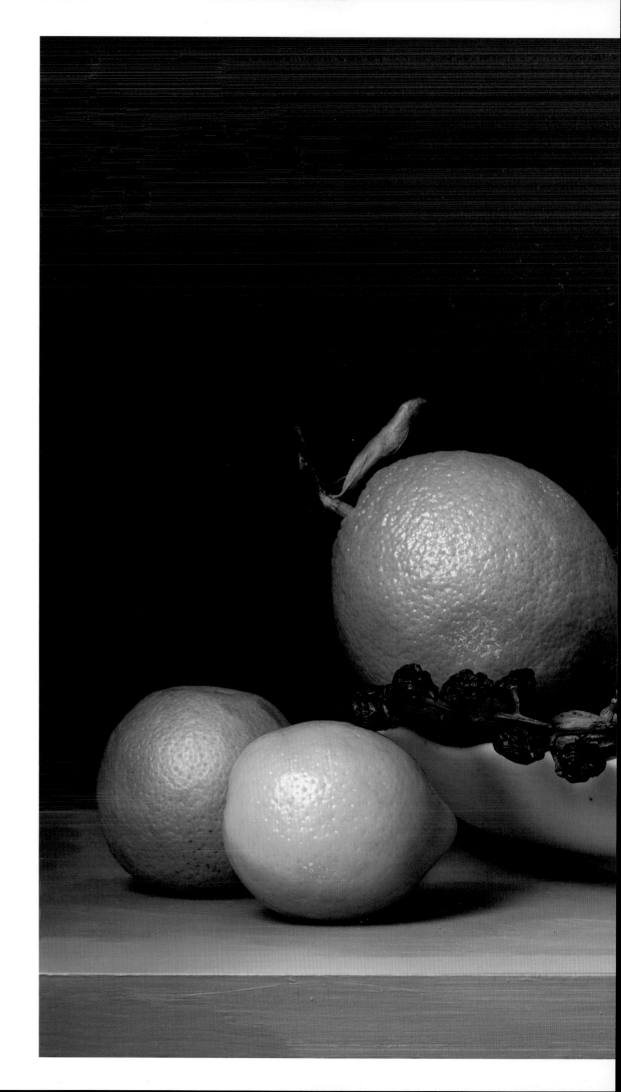

Sharon Core, *Early American—*
Still Life with Oranges, 2008

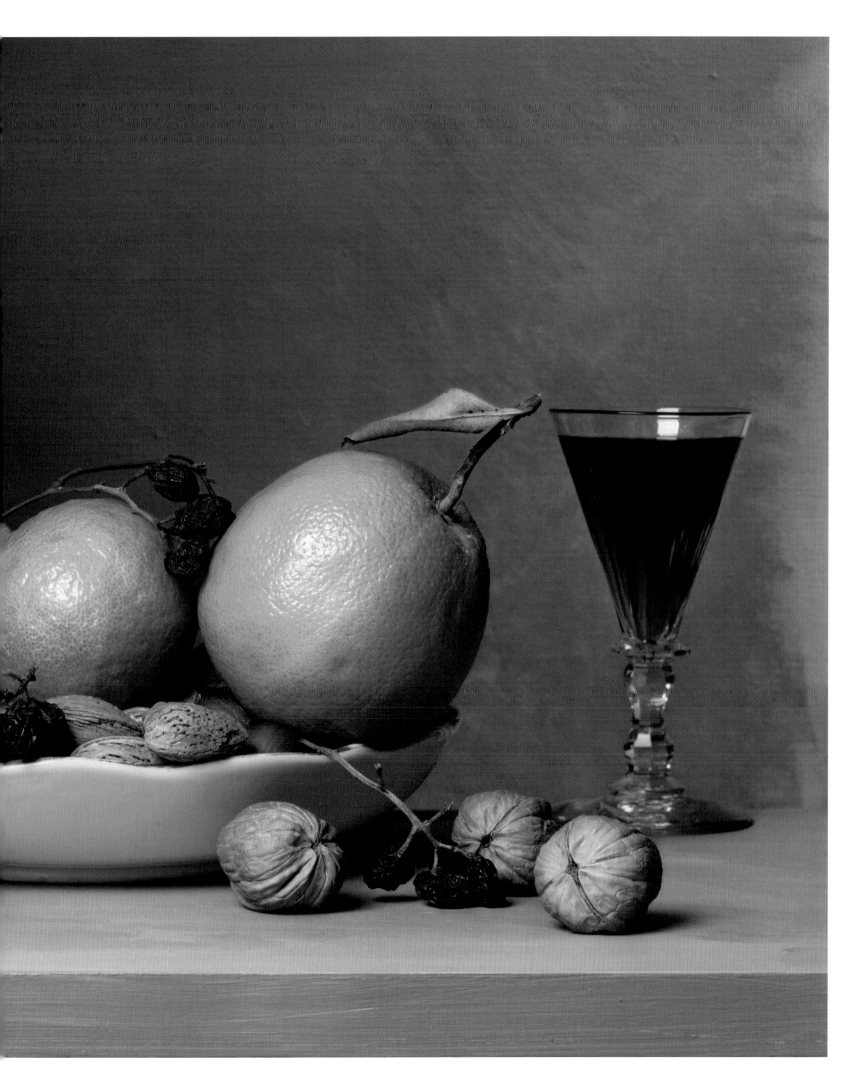

TIM WALKER

What fun it would be to live in a Tim Walker photograph. His pictures allow us to remember the joy and possibilities of imagination, which sadly fades for many of us as we grow up; imaginary games disappear, and the rigors of daily living replace fantastical stories. Not so for Walker. Photography allows him to harness such childlike abilities of the mind. Here, he has photographed himself sitting in a sumptuous bed, hoarding cakes—just as a child might hide his or her stash of candy under the bed. Of course, we know it would make one sick, but this is a moment of wicked delight and satisfied glee, free of such consequences, in the sheer extravagance of fantasy. Like all of his work, this portrait is transcendent: Walker pushes the possibilities until the picture is right. He gilds the lily, going over the top and as far as he can with an image—until it is unmistakably his, almost bursting at the seams with exuberant joy and romanticism.

Cake also features in the tree growing in a grand sitting room (pp. 274–75). The British model and actress Lily Cole stands as if frozen by some magical power, like Alice after she has succumbed to the tempting signs of "Eat Me" and "Drink Me" in *Alice's Adventures in Wonderland*. A tree sprouting cake? How wonderful! Fashion photography is often about desire and fantasy. Perhaps that is why cake is so often featured within the pages of editorial spreads; not only does it look good, but it elicits a sinful craving from those who know they "should not" eat it—remaining an elusive and much-longed-after temptation.

273 Tim Walker, *Self-Portrait with Eighty Cakes*, 2008

Tim Walker, *Lily Cole and Cake Tree*, 2004

ROMULO YANES

Romulo Yanes's photography from this period is an example of how commercial food photography changed going into the twenty-first century and became the style we now associate with magazines and cookbooks. There is nothing fake about the food he photographs, and his approach is not one that looks like it requires hours of styling, or as if it's been lit and arranged to perfection. Instead, this is food that is cooked to eat.

Yanes's photographs are highly attentive to textures in the food and have a sense of suspense—the food is about to be eaten or is in process: a piece is missing from the cake, the food's in the pan, or a fork's on the plate. The photographer invites the audience to make the dishes just the same way, and suggests that they can. Everything looks delicious, but not out of reach, with a realism that taps into the eyes, mouth, brain, and stomach. The food is lit by daylight or softly diffused light; nothing is shiny and everything is gorgeous, with a relaxed elegance and clarity of vision. The food is prepared with quality ingredients and simply looks as good as it can get. This does not involve elaborate styling—just a lick of oil or slightly undercooked vegetables, so they still appear perky.

Any commercial food photography will have undergone some kind of digital processing, but for these photographs, it is just a tidying up, retouching a stain or simply enhancing. A staff photographer for *Gourmet* for over twenty years, Yanes perfectly reflected the brand of the magazine: exquisite quality and seriousness, both in the studio to accompany recipes, or for food editorial. With Yanes's photographs, we can consume the food with our eyes and be completely satiated. It isn't even necessary to attempt to cook the recipes ourselves.

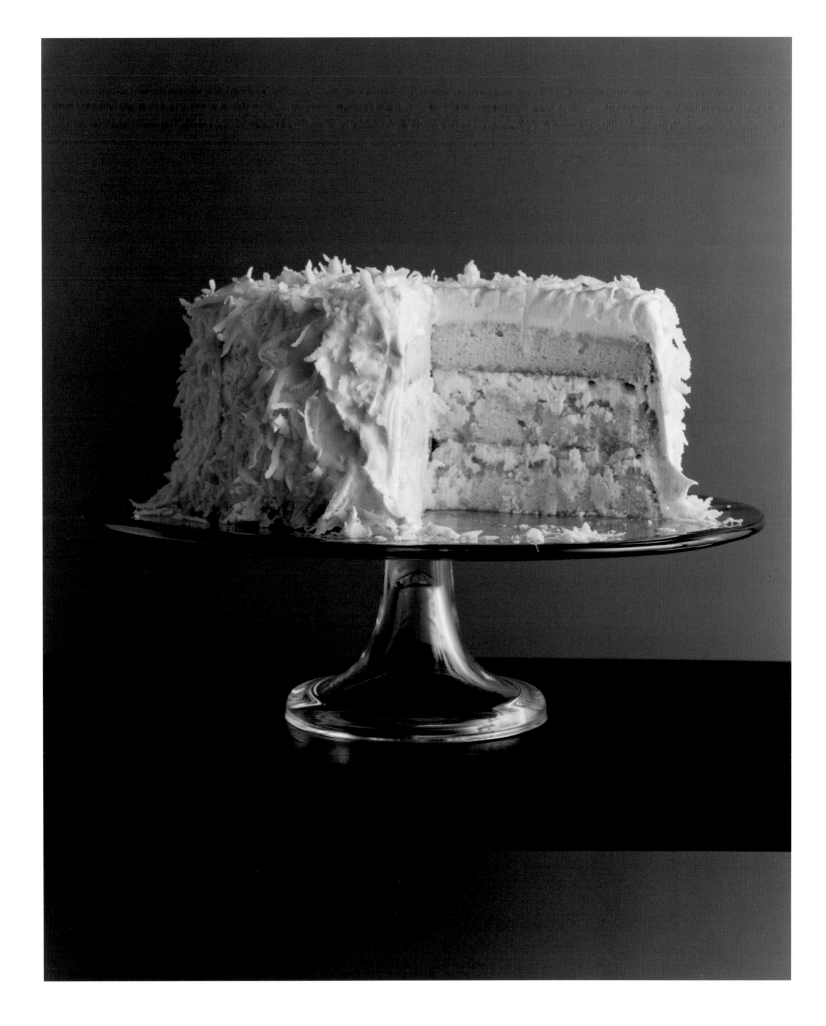

Romulo Yanes, *Fresh Coconut Layer Cake*,
Gourmet, January 2008

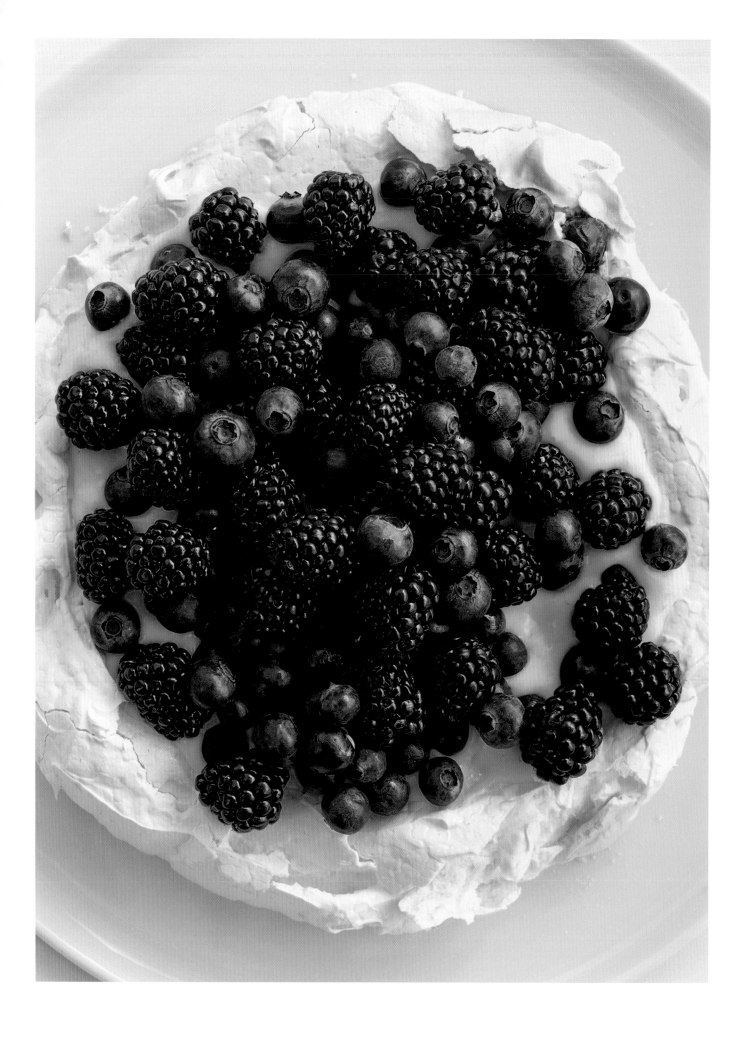

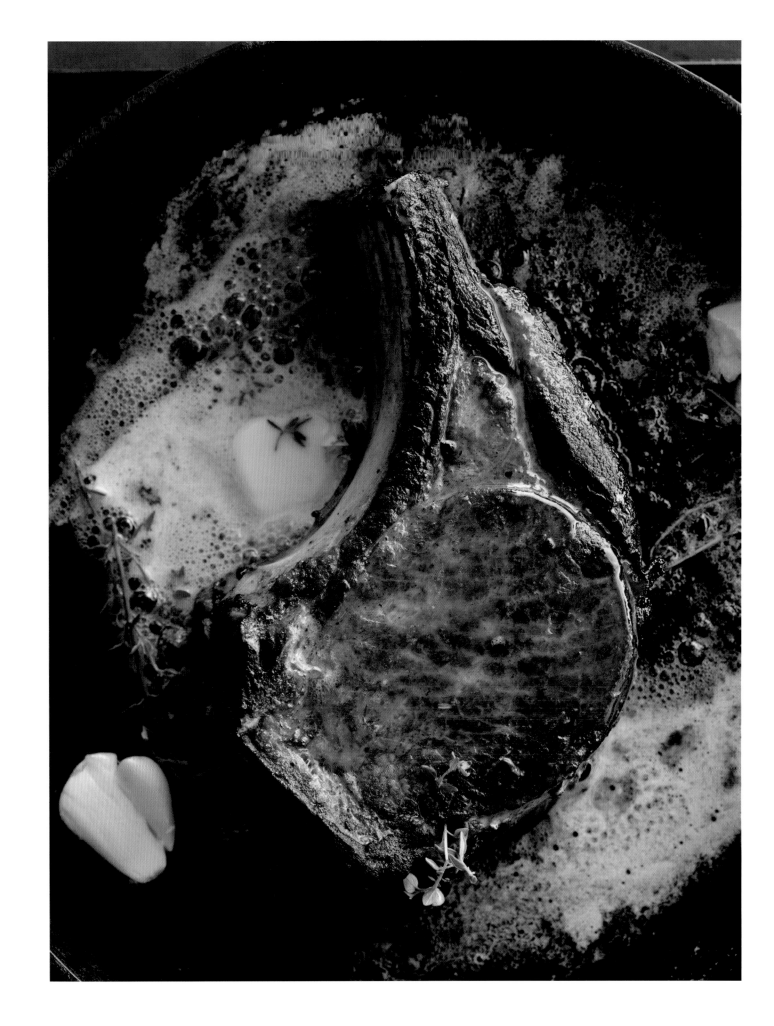

↖ Romulo Yanes, *Pavlova With Lemon Curd and Berries, Gourmet*, April 2009
↑ Romulo Yanes, *Pan-roasted Brined Pork Chop, Bon Appétit*, January 2013

Carl Kleiner, pages from *Hembakat är Bäst*, 2010

HEMBAKAT ÄR BÄST (HOMEMADE IS BEST)

The IKEA cookbook *Hembakat är Bäst* (Homemade is best), photographed by Carl Kleiner and styled by Evelina Bratell, was part of an advertising campaign to sell the store's kitchen appliances. They decided the best way to do this was to show the food that could be made with their products. The book contains two photographs per recipe: the first shows the ingredients, while the second shows the completed dish.

The photographs of the ingredients are of the most interest here, as they were an important marker in the way that ingredients were photographed in many books that followed. Although the technique of separating out ingredients also appeared that same year in the book *What to Cook and How to Cook It*, written by Jane Hornby and photographed by Angela Moore, *Hembakat är Bäst* takes the technique to an elegant and minimalist extreme. Shot from above, the ingredients are shaped and arranged into geometric forms on pastel backgrounds. The singular ingredients bear no resemblance to the finished food, and this highlights the alchemic magic that happens when you combine ingredients to cook. The clinical smears of chocolate or oil and piles of flour expertly molded into a pyramids do not act as a visual aid for the cook, as the laying out of ingredients does in many other cookbooks; rather, it is more of an example of a great collaborative idea realized, and a wonderful combination of design and photography.

Ingredienser:
9 dl ca (550 g) vetemjöl
1 msk hjorthornssalt
2 dl strösocker
200 g smör
2 ägg
2 dl filmjölk

Smaksättning:
2–3 droppar bittermandelarom
alt. rivet skal av 1 citron eller
1 msk stött kardemumma

Pensling och garnering:
uppvispat ägg
pärlsocker

45

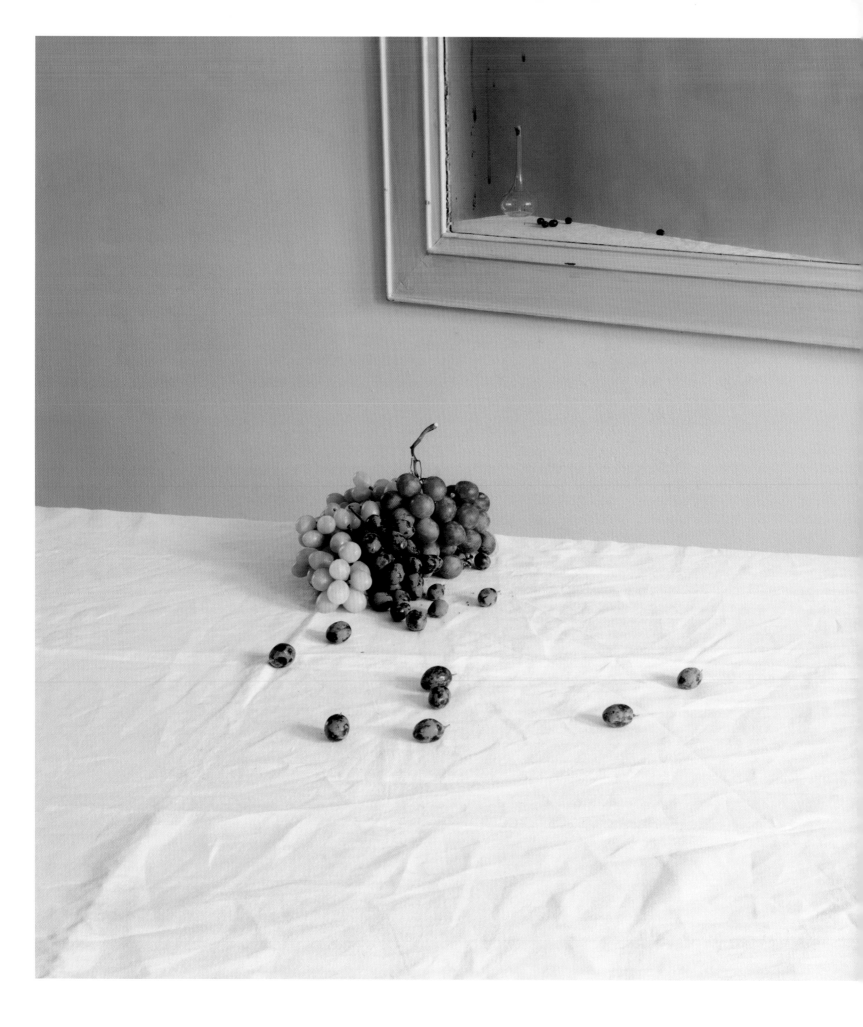

Laura Letinsky, *Untitled #117,* 2001; from
the series Hardly More Than Ever

LAURA LETINSKY

Since the 1990s, Laura Letinsky has been creating meticulously composed still-life photographs influenced by seventeenth-century Renaissance painting and later masters such as Chardin, Cézanne, and Morandi. But instead of simply referencing art history, her photographs are inscribed with the remnants of family life, as can be seen here with a child's sucked lollipop gouged onto a plate (p. 287). Her earlier work focuses on what remains on the table—the aftermath of a meal—and hints at action outside the frame.

This is something that is always contained in photographs of food: they suggest a lifestyle. When you look at the very best photographs, you want not only the food, but also the tableware and cutlery. You crave the feeling of comfort that comes from knowing somebody has taken the trouble to bake you a cakc, or pick you gorgeous peaches. This messaging is especially strong in commercial food imagery. Letinsky fully understands this latent desire and transforms this into her art. As such, the work is infused with ideas of family, conviviality, and love, and she positions her work in a place of intimacy and tenderness. But it is far from purely

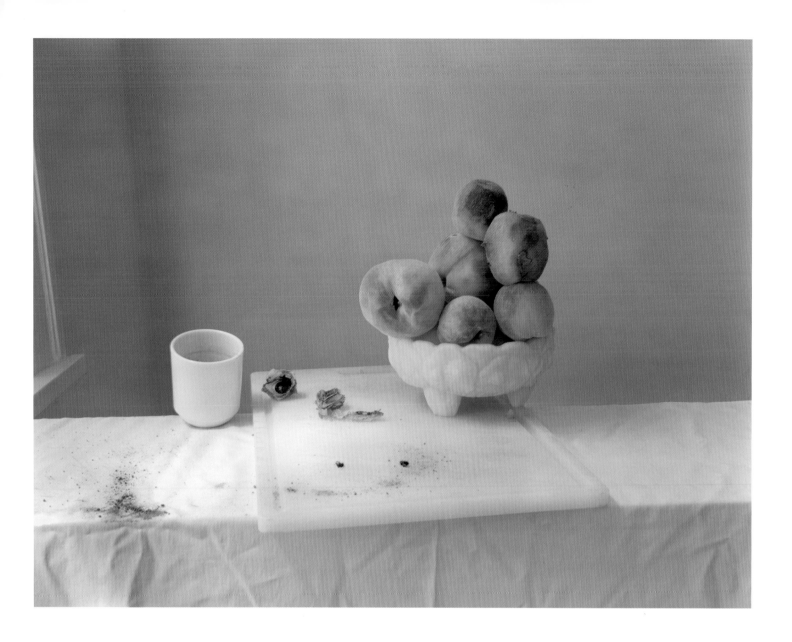

decorative or sentimental. With Letinsky, every household article (be it food or domestic prop, or even a reproduction of such) is rife with issues of want and need, capitalism, consumerism, and obsolescence. She also obliquely comments on feminist discourse around pattern, prettiness, and ornamentation as they are circumscribed within the domestic arena.

Since 2009, Letinsky's work has shifted into a sophisticated questioning of the medium of photography and its influence on how we see and make our world. She creates photographs in a studio setting that comment on image culture—how food appears in magazines and is then regurgitated onto various other platforms. In order to create them, Letinsky incorporates cutouts from ads and lifestyle and art magazines—infiltrating her setups with both objects and their reproductions, their hierarchies stripped. Food still features, but the photographs can no longer be read in the still-life tradition, and instead are meditations on plane and space, and the function of the photograph itself.

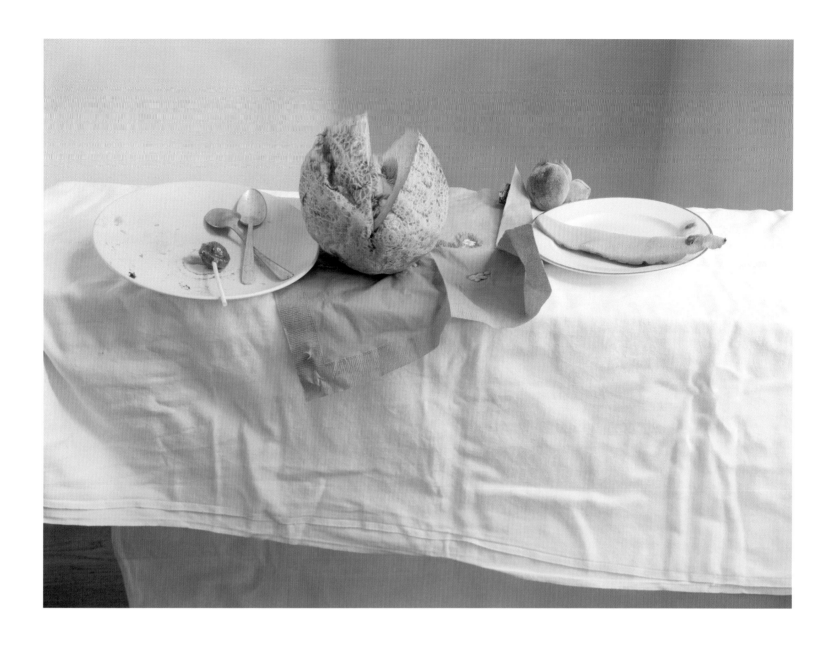

In this way, Letinsky's work resonates with that of Daniel Gordon (pp. 314–17), but her use of existing reproductions—especially those of food from lifestyle magazines such as *Martha Stewart Living*—comment more directly on the way food has been imaged, imagined, and consumed. What has not changed through this development in her work, and its concomitant uneasiness between objects, is an understanding of the importance of beauty and desire when considering the function, role, and relationships of the representation of food.

↖ Laura Letinsky, *Untitled #49*, 2002; from the series Hardly More Than Ever

↑ Laura Letinsky, *Untitled #54*, 2002; from the series Hardly More Than Ever

Laura Letinsky, *Untitled #19,* 2011; from
the series Ill Form and Void Full

ELAD LASSRY

Whereas others, such as Laura Letinsky, use the still-life genre to hint at lives lived, Elad Lassry creates disciplined arrangements that have no narrative intent or political or personal reflection regarding the subject matter of food. Here, food is purely a prop. Lassry takes his cues from commercial and stock photography's generic slickness, but there is nothing to sell. The work, instead, is a rigorous investigation into perception and the meaning of contemporary images. While looking at them, you might ask: what do these images mean? Why has he used food? Are they just artful juxtapositions of objects that reflect a similar color and contrasting textures? Why has he put them all together? What purpose does the cabbage serve?

No answers are forthcoming, but the fact that we might ask them of photographs forefronts that we would not ask them of paintings. This highlights the expectation we still have of photography to be closely tied to the real, or at least the metaphorical. When the food responds to none of our interrogations, the pictures can be infinitely frustrating and confusing.

Lassry always prints his photographs the same size—no bigger than a page of a magazine—and frames them in a color drawn from the picture. This makes them both object and image. They demand close looking, operating between abstraction and figuration, and are perhaps best understood in the wider context of his work, which includes film, sculpture, and drawing—all of which share recurring themes of subjectivity and visual perception.

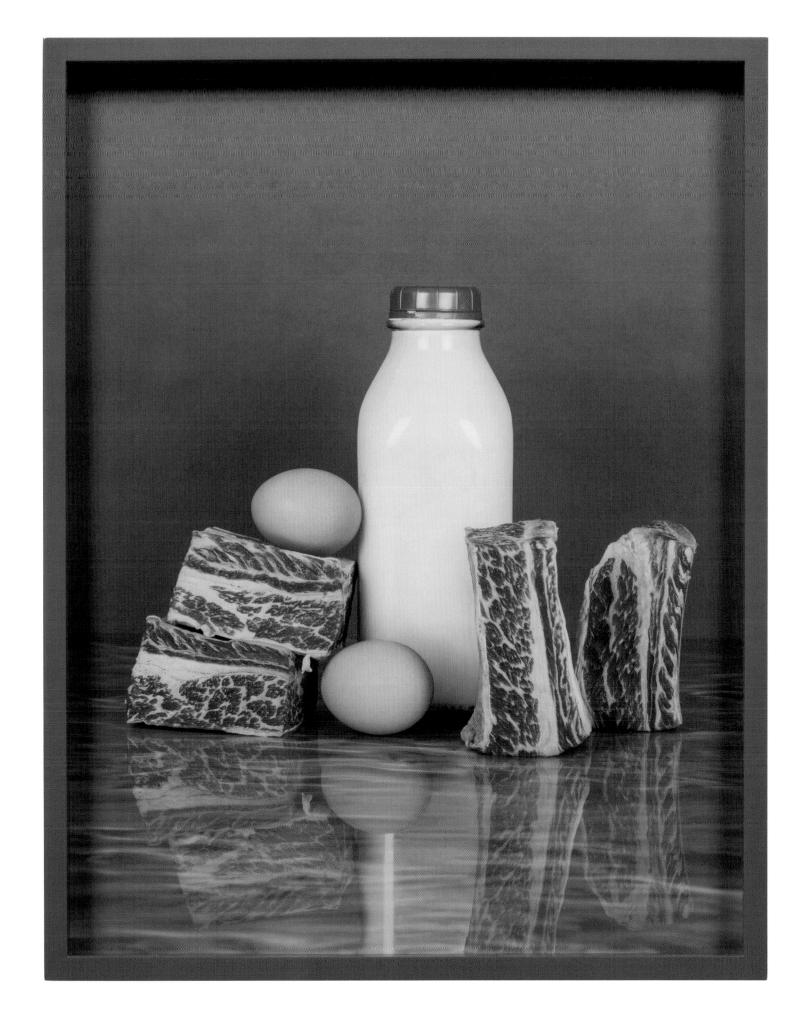

291 Elad Lassry, *Short Ribs, Eggs, Milk*, 2012

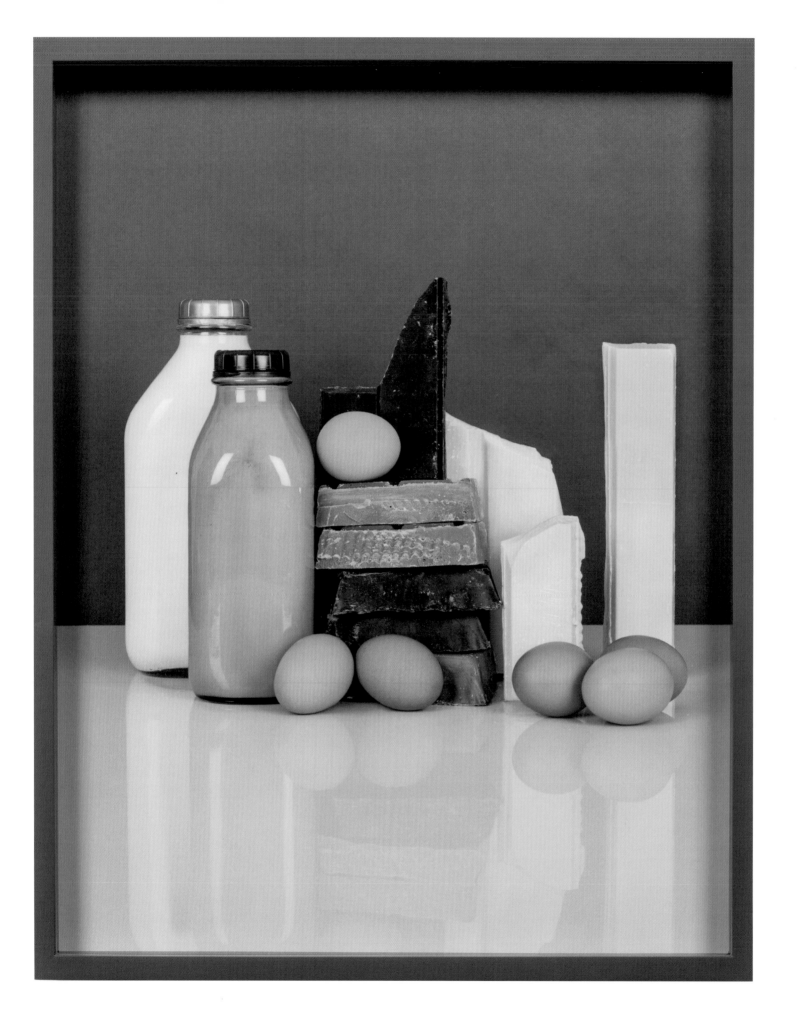

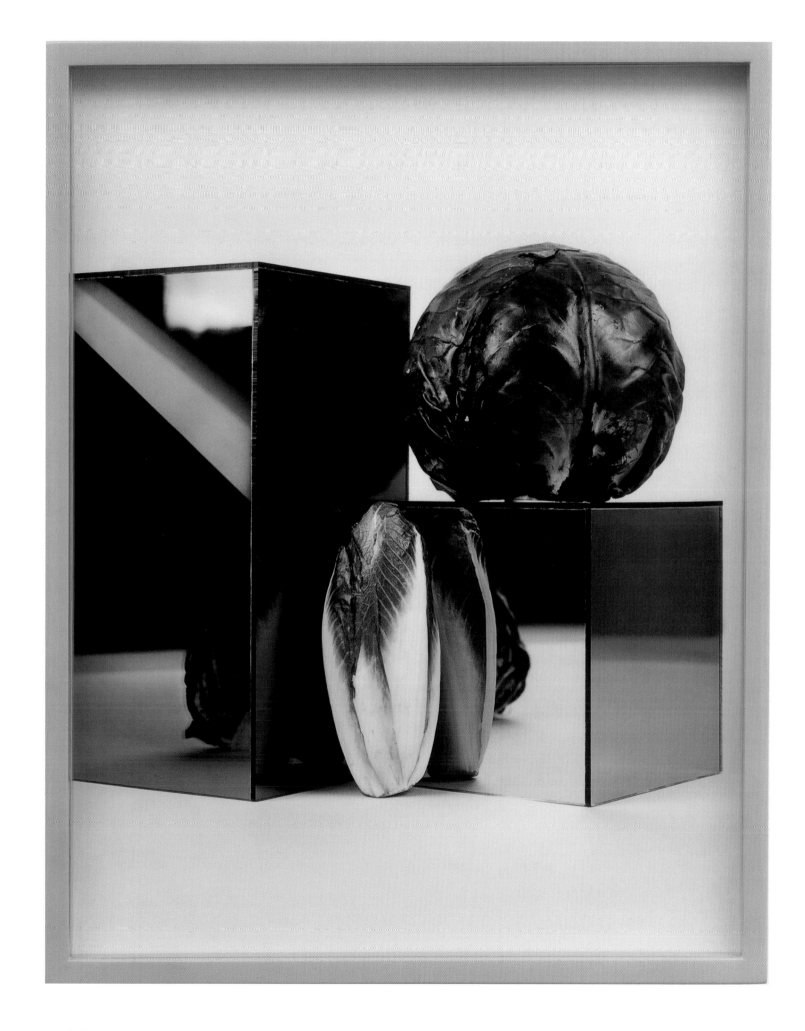

↖ Elad Lassry, *Chocolate Bars, Eggs, Milk*, 2012

↑ Elad Lassry, *Untitled (Red Cabbage 1)*, 2009

BOBBY DOHERTY

Bobby Doherty is the staff photographer for the biweekly *New York* magazine. He has to photograph a wide range of subjects in a style that is recognizable but never repetitive, so he employs trademark strategies that make his work stand out and have become synonymous with the identity of the magazine. It is with food photography that he really excels: Doherty often cuts the photograph down, to concentrate only on the bare essentials. There is rarely any elaborate staging, and props are minimal. He creates his characteristic graphic punch through repetition, or with the use of vibrant, contrasting color backdrops.

Doherty often goes in close, where he manages to expertly capture the textures and essential qualities of food in a way that exaggerates them and traverses the thin line between looking utterly delicious and horribly disgusting. There are touches of the surreal to his juxtapositions, and a surprising tenderness; his overall approach is joyous rather than ironic or arch, as it is with other contemporary still-life photographers working with food. The fast-paced cycle of a biweekly magazine means that Doherty has to come up with speedy answers to photographing food and different strategies for repeated magazine features—so his work has a lightness which looks effortless, but of course is not.

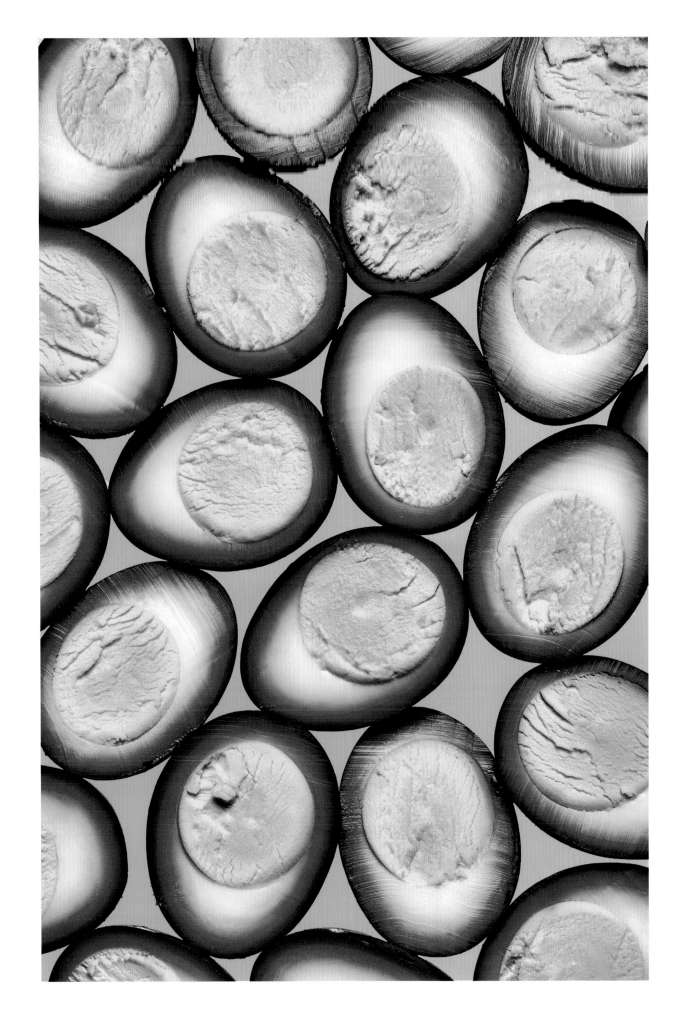

Bobby Doherty, *Pickled Eggies*, 2015

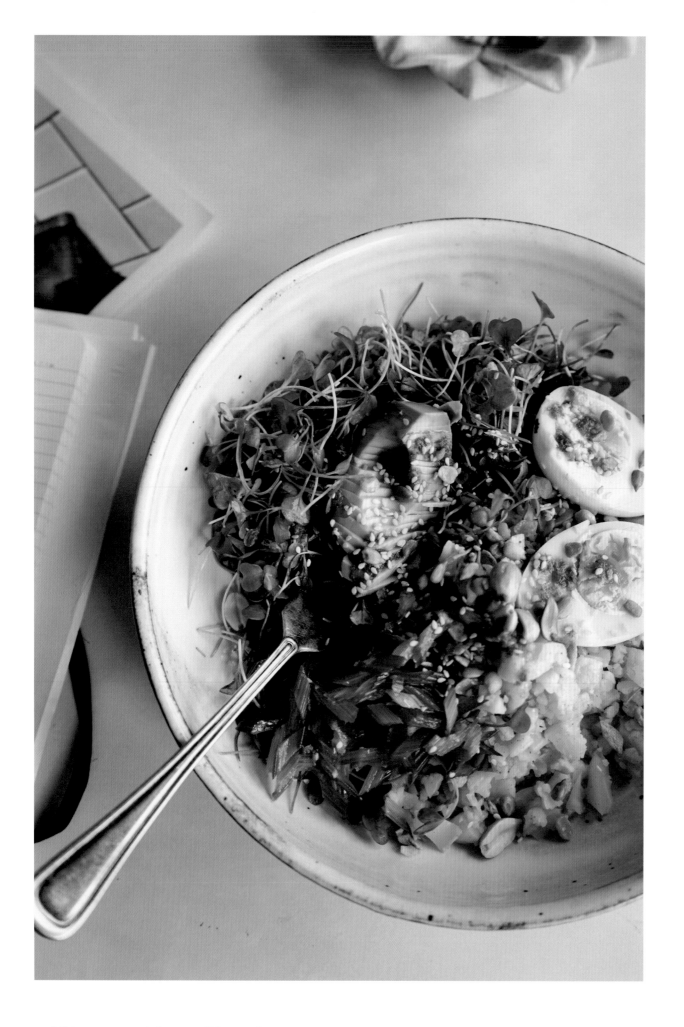

Heidi Swanson, *Rainbow Cauliflower Rice*
Bowl, June 2016

101
COOKBOOKS

A pioneer in food blogging, Heidi Swanson created *101 Cookbooks* in 2003. The idea was to highlight meals from her vast collection of cookbooks, as well as creating and documenting her own recipes, with an emphasis on healthy eating. Swanson quickly realized that blogging was a time-consuming process, so the photographs of her food had to fit around her lifestyle. Food could not take a long time to set up, so she took the photographs as things cooked. The key to her images' success is that they always look so fresh and enticing.

From the very beginning, these kinds of logistics have produced the specific, relaxed style which has come to dominate food blogs. The photographs, although tightly shot around the food, depend on minimalist styling to create quiet and naturalistic still lifes with an air of insouciance. The virtual space allows the chance for many photographs to illustrate each recipe and show how each dish is constructed—something which set blogs apart from their equivalents in book form, which are limited by the economic forces of space and page count. However, the labor of maintaining a blog—the endless taking, editing, and uploading of photographs, alongside all the writing and cooking—is made invisible. The viewer is invited into a seductive vision of a lifestyle that can also be accessed across many image-sharing and social-media platforms. Swanson has also written and photographed four of her own cookbooks.

MALE CHEF

Male Chef indirectly mocks healthy-living and food blogs and the values to which they aspire. The photographer, Chris Maggio, describes Male Chef as a "holiday gift guide" column that satirizes current trends and traditions (culinary and otherwise) with austere absurdity. Male Chef is also a hapless persona. Themed editorials appear regularly on the *Vice* magazine website, as well as a dedicated Tumblr blog.

 Male Chef takes the particularly American aesthetic and approach of the "gross-out," also seen in Cindy Sherman's work (pp. 206–7) and a trajectory of films about young men, such as *Porky's* in 1981 through to *American Pie* in 1999. This series can appear to be in the same facile, juvenile, and inane vein as those films, but it has an intelligence and pointed humor that sets it apart. First, Maggio addresses issues of class and metropolitan taste and aspirations. The culture of gastronomy, as well as its online photographic obsessions on blogs and social-networking platforms, is one of privilege and wealth. Male Chef does not belong to this group; he has neither the time (nor the knowledge) to milk almonds, and the stores in his neighborhood do not sell chia seeds.

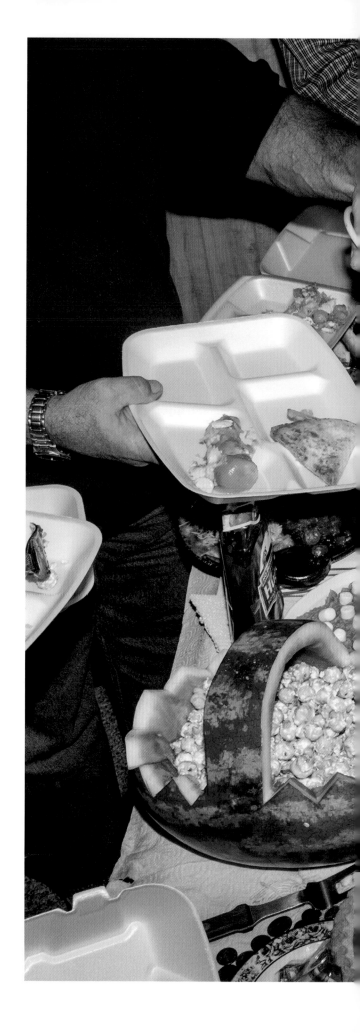

Chris Maggio, from the series Male

Chef Thanksgiving, 2013

Chris Maggio, all from the series Male
Chef Thanksgiving, 2013

He would not know what to do with them even if they did. Second, Maggio addresses issues of gender, playing on the stereotype that men cannot cook and are useless in the kitchen, simply because it is not their domain or job.

The Male Chef Thanksgiving series was a commission from *Food Republic* magazine, which regularly conforms to much of the culture around food photography that Male Chef is satirizing. The task of planning, shopping, cooking, and clearing up the Thanksgiving meal is primarily and traditionally the task of women, while the men eat and watch football. Here, Maggio has taken all those traditions and mashed them together into a surreal and disgusting event. He has set it in a strange office-barn hybrid and filled it with men in "dad jeans" and Gap T-shirts. The cranberry sauce is canned, the plates are Styrofoam take-out containers, and frozen leftovers from the last year's Thanksgiving are on the table (perhaps a knowing nod to Irving Penn's glorious frozen-food still life?), along with a turkey basted in Powerade. It succeeds in being funny, disgusting, and melancholy all at once. The men are without family and rely on one another for company at this time of togetherness. But perhaps they are perfectly content?

LORENZO VITTURI

Lorenzo Vitturi's book *Dalston Anatomy* is a visual tribute to Ridley Road Market in the heart of Dalston in the East End of London. Quickly going through the transformation of gentrification, the market remains a specific blend of African, Turkish, and British communities. Vitturi merges the contrasting and vibrant environments through snapshots of the market and still lifes of the produce sold, thus creating a coherent visual link between street and studio. He achieves this by regularly using the artistic device of the diptych. The works are also realized as an exuberant installation, in which the structures echo the street stalls, and the haphazard display captures the frenzy and excitement of the market.

Vitturi's portraits and the still lifes of food are created by collaging and coloring. For example, the "candies" on the woman's face are made of foam, but the powder covering them is a mix of cassava powder (an essential ingredient in African cuisine) and bright-pink pigment. The still life across from it includes lamb trotters and a taro root covered in the same pigment. The sculptures that he creates echo the temporary nature of the market, which is dismantled and replaced every day. The juxtaposition of fresh and decaying food also suggests this lack of permanence. Produce such as breadfruit and dried fish are exotic to Vitturi; he purposefully depicts the food (and, indeed, the people) as "other," contradicting their ordinariness to those who sell, buy, and cook with it. This highlights the potential for a dual reading of images of food, in terms of local and foreign, exotic and ordinary.

Lorenzo Vitturi, *Red #1*, 2013; from the series
Dalston Anatomy

↖ Lorenzo Vitturi, *Pink #1*, 2013; from the series Dalston Anatomy
↑ Lorenzo Vitturi, *Pink #2*, 2013; from the series Dalston Anatomy

↑ Joseph Maida, *#rainbow #twist #trash #thingsarequeer*, March 19, 2015

↗ Joseph Maida, *#jelly #jello #fruity #fruto #thingsarequeer*, October 26, 2014

JOSEPH MAIDA

Joseph Maida's prolific vision is campy, full of fantasy and critique of contemporary material culture. He shakes up national and cultural references, often relying on cliché and wordplay in the titles for success. The use of absurd juxtapositions, as well as the tinkering with perception and scale were prompted by a 1973 Duane Michals photographic work, which employs some similar strategies. The initial platform for Maida's series Things "R" Queer was Instagram. The app is not only a way to share everyday autobiographical moments, but also a serious platform for some artists to reconsider the distribution and consumption of photography. For Maida, this means crafting subversive tableaux that take their first cues from the social-media trope of food porn, and add purposeful doses of Pop art humor, advertising gloss, and Japanese *kawaii* (cuteness).

 The series, which has been ongoing since 2014, is photographed in a detached, matter-of-fact, documentary style. Maida makes images that are historically understood as "straight"—referring to both skillful aesthetics and lack of manipulation—undoubtedly queer. For Maida, queer goes beyond sexuality and sexual orientation, especially in the elastic space of social media and the

↑ Joseph Maida, *#egg #sushi #rice #puff #thingsarequeer*, February 5, 2016

↗ Joseph Maida, *#fishy #donut #divers #thingsarequeer*, December 1, 2015

Internet. Maida's poppy, absurd, and transgressive representations of food—the most
common denominator of survival—play not only with what we eat and how we see,
but also with conventional notions of the photographic medium. "I don't know if
I believe in the idea of any photograph being straight in the sense of being fully true or
fully real, because there's always room for interpretation," he says. "I'm interested in
paradoxes . . . What you see is not easily categorized. The identity of the work is fluid."

INDEPENDENT JOURNALS

Over the last decade, food-magazine publishing has undergone a radical change. With the closure of established, but undoubtedly niche magazines such as *Gourmet*, a new crop of independent journals has emerged internationally among the more mainstream staples. These include titles such as *Lucky Peach*, *Put a Egg On It*, the *Gourmand*, *Alla Carta*, *Luncheon*, and *Gather Journal*, to name a few. These contrast vividly with more aspirational magazines such as *Kinfolk*, which have also gained popularity. Although they all have very different identities and audiences, the approach to the photographing of food within these magazines is one of upbeat humor and energy. The photographers show an astute understanding of the history of commercial food photography during its heyday—with knowledge of photographers such as Nickolas Muray and Victor Keppler—but they also reference the fluorescent colors, shifting perspectives, and abstraction found in art and the reinvigorated still life genre.

This is not food you want to eat. Instead, the food here seduces the viewer in another way altogether, often in themed scenarios that can appear lurid and zine-y. The photographers reference nostalgic periods, especially the 1970s, and employ clichéd approaches to props and styling. This particularly affects the work of Grant Cornett, as well as husband-and-wife team Keirnan Monaghan and Theo Vamvounakis from *Gather Journal*. While some of these magazines may be recipe-driven, such as *Gather*, others such as *Lucky Peach*—which is associated with chef David Chang, founder of the New York restaurant Momofuku—ask celebrity writers and chefs to contribute, but in a way that is thorough and diligent. The magazine has an obsessive respect for food culture and history—albeit with a slightly knowing, "punk rock" aesthetic in its writing and design.

Keirnan Monaghan and Theo Vamvounakis, *Strawberry Vanilla*
Semifreddo, 2015; for *Gather Journal*, food styling by Maggie Ruggiero

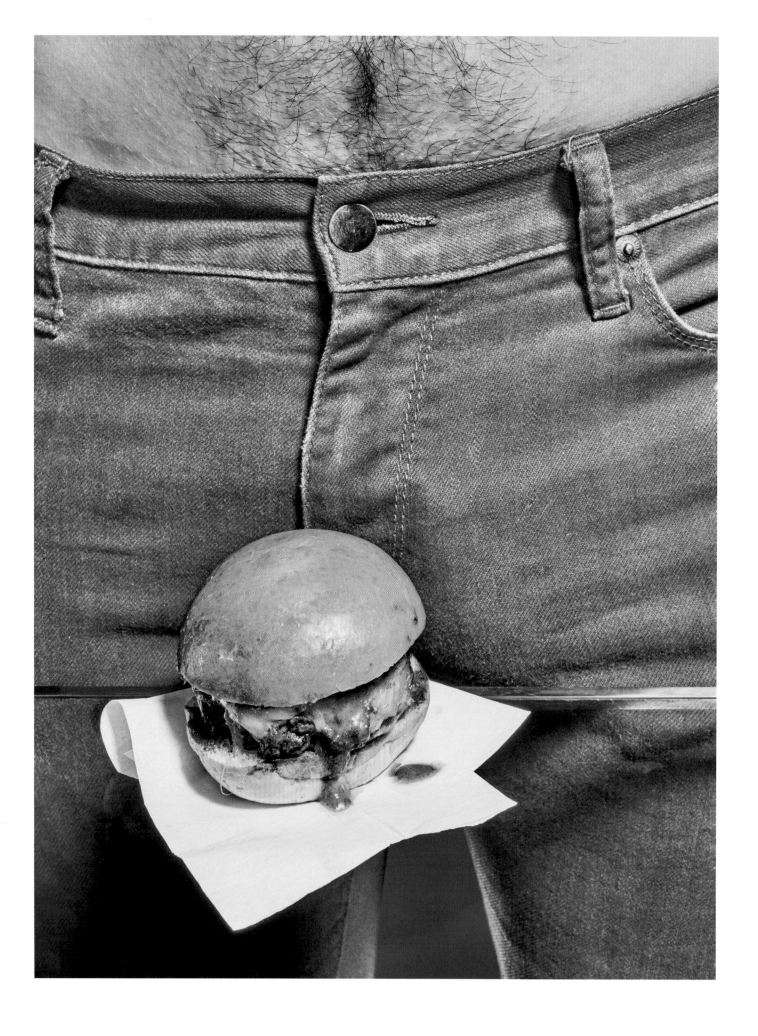

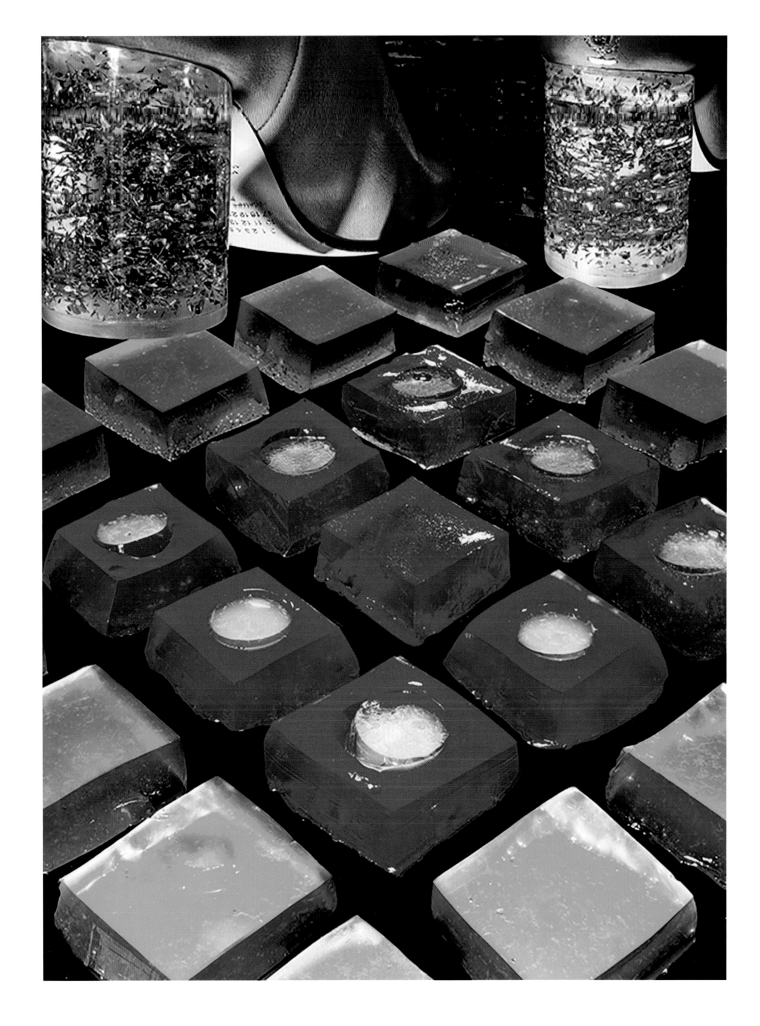

↖ Grant Cornett, *Sexy Silders*, 2016;
 for *Gather Journal*, food styling by Janine Iversen

↑ Grant Cornett, *Jello Disco Floor*, 2016;
 for *Gather Journal*, food styling by Janine Iversen

DANIEL GORDON

Daniel Gordon meticulously cuts up pictures found in magazines and the Internet as well as colored paper to create tabletop scenes, which he then photographs on a large-format camera, in a similar way to Thomas Demand. Like William Henry Fox Talbot's still life (p. 25), these tableaux of food are created purely with the artistic intent of making a good photograph that can be understood as art. They reference painting and its tradition, but the food is far removed from any links to nature and its attendant art-historical symbolism. In fact, it's not food at all, but constructions made to look like food. Gordon does not appropriate artistic references here to establish his photographs' status as art, as Talbot did—that status is already firmly established. Instead, like many of his contemporaries, Gordon does so simply as part of a contemporary artist's vocabulary, as part of a strategy and method that relishes the possibilities of photography and allows us to see the potential of how food can be photographed anew.

In these photographs, Gordon creates scenes not to mimic reality, but to present a version of it, making little attempt to hide the labor put into their construction. Crumpled paper and glue sit side by side with obvious Photoshop devices such as changes of color (a pineapple is not turquoise) and cloning repetitions or digital "noise" in the backdrops. Gordon references the masters but creates something with a wholly modern twist. The cutouts so associated with Matisse are combined with visual suggestions of the structures of Cézanne paintings and Cubist sensibilities. The use of certain colors also brings to mind photographic processes that have been used throughout photo history, especially in the work of Nickolas Muray and Paul Outerbridge. These intricately constructed tableaux illustrate a perfect marriage of digital and analog photographic process and of high and low artistic references, complicating our idea of what is understood as sculpture, photography, painting, and the cutout.

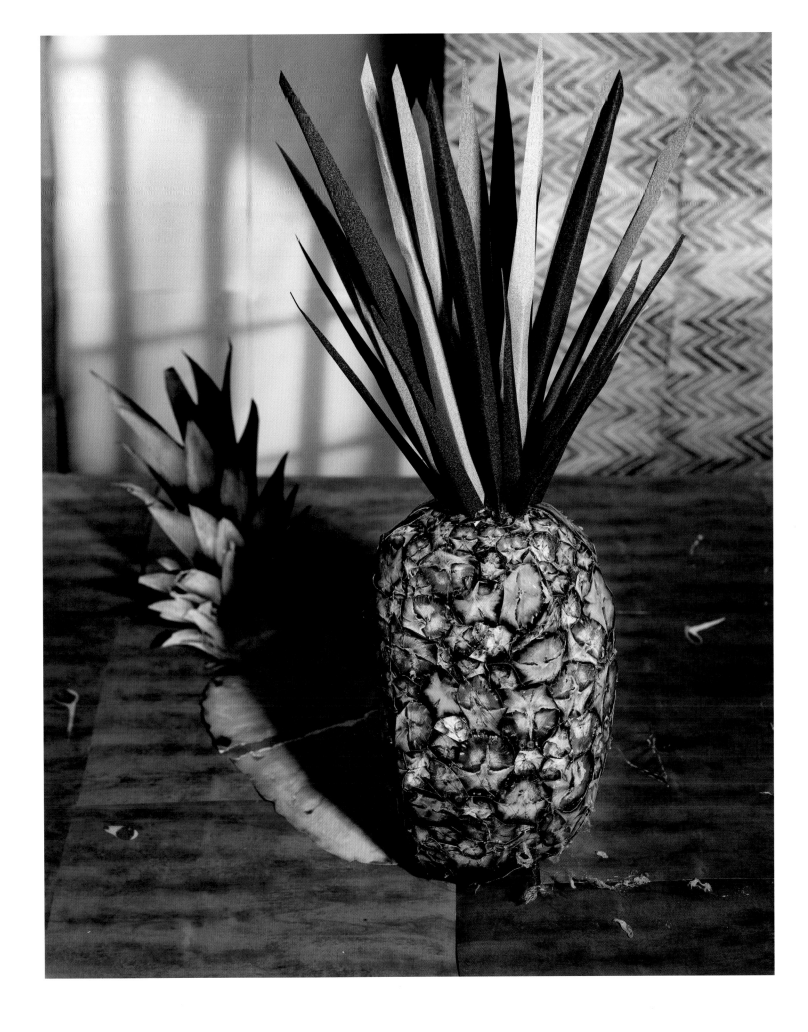

Daniel Gordon, *Pineapple and Shadow*, 2011

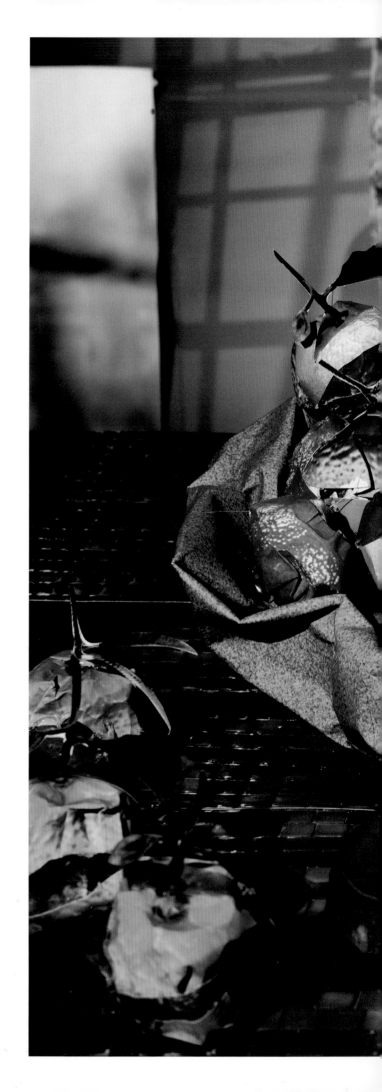

Daniel Gordon, *Clementines*, 2011

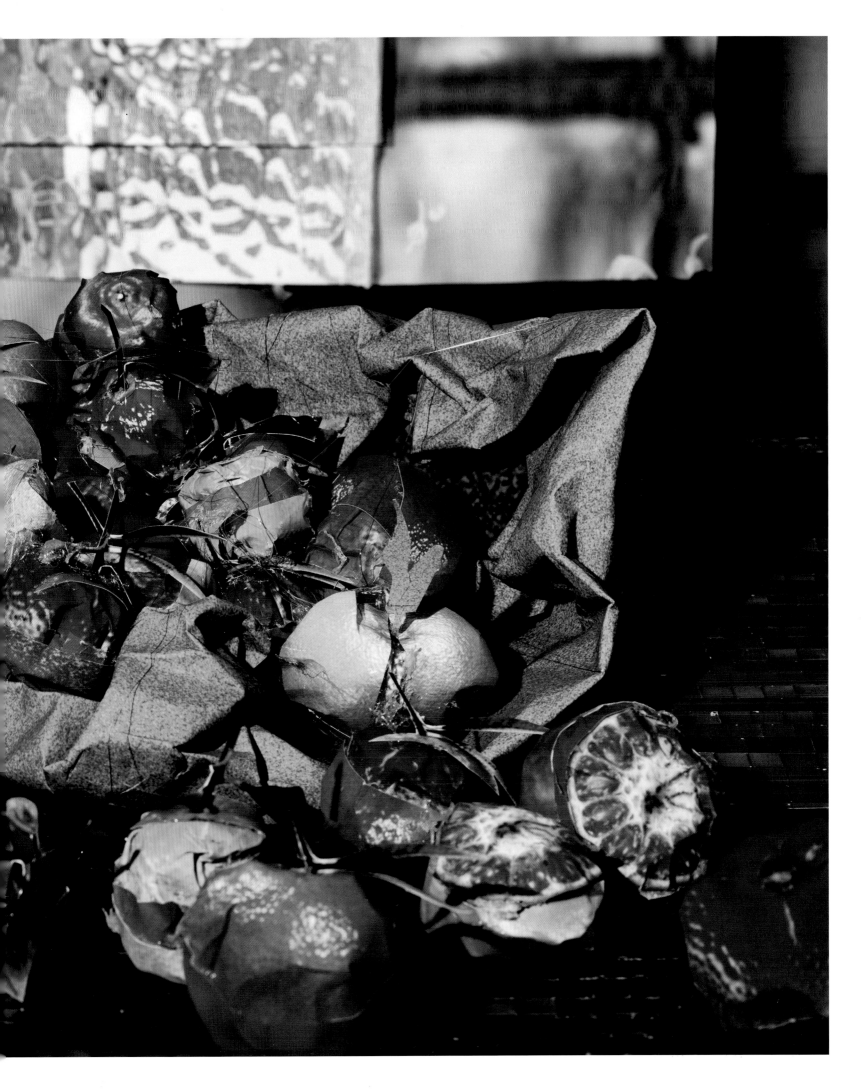

ACKNOWLEDGMENTS

A lot of hard work has gone into this book: most notably by Denise Wolff who has brought vision, energy, rigor, knowledge, encouragement, passion, and patience to the project. Quite simply, working collaboratively with her made *Feast for the Eyes* a better book. I cannot thank her enough.

I am most grateful to all the photographers who contributed so kindly to *Feast for the Eyes*.

My sincerest thanks must also go to Charlotte Chudy, an invaluable work scholar and dogged negotiator, and to David Arkin, who helped research in the initial stages. Thanks also to Madeline Coleman for her diligent and precise eye on the text; to Susan Ciccotti and Sally Knapp for their eye over the whole; and to Nicole Moulaison, Nelson Chan, and Alta Image for their work on the photographs.

Designer Sonya Dyakova brought this book to life. Thank you for your time, flair, and dedication.

Many have gone out of their way to support and help me, and their kindness must be acknowledged. I am especially grateful to Fred Bright, Carla Carr Bright, Daniel Palmer, Bronwyn Rennex, Isobel Parker Philip, Ian Potter, Brian Liddy, Diane Smyth, and Hedy Van Erp.

This book is dedicated to Mike and Ruby Reynolds—my favorite people to cook for.

—Susan Bright

Aperture wishes to thank Tammy Carter, Center for Creative Photography, Tucson; Isabella Donadio, Harvard Art Museum; Lisa Hostetler, Sarah Evans, and Lauren Lean, George Eastman Museum; Isabella Howard and Meagan McGowan, Howard Greenberg Gallery; Allison Ingram, Condé Nast Collection; Irving Penn Foundation; Mimi Levitt, Nickolas Muray Photo Archive; Ella Miller, Jamie Oliver Group; Shannon Perich, National Museum of American History; Chris Rawson, David Zwirner Gallery; Michael Shulman, Magnum Photos; and Claartje van Dijk, International Center of Photography. Thank you to Marvin Taylor and the staff at New York University's Fales Library for their advice and special access to their collection; to Peter J. Cohen for lending snapshots of cakes and celebrations from his collection; to Richard Marot for photographing the books, magazines, and ephemera. And thank you, especially, to the artists whose work appears in this book, to Sonya Dyakova for a stunning book design, and to Susan Bright, for a sterling survey of the subject.

IMAGE CREDITS

Feast for the Eyes:
The Story of Food in Photography
by Susan Bright

Front cover: Irving Penn, *Salad Ingredients,*
New York, 1947

Editor: Denise Wolff
Designer: Atelier Dyakova
Production Director: Nicole Moulaison
Production Manager: Nelson Chan
Associate Editor: Katie Clifford
Copy Editor: Madeline Coleman
Senior Text Editor: Susan Ciccotti
Proofreader: Sally Knapp
Work Scholars: David Arkin,
Charlotte Chudy, and Jasphy Zheng

Additional staff of the Aperture book program
includes: Chris Boot, *Executive Director*; Sarah
McNear, *Deputy Director*; Lesley A. Martin,
Creative Director; Amelia Lang, *Managing Editor*;
Kellie McLaughlin, *Director of Sales and Marketing*;
Richard Gregg, *Sales Director, Books*; Samantha
Marlow, *Associate Editor*; Taia Kwinter, *Associate
Managing Editor*

This project was made possible, in part,
with generous support from Furthermore:
a program of the J. M. Kaplan Fund.

Furthermore:
a program of the J.M. Kaplan Fund

First edition, 2017
Printed in China
10 9 8 7 6 5 4 3 2 1

Library of Congress Control Number: 2016956987
ISBN 978-1-59711-361-8

To order Aperture books, contact:
+1 212.946.7154
orders@aperture.org

For information about Aperture trade distribution
worldwide, visit:
www.aperture.org/distribution

aperture

Aperture Foundation
547 West 27th Street, 4th Floor
New York, N.Y. 10001
www.aperture.org

Aperture, a not-for-profit foundation, connects
the photo community and its audiences with
the most inspiring work, the sharpest ideas, and
with each other—in print, in person, and online.